Their Portraits in My Books

The Fiction of George Gissing

a critical study by

James Haydock

authorHOUSE®

AuthorHouse™
1663 Liberty Drive
Bloomington, IN 47403
www.authorhouse.com
Phone: 833-262-8899

Published by AuthorHouse 01/30/2023

ISBN: 978-1-7283-7861-9 (sc)
ISBN: 978-1-7283-7869-5 (e)

Also by James Haydock

Portraits in Charcoal: George Gissing's Women
Stormbirds
Victorian Sages
On a Darkling Plain: Victorian Poetry and Thought
Beacon's River
Against the Grain
Mose in Bondage
Searching in Shadow: Victorian Prose and Thought
A Tinker in Blue Anchor
The Woman Question and George Gissing
Of Time and Tide: the Windhover Saga
But Not Without Hope
I, Jonathan Blue
The Inward Journey: Original Short Stories
Cayenne Heat: A Novel Based on Real Events

"Strange this friendly association with people. It would be awkward if they came to recognize their portraits in my books!"

— George to Margaret, June 13, 1886

Contents

Chapter One

His Study of Women

*"I have by no means completed my study
of women yet. It is one of the things in which
I hope to be a specialist some day."*

Speaking through Jasper Milvain, a young writer in *New Grub Street*, George Gissing was thinking of his own goals as a novelist and the reputation he hoped to achieve within a decade. All his life, though often from a distance, he had studied women. Now at thirty-four, in well-crafted fiction, he was becoming an expert in the portrayal of girls and women. His interest in their world is seen as early as his first novel, *Workers in the Dawn* (1880), as well as in the early short stories of the 1870's. His unique insight is shown in every novel published during the 1890's, indeed in all of twenty-three novels. A casual reader, leafing through one of a Gissing's books, will find an assortment of female

characters carefully positioned to advance theme and plot. A more serious reader will see Gissing trying to understand the women of his generation and trying to present them with unerring realism.

If you examine Gissing's female charactiers as they relate to his life, you will discover an important aspect of his work. His novels, published during the last two decades of the nineteenth century, are memorable for their detailed portraits of women. As a young man, as a mature novelist, even as a classical scholar, a persistent intellectual pursuit for Gissing was the study of women. With meticulous attention he observed them in his daily life wherever he happened to be. When reading about women, he jotted down notes in a miniscule handwriting not easily deciphered. His books, several of which bear women's names for titles, present female characters with frankness never seen before in Victorian novels. Even though women in Gissing's life were relatively few, each to a person exerted a lasting influence upon his work.

The woman at the center of George Gissing's early work, the one who exerted the most influence without knowing why, was Marianne Helen Harrison, a prostitute he met when a student in Manchester. He stole money from classmates to support her and left the college in disgrace to live in America for a year. On returning, she became his wife in a London slum in 1879. In that year he wrote his first novel. His presentation of prostitution as a social issue in the novels of the 1880's,

originates with the woman he referred to as Nell. It is doubtful that his personal behavior at this time went beyond the relationship with Nell. Yet poverty made him the alien neighbor of those women who walked the streets at night to sell their bodies in tough economic times.

As Nell disappointed him again and again, he came to believe she was a victim of heredity rather than that of an uncaring society. She was, therefore, naturally unregenerate. But in 1888, viewing Nell in death, he felt a powerful resurgence of pity for her wasted life, and it brought a change of heart. He vowed he would battle against a corrupt society that permitted in spite of its wealth the exploitation of women. Although his opinions on this subject vacillated through the years, he continued to view prostitution as an ugly and destructive disease.

By 1884 Nell had yielded once more to her fondness for alcohol, had drifted away from Gissing's protective hearth, and had become a prostitute again. Her husband lived alone in poverty, but continued to write when he could steal the time from his tutoring. His second novel, *The Unclassed*, was published in that year. Soon afterwards, solely by chance, he found himself in the midst of cultivated people of leisure. To augment his spare income, he began to tutor the children of Mrs. David Gaussen, a wealthy and traveled woman who became a close friend. At a formative and

vulnerable time in his career she came into his life to exert an important and lasting influence.

For a time Gissing gave up entirely the novel of social purpose, the genre he hoped to found his career upon, to write a novel in tribute to Gaussen. He titled the book *Isabel Clarendon*, and it was published in 1886. His new friend had become the model for the superlative main character. She had charmed the young author into idealizing the women of her world. Wealthy women in later novels also show the woman's influence. Years later his memory of Mrs. Gausssen inspired a gallery of captivating older women; They were mature yet alive and sensitive. He labeled them "women of the world."

In the summer of 1889, five years after he became the friend of Mrs. Gaussen, Gissing established correspondence with another woman of wealth and refinement. Her name was Edith Sichel. Though Sichel was younger, she lacked the grace and charm of Mrs. Gaussen. Also she wasn't as feminine, a quality Gissing prized. Her influence helped him shape his concept of "the New Woman." Her impact as well may be seen in the novel he published shortly after meeting her, *The Emancipated.* Her influence extended with less force into *New Grub Street*, for he wasn't impressed by her career as a writer. In that novel Marian Yule finds writing for periodicals unpleasant. Though under the thumb of a demanding and domineering father, Marian gathers the strength to escape "the beastly scrimmage." Gissing has Bertha Childerstone, also a rare journalist,

become less feminine as she competes in a tough and unforgiving profession.

In *Workers in the Dawn*, his first novel, a main character is named Helen Norman. Sensible and cerebral but stuffy, staid, and pedantic, she declares that "such work is not woman's true sphere." Only ambitious Ada Warren in *Isabel Clarendon* seems fitted to become a true woman of letters. Gissing believed that women were as capable as men when it came to puting words on paper -- he had great respect for Charlotte Brontë -- but writing articles for a pittance seemed more commercial than creative. One did it to earn a living, not to advance the arts or achieve recognition. Wealthy Edith Sichel was not in the market for gainful employment. She was seeking personal satisfaction, rather than recognition, when she tried her hand at writing. So Gissing thought her attempts to publish were little more than a hobby. Her philanthropic work, while impressive, was also of questionable value. He liked Edith Sichel and respected her as an educated heiress, but he would never show more than a passing interest in her.

His sisters, Ellen and Margaret, also exerted influence on his work. As a novelist seeking to create realistic feminine characters, he turned inevitably to the people close to him. He viewed his younger sisters as unliberated women bound by narrow religious dogma. They were not able to become liberated because of their stultifying code of morality based on puritanical teachings. In many long letters he offered them careful

and patient instruction but without notable success. They never married, and they remained conventional women all their lives. They trusted tradition for their advancement in the world, and they ignored or resisted the new secular developments that were improving the lives of women. But in time they surprised their brother with grit.

When Gissing brought the emancipated woman into his work, in many respects she was the opposite of his sisters. When he carefully traced the sea change of a young woman from puritanical bondage to hellenistic freedom, he was thinking of his sisters as the kind if women they might have become. He wanted them to be strong, intelligent, and independent of a man's support. As it turned out, he was not entirely disappointed. In the 1890s, after several years of teaching long hours at low incomes, his sisters were able to open and manage a successful grammar school of their own. In later years it flourished, and Gissing allowed one of his sons to be a pupil there.

Of importance, as the sisters struggled to make their way in the world, was the changing status of women and its economic impact. The question confronting most of Gissing's middle-class women, as they become more independent, is "What shall I do in the world?" Because they lacked the necessary training, few jobs outside their homes were open to them. So Gissing urged middle-class parents to think in practical terms and provide their daughters with a practical education. The girls were not above being trained as servants — a

statement some readers found shocking — to work in the homes of the wealthy.

His earliest instruction on this subject, except for the letters to his sisters, can be seen in his third novel, *Isabel Clarendon* (1886): *"Of no greater unkindness can parents be guilty than to train as if for a life of leisure children whose lot will inevitably be to earn a livelihood by day-long toil. It is to sew in them the seeds of despair."* His portrayal of the ineffectual Madden sisters in *The Odd Women* (1893) supports this theme. Their education, a collection of genteel *"accomplishments,"* fails them when they are required by circumstance to support themselves. Late in life they dream of opening a school of their own, but unlike the Gissing sisters, they can find neither the will nor strength to realize their dream. Superfluous women, they cannot find their place in the world's marketplace and sadly sink downward. Gissing's middle-class sisters, unmarried evangelicals, were in his mind when he created the Madden sisters. However, as real women living daily lives they don't share the Madden melodrama created by Gissing.

In the autumn of 1890, perhaps in a candle shop in London, Gissing met a young woman named Edith Underwood. She was a working-class woman of no particular beauty but young and attractive in his eyes. For months he had prowled the city streets looking for someone similar. He married Edith on February 25, 1891. Before the ceremony, he confided to his German friend, Eduard Bertz, that he could no longer live alone

and was too poor to marry a woman of his own class. For a second time he had deluded himself into making the bitter mistake of looking for a lower-class woman who could could be trained to his way of life. In his reading he had come across men like William Blake who had wives of humble background. Blake lived comfortably with his wife, and she helped him achieve exceptional creative work. Wouldn't it be possible to accomplish the same miracle with Edith?

Within a year the slim young woman who seemed to be soft and pliable when they met was showing signs of ill temper. Within two years the marriage had slipped into bickering and discomfort. In 1897, after six years of domestic unrest and the birth of two healthy sons, the couple separated. Even though he knew legal action was difficult and expensive, Gissing wanted a divorce. When Edith refused to sign the legal papers, the attempt to free himself of her became impossible. For years thereafter, even when rational thought told him he had escaped her, he viewed himself as "vixen-haunted." Inevitably the misery of that second marriage found its way into his work. Edith Underwood, the woman who robbed him of domestic peace, influenced his creativity more profoundly than his first wife, Nell Harrison.

As Gissing's second marriage fell into ruin, he began to question his own fitness and adaptability, but also the institution of marriage itself. Most of his novels of the 1890s, show marriage as a precarious and uncertain arrangement. When couples marry for

convenience or economic reasons, they are likely to experience all too soon dark and painful misery. At times the wife is to blame, but often as not the trouble originates with the wretched husband whose sense of male dominance will not allow him to view his wife as an equal. The turn of the screw, a gradual tightening of male control, usually provokes the wife to resist or rebel. That reaction tends to hasten the failure of the marriage. Also the feminist movement is seen as a troublesome cause of middle-class domestic conflict, particularly when the feminism of the wife clashes with the conservative values of the husband. Gissing believed the solution to the marriage problem was affordable divorce. However, expensive antiquated laws made divorce a public shame and placed it beyond the reach of all but wealthy couples.

In 1880, the year Gissing reluctantly published his first novel at his own expense, the movement to improve the lives of women had become one of the important issues of the day. As a social novelist he was keenly aware of its potential as literary grist, but chose to focus on the problems of working men and women. The feminist movement was mainly a product of the middle class and thus beyond the purview of his subject matter at that time. But when he turned away from proletarian themes to examine issues in the lives of the middle and upper class, that movement demanded and received his most careful attention.

After *The Nether World* (1889), the dark and

powerful novel in which he purged himself of all that reminded him of his poverty-bitten life with Nell, he began to think of the women's movement and its aims as a fertile source of new and vital ideas. A main type of the movement, the womanly woman, had already appeared in his fiction. Two other types of the movement, the woman in revolt and the new woman, would soon follow. He believed his readers, whether sympathizing with the new feminine types or not, would find them more entertaining than the old. A treatment of the new types might also increase readership.

He met his first unequivocal feminist, Clémence Louise Michel, in the autumn of 1888 when he attended a lecture she was delivering in Paris. Though on his first Europen journey, he listened to her rapid and fiery French, half understanding most of it, and studied her face. Later he confided that her speech and manner showed signs of intellect even though her face was that of an English fishwife. That negative opinion of a leading French activist revealed an ambivalence toward the feminist movement that remained with him to the end of his career.

In 1892 Gissing observed bitterly that the simpering, conventional female would have to yield to a superior specimen. In 1893 he could see signs of the traditional woman being supplanted by a vigorous new type. In that year he met Clara Collet, a woman of caliber who later achieved distinction as a social scientist. An authority on woman's work, she impressed him as

she made use of qualities he hoped his sisters would soon acquire. Independent and intelligent, brimming with self-confidence and well-educated, she enjoyed in her private and public life a freedom of movement that suggested full equality with men. Yet, to his happy surprise, Miss Collet seemed not at all extreme or abrasive. He accepted her as a close friend willing to help him in time of need. She, on the other hand, seems to have fallen in love with him.

Circumstance, or the vagaries of life, prevented their becoming romantically involved. But as Gissing came to know Collet better, she became the model for his most substantial portrait of the new woman. After his death she worked hard to secure his reputation as a man of letters. H. G. Wells found it difficult to get along with Collet. Irascible and unbending in the presence of strong-minded women, he seems to have generated the conflict between them that never ended. Her personality was too self-assertive for the obstinate and egotistical Wells. He liked passive, old-fashioned women. In time he would become the author of novels that eclipsed Gissing's. They remain popular even today.

The feminine type Gissing admired most, in daily life and in his fiction, displayed through her behavior a judicious blend of the new and old. She could be active in the market place, in the commercial arena, in professions held mainly by men, but remain a loving mother and wife at home. Moreover, she was guided at all times by intelligence of the heart. It was a quality

Gissing valued unconditionally, particularly when it was tempered by intelligence of the head. As he grew older and garnered experience in a world not entirely his own, the Ruskinian idealism of his youth yielded to a somber realism. But even when most cynical he never believed women were inferior to men.

After returning from his Italian journey in April 1898, Gissing went to live in Dorking to escape the fury of Edith and to be close to H. G. Wells, who had become a good friend. An abundance of labor gleaned during the trip abroad demanded full attention. To pay his monthly bills he had to produce and publish. But unrest and anxiety mounting almost to despair prevented the completion of one project after another. Then on June 23, 1898, a pleasent day with blue skies, something happened that changed his life. He received a letter from a young Frenchwoman who signed the letter with the name Edith Fleury. In a brief paragraph, she asked permission to translate *New Grub Street* for readers in France. Gissing found her letter proper and business-like in every word but delightful in Gallic phrasing. It gathered importance quickly and became a turning point in his life.

The letter triggered a series of events that affected all aspects of his personal and professional life. The bitter years of domestic misery and the agonizing loneliness would soon be replaced by a quality of human comfort that he had ceased even to dream about. On the same day he received her letter he replied to it. They

met at the Wells home on July 6. At the end of that day he knew he would see her again and again. Their lively correspondence would quickly become a collection of passionate love letters, and pervasively she would inspire *The Crown of Life* (1899). Day after day as he wrote the book, Gissing was convinced it would in time be judged the best of his novels.

He called her Gabrielle to forget Edith. She came into his life at a time when he needed her most. Asserting the mysticism he never lost, he avowed she was driven to him by destiny. Gabrielle honed his sense of beauty, restored his youthful idealism, brought him strength of mind and heart, eased and tempered his bitterness, brightened his future, and offered hope for superb work as an artist. She charmed him with her slender good looks, her exciting femininity, her musical voice, and her eager intelligence. He saw in this person all those characteristics he had always wanted in a woman. Within a month the seasoned and cynical intellectual, a mature novelist of ideas and a student of the classics, became an unrepentant lover placing all his faith in feeling. They were married in a simple ceremoney with only her mother attending in May of 1899. *"For the first time in my life,"* he confided joyously to his German friend Bertz, *"I am happy!"*

So these are the women considered important in Gissing's life, the ones who exerted a lasting influence upon his work. Another woman of importance was his mother. Margaret Bedford Gissing was born in 1832

and died at eighty-one in 1913 less than a year before the beginning of World War I and ten years after the death of her son. It was the war that would take the life of Gissing's first son, Walter. Margaret Gissing was a typical middle-class English woman living in a small town, Wakefield in Yorkshire. Her husband, a chemist, died when George, her oldest son, was twelve. She was tasked with keeping the family together with smaller income. It was a large family, and she did all right. Neither she nor any member of the family was able to attend her son's funeral in France. H. G. Wells was there beside the death bed in 1903, but the family did not learn of the novelist's death until later. Even though we have no specific portrait of her in Gissing's novels, Margaret Bedford Gissing left her mark.

As one thinks about Gissing's final position regarding women, one remembers the ambivalence that must have bothered him. Perhaps in the last two decades of the nineteenth century he was too close to the complex changes affecting women to understand them fully. Perhaps he lacked the necessary detachment to form a balanced judgment of the types of women he came to know. With individual women the bitterness of his domestic life with Edith could have warped his judgment. That alone could have caused him to present his portrayal of women in variable tones of gray. While some portraits are sunny and bright, many of them are darkly rendered. All of them, however, are filled with

detail that makes them them warm, subtle, satisfying, and memorable.

The idealism which Gissing never entirely lost made clear vision prismatic and prevented a fair and just appraisal. That could explain why some of the female characters in his fiction, both early and late, have few redeeming qualities. Some indeed are demonic while others are angelic. He himself saw this dichotomy as a flaw. Creating lively and believable characters year after year siphoned his ceative ability but not his determination. A long fascination that yielded eventually to weary resignation might help us understand why he could observe at the end of his career that he really knew nothing about women. Their mystery, their mysticism, he admitted he had never been able to fathom. That utterance suggesting exhaustion after many years may contain a nugget of truth. He had given up trying to understand the female sex, but it was not because he had failed to make a thorough study of women.

Chapter Two

Marianne Helen Harrison

The telegram read, "Mrs. Gissing is dead. Come at once." George Gissing returned to London in haste from Sussex. It was a journey by train of three hours in frigid weather. The next morning, Thursday, March 1, 1888, he went to 16 Lucretia Street, Lambeth, where his harlot wife had spent the last days of her life. She was Marianne Helen Harrison; his name for her was Nell. They had met in Manchester in 1876 and had married in 1879. In 1888 at twenty-nine, she lay dead in a squalid room that reflected the sordid barrenness of her existence. With detached but characteristic precision, Gissing examined every corner and crevice of the room and recorded details in his diary.

On the rumpled deathbed were rags for blankets. Under the bed on the dirty floor were the only shoes the woman owned, a pair of cheap boots. Hanging on the back of the door was a tattered dress covered by a threadbare coat. No other clothing was in the room.

On the table were soiled and wrinkled pawn tickets. During the summer of 1887, unable to think ahead, Nell had pawned her winter clothing. In a bureau drawer Gissing found some scraps of stale bread and a dollop of rancid butter. It was the only food in the shabby room with not enough heat to soften the butter. In another drawer he found to his amazement the love letters he had written Nell during his year in America. She had saved them all, as well as a faded photograph of him. The condition of the letters indicated she had read them often.

Near the pawn tickets were three grimy "pledge cards" pushed upon her by temperance workers she had met in the streets. On the cards were printed promises to abstain from alcohol. Nell had signed the cards on the proper line within the last six months. The pledges, made in good faith but quickly broken, gave silent testimony of a painful struggle she had lost. Gissing believed the cards were proof she was trying to resist the demons that killed her while still a young woman. For most of her life she had been an alcoholic and a prostitute. Any money she was able to earn had gone to buy cheap liquor that could bring a few hours of escape from a harsh reality.

While the alcohol perhaps made her life easier to endure, she died in a hostile environment without care of any kind from anybody. As the woman lay dying by slow degrees, her landlady disclosed that not one person had come to assist her. Nell had a few known associates,

but they were so vile in appearance, according to the landlady, that she had forbidden them to enter the house. Looking into the dead woman's ravaged face, half hidden by a mane of dark hair, Gissing was uncertain whether he was able to recognize it. Only the even white teeth remained the same. Her teeth as one of her finest features eventually went into his novels. Some degenerate female characters, in unwittting imitation of Nell, have perfect teeth.

From *Workers in the Dawn* comes the following: *"This Polly Hemp* [a dissolute prostitute] *was as evil-looking a personage as one could encounter in the streets of London. She had eyes of green, out of which gleamed malice and cunning. She had a habit of holding her lips slightly apart, so as to exhibit the remnants of a very fine set of teeth."* Perhaps he was thinking also of Nell when he described other female characters as having white, even, and attractive teeth. They are Mrs. Damerel with no first name, Jenny Evans, Mary Liversedge, Alice Mutimer, Rhoda Nunn, Bridget Otway, Mrs. Bruce Page, and Polly Sparkes. Only two of the women (Jenny Evans and Polly Hemp) were created before Nell died. For books with year of publication in which the characters appear, see the list that ends this book.

The doctor who visited the woman shortly before or after her death –- no one knew exactly when -- recorded the immediate cause as "acute laryngitis." Exposure to the harsh winter of 1887/1888 brought on the condition. But the dormant, underlying, persistent

cause, as her husband well knew, was a life of sexual freedom made worse by poor health and drunkenness. More than once Gissing had taken Nell to a London hospital to be treated for one of her many ailments. A physician on one occasion detected what appeared to be a venereal disease and asked her about it. She lied about the source of the disease, implicating her husband. Gissing remembered the painful incident in conversation with his friend Morley Roberts. In doing so, he released a torrent of agonized confession, declaring he made no attempt to defend himself. Feeling trapped, he endured the doctor's angry rebuke in silence.

In the early spring of 1888, suppressing remembrance of those events, he felt a renewal of indignation. That same emotion had stirred him when he was drawn to Nell at eighteen. He couldn't blame himself and was unwilling to blame her. At fault was a callous society and *"a vice inherent in the nature of things."* Bristling with anger, he rededicated himself to his mission as a social novelist, affirming that Nell would assist him more in death than she had hindered him in life. He would try to undertand the forces that had destroyed her, and he would thrust into the teeth of the world a severe indictment against them. Before the year was out he had written one of his most powerful novels, *The Nether World* (1889). Writing the book helped him come to terms with the misery associated with Nell. The labor he expended was purgative. It released him, at least in part, from the bondage of the

past. In later novels, looking forward, he would focus on the middle class.

During his early years in London, Gissing lived in spare lodging houses in raw neighborhoods not far from those fashionable streets and squares that for more than a century had been the center of prostituion in London. Soho, Piccadilly Circus, Berwick Street, and the Haymarket attracted women and girls of every description from all parts of the nation. They plied their trade in the glare of the gaslamps, quickly ushering customers into the shadows of public parks and to rented rooms. Some were asssigned to brothels, but those less fortunate often worked in parks with little or no interference from the police.

The sheltered wives of the middle class pretended to know very little about these "fallen women," as they were called by the popular magazines of the day. However, many wives knew far more than they were willing to admit. On more than one occasion the skirts of middle-class women brushed against the skirts of prostitutes when passing on the pavement. Some bored and complacent women, looking from their dull world into a world they thought more exciting, viewed London harlots as mysterious and glamorous. In error they believed the well-dressed prostitute lived in luxurious surroundings. They believed she had loads of money to spend on expensive items when not working.

In a unique position to see behind the façade, Gissing knew better. From experience and observation

he knew the life of the prostitute was sordid rather than glamorous, filled with hardship rather than leisure, and burdened by poverty. Her shallow existence was stamped with pain and suffering, not laughter and joy. Her moment of demand was brief, and all too soon, like a broken toy, she was thrown away. The forces that brought her to the streets were difficult to discover, but Gissing believed the callous indifference of an apathetic society was the main cause. In temperate moments he viewed prostitutes, ranging in age from fifteen to fifty or more, as victims of circumstance who could be saved. In a more somber and cynical mood, he believed the female who drifted into prostitution had only herself to blame and was beyond help.

In 1876, when he first encountered Marianne Harrison on the streets of Manchester, Gissing was eighteen, naive, and visionary. The boy in *The Whirlpool*, who asks his father whether catching a fish is not a cruel sport, displays a sympathy for suffering that describes Gissing as a child. Throughout his life the spectacle of human affliction moved him to sorrow. The news that women in Russia were often forced by poverty to sell their hair made him angry. So when he met Nell, only seventeen and already earning her living on the streets, he accepted the girl as a helpless victim and began to show deep compassion for her. Frail and pretty and appealing to his masculinity, she flattered him with praise and attention. When he learned she was *"unfortunate"* (a euphemism for harlot), impulsively he

made up his mind to rescue her. It is certain he thought of her as a maiden in distress, a hapless victim of a cold and uncaring society, and one who desperately needed his help.

In his Commonplace Book, young Gissing quoted the conclusion of William Lecky's statement on the function of the prostitute in European society. The noted historian began by saying, *"There has arisen in society a figure which is certainly the most mournful, and in some respects the most awful upon which the eye of the moralist can dwell."* The passage ended with poetic prose: *"She remains, while creeds and civilisations rise and fall, the eternal priestess of humanity, blasted for the sins of the people."* The careful prose struck sentimental chords in Gissing.

As the affair with girl progressed, a fellow student and friend at Owens College, Morley Roberts, learned all about it. In The *Private Life of Henry Maitland*, a roman à clef published in 1912, Roberts recalled that one day Gissing showed him a photograph of the girl. She looked only seventeen. She had dark hair worn long, youthful good looks, and a bold, audacious expression. Gissing confirmed that she was a prostitute, and said he was trying to rescue her. Practical-minded Roberts wanted his friend to stop seeing the girl, but Gissing argued she was a victim of society and needed help. Unless he made an effort to reclaim her, she would be used and abused and thrown away like broken furniture. Stubbornly Gissing refused to end the affair.

Nell, as he soon came to call Marianne, probably told him that poverty alone drove her to sell her body on the streets of Manchester in the vicinity of the college. If he could supply her with money, she would pursue a decent way of life. Believing her implicitly, he sacrificed to buy her a sewing machine. But the feckless girl was too lazy to labor many hours each day as a needlewoman. Also that kind of work was notorious for its low wages. She knew she could earn more in a night as a whore than in weeks as a needlewoman. As the months passed, Nell began to take for herself most of the small income Gissing was receiving from his scholarships. To supply her with money and gifts, he sold for half its value a treasured heirloom, the gold watch his deceased father had left him. She demanded more, and that he didn't have.

Fearing the girl would abandon him and return to the streets, a stormy desperation drove Gissing to steal from the college cloakroom. A detective hired by the college caught him filching marked money from a student's overcoat and arrested him. The promising student was on track to become a distinguished classical scholar (his specialty) in a prestigious university. Branded as a thief, he was tried and convicted and sentenced to a month's hard labor in prison. Dismissed by Owens College, he was forced to begin a new life in America.

This was a major turning point in Gissing's life. Had he never become involved with the circumstances

surrounding Nell, it is likely he would have graduated with honors to become after graduate study a classical scholar and don at Cambridge or Oxford. That would have made him a privileged member of the upper middle class. He would have suffered less, and his personal life would have been happier, but the enduring novels he gave to the world would have been lost. He was arrested at the end of May. After a short trial in which he refused to involve Nell, he was committed to Bellevue Prison in Manchester on June 6, 1876. The warder described his appearance this way: "height 5-8 1/2; complexion light; face freckled; hair light brown; eyes gray." His date of discharge was shown as July 5, 1876. In the weeks that followed he planned his departure for America.

Perhaps he convinced himself that stealing from a debased society to help a person in distress was no wrong. Also he loved Nell and was willing to do anything to assist her. In August of 1876, as he prepared to sail for America and a new beginning, his thoughts turned to the one he was leaving behind. In a sentimental poem, titled "A Farewell," he spoke of finding a home far from England and having the gitl join him there. While crossing the Atlantic, suffering as he had never suffered before, he scribbled verses of saccharine sweetness in honor of his devoted lady, a tender flower blooming bravely in his heart. In America, losing himself in lofty idealism, he penned four sonnets in praise of womanly virtue, all with Nell at the center. Alone in a foreign land and apprehensive of the future, he couldn't abandon the

wraith who haunted him, the slender girl with perfect teeth who had changed his life. He loved her.

In America he wrote those love letters found in Nell's deathroom. They were surely extravagant in their expression of love and longing, and they were intensely personal. Stumbling upon them by accident a decade later brought to his mind vivid pictures of the past, which afflicted him with pain. Perhaps an indulgent fate allowed him to find and destroy the letters. They were the best record of his emotional life as a young wanderer in America. Any biographer would see their worth and pounce upon them. But Gissing had the prudence (a quality he sometimes lacked) to burn them.

However, the cheap little notebook which he bought in Chicago and used to jot down his thoughts and feelings in a vast new land, he was able to preserve. It shows a persistent brooding over Nell and her impact upon him. Its pages reveal a sanitized outline of the Manchester episode. Stung by what has happened, he tries to disguise the sordid details of the misadventure and make them respectable. A young man, he notes in scratchy black ink, meets and marries a vain and selfish woman. Her expensive tastes drive him to commit a crime. He is caught in the act and must pay for his crime, but his faithful and repentant wife offers him limitless support.

On another of the unnumbered pages is a plot outline for his first published story, "The Sins of the Fathers" (1877). The plot idealizes Nell as a latter-day

Laura and himself as a stalwart Petrarch. Laura has intense dark eyes and lush black hair, "all unkempt and streaming over the shoulders." The description offers an accurate image of Nell. As the young woman drifts toward prostitution, her lover suggests she that earn her living by sewing. But as Nell rejected that idea, so does Laura. The story ends with the lost girl clinging to her lover, falling into a river with him, and holding on as both sink downward to death. The stock symbolism is a bit crude and too obvious not to have been intentional. The scene suggests that Gissing feared Nell had destroyed any pleasant future he might have. Even so, as he began his career as a novelist in London, he was willing to make any sacrifice to keep her in his life.

In the autumn of 1877, after a year in America, where he briefly taught school in Massachusetts, Gissing returned to England. By the end of October he was living in London and attempting to find work. Nell came to live with him. They were married in October of 1879. Though at first neither poverty nor rejection by Gissing's family could spoil or deter their happiness, in time the marriage disintegrated into prolonged agony. He had suffered greatly in the summer of 1876 while crossing the Atlantic alone, but that was minor compared to being married to Nell after all their dreams dissolved.

Vulgar and quick of temper, she came to believe that Gissing loved his literary labor more than she. Compatible and pleasant in the first months of their

marriage, she soon became a nagging wife, complaining and combative. She fought with their landladies and the neighbors, causing the couple to move often from one shabby lodging-house to another. She began to drink heavily, and despite desperate and frequent attempts to stop her, she returned at intervals to the streets. After a prolonged absence, she would beg her husband to remember his marriage vows and forgive her. Invariably he forgave her, but rapidly she sank into irretrievable self-indulgence and dissipation. In several novels Gissing dramatized her poignant spiral downward.

His fiction, as well as factual reports, show that women of the slums drank heavily, beginning when children: *"Of late Amy Hewett* [of *The Nether World*] *had become the victim of a singular propensity; when she could obtain vinegar, she drank it as a toper does spirits."* Clara Collet, his friend and social scientist working with Charles Booth, said this of working women: *"Their great enemy is drink; it is the curse they have inherited, which will be transmitted to the few of their children who survive."* Collet was speaking of the London poor, the people Gissing lived among and wrote about in *The Nether World*.

He left behind no evidence that any of his relatives ever met Nell. His friends, Bertz and Roberts, met her before the marriage fell apart. When Roberts paid a visit on one occasion, Gissing explained with marks of agitation that his young wife was dreadfuly sick and in

pain. He was speaking truth, for the woman suffered from a litany of ailments: rheumatism, imbalance, an eye condition, neuralgia, poor nutrition, and convulsions that brought on comas. In the spring of 1881 she suffered a seizure in a chemist's shop and had to be carried home through the streets. That gained the attention of the police, who already knew her. The chagrin of her middle-class husband of a puritan family in Yorkshire was surely severe. Yet Gissing had chosen to marry Nell after a year of separation, and he had chosen to live with her in poverty while trying to become an author. Had he stayed in America, he might have lost contact with the woman and done better. One can only speculate.

Somehow in the midst of all the trouble his wife was causing he managed to go on writing. He had published at his own expense, using money left by his father, his first novel in 1880. That was before the misery began. He was also working on his second. Every evening from five until nine he locked his door to prevent interruption. Often when he emerged, he discovered Nell had left their lodgings to prowl the streets. The novel in progress had a catchy title, "Mrs. Grundy's Enemies." It was completed in September of 1882, revised later, and even set in type by a printing shop. Yet the book was never published and was eventually destroyed. A huge amount of work had come to nothing, and yet it gave the struggling author direction for subsequent books.

Gissing feared agitation created by Nell's behavior ("*I am getting most frightfully nervous*") would weaken or destroy his creative power. He was becoming so agitated that he dreaded the doorbell ringing, or the postman's knock. In a long letter to his brother Algernon he confided he had lost all peace of mind; his writing had suffered interruptions that delayed any and all progress; and he was losing the last shred of hope for domestic peace in his life. He spoke of costly illnesses consuming his wife, her embarrassing seizures in public, shrill and violent behavior, descent into chronic alcoholism, and his decision to commit the woman to a medical facility in Battersea for treatment. However, she viewed that place with its benign mission to rehabilitate alcoholics as a prison. She begged her husband not to send her there. but he held firm.

In June of 1882 she walked away from the facility in a medical coat and went to live with friends unknown to her husband. The tales she told them we can only imagine. They were surely extreme because her friends reacted by writing abusive and accusative letters to her husband. By October he had taken Nell back, but soon afterwards she left her husband and found lodgings elsewhere. Although she was living within walking distance of his residence during most of 1883, he had nothing to do with her. In her absence he slowly regained peace of mind, only to have it shattered when a policeman came to his rooms and told him his

wife was in trouble. She had given his name as nearest of kin. Again Gissing had to make a decision.

She had been arrested at one-thirty in the morning for brawling in the streets with drunken harridans. Drunk and disorderly and in trouble again, Nell was reaching out to her gullible husband for help. However, she had pushed him a little too far, and he was no longer responsive to her needs. Though indecisive, he resisted her call for rescue and did not go to her. She remained in jail until released and was allowed to shift for herself on the streets. Gissing didn't see her again until he received the telegram that summoned him to London. He went there on March 1, 1888. The day was cold. A heavy mist lingered in the streets. Marianne Helen Gissing, before reaching the age of thirty, lay dead in a ghastly lodging-house room in London slums.

Chapter Three

Nell's Influence on Gissing

The woman with the pretty name, but consistently called Nell, exerted a dominant influence upon Gissing's fiction. The heartsick reality of her deathroom pushed its way at once into *The Nether World*, the powerful novel written to purge himself of all that reminded him of her. Nell's room became the squalid retreat of Mrs. Candy, an aging and beggarly woman destroyed by drink and hardship. The pledge cards he found in Nell's room turn up in Candy's room, though not on the table. *"Over the fireplace the stained wall bore certain singular ornaments. These were five coloured cards, such as are signed by one who takes a pledge of total abstinence."* The unsteady signatures on the dated cards, each more unsure than the one preceding, were proof of moral and physical decline similar to the downward spiral that killed Nell.

In the same novel the death scene of Margaret Hewett is another vivid reminder of the room visited

by Gissing in the Lambeth slum. On entering the deathroom Sidney Kirkwood, a longtime friend of the woman, reacts in the same way Gissing had: *"The first view of it made him draw in his breath, as though a pang went through him."* Kirkwood is shaken by what he sees, and he feels *"a profound pity for the poor woman."* As Gissing had done, he stares at her stricken face looking for something, anything, he might recognize. The sentiments of Hewett's husband, ably expressed in working-class English, belong to Gissing: *"Do you remember the hopes I used to have when we first married? See the end of 'em – look at this bed as she lays on! Is it my fault?"*

Again in *The Nether World*, Michael Snowdon's tale of conflict with a drunken wife bears a striking resemblance to Gissing's own: *"At last she began to deceive me in all sorts of little things; she got into debt with shop-people, she showed me false accounts, she pawned things without my knowing. Last of all, she began to drink."* The depiction of Sukey Jollop in the novel is another painful reminder of drunken Nell. For reasons her closest friends can't understand, Sukey abandons herself to hard liquor, takes up with mean companions, leaves her husband, and sells her body for a few shillings in the neghborhood of Shooter's Gardens. *"Sukey had strayed on to a downward path,"* the author wryly comm. ents. employing understatement. Once the descent had begun there was no turning back. Like Nell, she seemed to find a perverse pleasure in a life of dissipation and

depravity. It took her away from hunger and hardship. A wild and careless life also promised freedom in a restrictive society.

Nell's influence upon the book Gissing had written in a frenzy shortly after her death is not at all surprising. What does surprise is her pervasive presence in his first and second novels, *Workers in the Dawn* (1880) and *The Unclassed* (1884). In the first novel earthy, emotional Carrie Mitchell is modeled closely after Nell. It is no exaggeration to call the novel a formal study of human degeneration, a close and careful study of the same forces that in time would destroy Nell. And yet the book was composed years before Nell's death. In visionary awareness, Gissing had predicted her fate.

He had long brooded on the fallen woman, that forlorn *"eternal priestess of humanity"* in Lecky's phrase, sacrificed for the sins of the people. Now he traced with great care Carrie's slow decline after her seduction by the son of a clergyman. For a moment it occurred to him that *"the girl herself might be possibly to blame,"* but that unsettling thought he put out of his mind when he placed all the blame on her seducer. Gissing believed the initial loss of innocence triggered the downward spiral in girls whose life was similar to Nell's. Perhaps in their pillow talk she had described her first sexual encounter in terms that suggested seduction of an innocent girl.

A child is born to Carrie after her seduction. Perhaps Gissing knew of a pregnancy Nell had aborted; yet she was probably unable to bear children. Carrie's

predicament is the young author's attempt to create melodrama. Portraying Carrie, he sounds the G-minor note of pathos expected in Victorian novels. The tear-jerker note is reduced to an echo, or fades away entirely, in the mature novels of the 1890's. But in this first novel, Carrie's infant dies of starvation and exposure because an apathetic society, though wealthy, is unwilling to offer assistance. In *The Unclassed*, Gissing's second novel, Lotty Starr in a similar situation is more fortunate. She too bears a child, and the little girl resists hardship and heredity to become a splendid young woman. Except for the need to care for the child, Gissing tells us, Lotty would have fallen into *"the last stages of degradation."* She saved herself and her child by lavishing unconditional love upon the little girl. Love, care, responsibility, and sacrifice made the mother whole.

In *Workers in the Dawn* the protagonist Arthur Golding tries to rescue Carrie. He supplies her with comfortable quarters, nurses her back to health, and eventually marries her. But the experience of the streets, *"the period of wretched vagabondage,"* has left its indelible stamp upon her. After her marriage she becomes a railing shrew, an alcoholic, and once again a whore in the grip of strong and steady degradation: *"Arthur fancied that he could observe her features growing coarser, and he felt convinced that her voice had no longer the clearness of tone which had once marked it."* To get money for alcohol, she falsifies household accounts, pawns any object that will bring a few pence, and soon

returns to prostitution. The pattern of Carrie Mitchell's behavior is the same as Nell's at a later date. With Carrie, as with other characers, Giss*ing* was evoking prophetic *"intelligence of the heart."*

Because she is shapely, sensual, young, and attractive, Carrie is said to belong to *"the aristocracy of the demi-monde."* Despite her status she catches a dread disease, is shunned by the men who formerly sought her, and sinks rapidly downward. In her prime she cut a fine figure: *"there entered a tall girl showily dressed with features of considerable beauty, but spoiled with thick daubs of paint applied to conceal the pallor of the cheeks. Her eyes had that bleared, indistinct appearance so common in girls of the town."* Her decline and early death illustrate the fear-ridden despair of any sick prostitute in London streets. She could support herself only so long as good health and good looks went unimpaired. In *The Unclassed* a pathetic prostitute ravaged by chronic disease, resorts to begging when she can't entice a customer: *"She was ill, she said, and could scarcely walk about, but must get money somehow; if she didn't, her landlady wouldn't let her sleep in the house again."*

In this second novel, egregious Harriet Smales is also modeled after Nell. In many ways she is quite similar to Carrie, and together they form an authentic picture of Gissing's first wife. They are both tall with dark hair, of good figure, sensual, graceful of movement, and morally obtuse. Carrie is said to have a smooth and pretty face, but Harriet (reflecting Gissing's disillusionment as he

came to know Nell better) has a face of *"sickly hue."* Both make friends with coarse women and get into trouble when the landlady complains. Neither knows how to make use of her time, believes she lives too much alone, and quarrels with the respectable husband. Furtive in their glances and sensing hostility in the world around them, both women are nervous, restless, self-willed, discontented, quick of temper, jealous, selfish, and immoral. Both yield to physical drives early in life, become prostitutes, decline to wanton depravity, and die before the age of thirty. The many character traits they hold in common reflect comparable traits that Gissing in grievous dismay and disappointment saw in Nell.

Carrie is Gissing's depiction of his wife in the early years of their marriage. Harriet is the perception of her after he came to loathe her. Carrie creates sympathy as she struggles with forces that will kill her. Harriet, on the other hand, is presented harshly and without sympathy. One finds a few redeeming traits in Carrie but none whatever in Harriet. Even the woman's last name, Smales, shows the author's contempt. She is presented as bitter, hateful, peevish, cunning, depraved, and amoral but not evil. As a post-Darwinian moralist, Gissing sees her simply as weak. Even so, some of her character traits that suggest evil exhibit strength. Her cunning, for example, often places her in a position of advantage when dealing with others.

Influenced by current thinking on heredity and

reversion, Gissing asserts that Harriet is *"miserable in body and mind."* Yet her temper is sometimes a weapon skillfully used. From her parents, Gissing explains, she inherited *"a scrofulous tendency"* that pulled her downward in later life. *"The most serious symptons took the violent form of convulsive fits. Returning home one evening, Julian had found her stretched upon the floor, foaming in the mouth, and struggling horribly."* Letters to Eduard Bertz, his German friend, describe in almost identical terms the seizures that prostrated Nell. As he struggled to develop the character, Gissing was thinking of Nell as unregenerate from the moment of conception. He had come full circle to believe Nell was naturally depraved.

Years later in Nell's deathroom his sentimental remembrance of times past erased that conclusion. He placed the blame once more upon an apathetic society. Nell as prostitute became a symbol of all oppressed women, particularly in London. As time passed, however, he changed his mind again. The novel *In the Year of Jubilee* (1894) posed a question and provided an answer. A woman of maturity and experience speaks: *"How can anyone drive a girl into a life of scandalous immorality? She took to it naturally, as so many women do."* Later Gissing believed that heredity, society, and other forces in human life, worked in harmony at times to destroy women such as Nell.

Fashioned in deliberate and pointed contrast to Harriet Smales is Ida Starr of *The Unclassed*. Sensitive,

intelligent, and good of heart, Ida was forced into degradation mainly by economic circumstances. One bleak and simple choice lay before her, life or death. To her credit she chose to live. Even so, as the daughter of a working prostitute, heredity worked resolutely against her. At birth she inherited qualities that made her vulnerable to forces another woman might have resisted. Her story, one of hardship, adversity, and abuse, is realistic though melodramatic in the older Victorian tradition. It might be called extreme realism not altogether convincing. As he struggled to make her real, Gissing became emotionally involved with this character. The involvement was strong enough to blur his vision and carry him from truth.

When her mother died, Ida had to shift for herself as a throwaway child of eleven. For a time she worked as a scullery maid in a restaurant, receiving as payment only left-over food and a corner of the kitchen in which to sleep. In time she ran away, fleeing from brutal mistreatment and labor that left her exhausted. At seventeen she became a lady's maid in a middle-class home where she toiled many hours a day seven days a week. Eventually she was seduced by the spoiled son of her employer and persuaded to become his reluctant mistress. She justified the action by convincing herself it was the only way to escape a life of grinding poverty. When her callous seducer abandoned her, in desperation she became an unwilling prostitute.

An uncertain heredity could have been a major

cause leading to that decision, but Gissing's analytical mind sees other causes. Ida was a victim of the sexual force and robbed of innocence by seduction. Alone in the world and without emotional support from friends or relatives, what other course could she have taken? Lacking education or spiritual guidance, she also had no innate sense of honor or self-respect. With no solid sense of identity, she couldn't rely on those qualities to guide her. Though good of heart and basically strong, she lost direction at a pivotal time in her life. Gissing gives her the symbolic name, Ida Starr. She is vastly superior to Harriet Smales, and yet she is not the superb woman her creator saw. Ida Starr is Gissing's portrait of *"the noble prostitute,"* a stereotypical character in novels of the time.

Though he clearly admires the nobleness of her character, Ida is not so noble as he would have readers believe. Her story is riddled with contradiction, and her presentation shows the novelist deluding himself. She belongs to the working class but against all odds is trying to rise above it. She knows a life of leisure is foreign to her world, but tries to attain it by becoming a prostitute. She hopes to meet a generous man who will take pity on her and support her. So the author provides a young idealist, a carbon copy of himself, who promises devoutly to love and protect her forever. Ida's opportunism is interpreted without criticism as the universal struggle to survive. Her story is believable only when one remembers that gentlemen in Gissing's

day were known to marry their servants and women with suspect backgrounds. Moreover, one can't forget that Gissing himself married a prostitute three years after meeting her.

To make herself worthy of Waymark and socially fit, Ida performs a ritual of cleansing and rebirth. In the calm sea at night, she scrubs her naked body, washing away all vestiges of the unclean past. She emerges from this symbolic baptism a shining example of feminine purity. Her beauty dazzles the eye of the author himself. As she steps from the water, rising above the ugliness of her past to confront the world with serenity and strength, Gissing insists that she has always been clean of mind and pure of heart. Clever and resilient and capable, she is *"strong in character, admirably clear-headed, gentle, womanly."* She is Gissing's unrestrained idealization of Nell, his image of her not as she was, but as she might have been.

The portrait of Ida Starr, for all its faults, occupies a prominent place in his gallery of angel-women. Some other idealized women are Helen Norman (1880), Isabel Clarendon (1886), Adela Waltham (1886), Thyrza Trent (1887), Emily Hood (1888), Jane Snowdon (1889), and Irene Derwent (1889). By the time he was writing the mature novels of the 1890's, his idealistic bent was waning. In its place was an obvious admiration for some female characters and a cynical attitude toward others. In 1898, in passionate letters to Gabriel Fleury, he described himself as a tireless idealist of women.

A famous print in Hogarth's *The Harlot's Progress* (1731) shows an innocent girl, fresh from the country, falling into the clutches of pimps. Nineteenth-century novelists, paying homage to Mudie and Mrs. Grundy, usually found a position for the girl as a servant. But at the risk of having his books shunned by Mudie's Select Library, Gissing tried to show that Hogarth in the eighteenth century was more open and closer to the truth than similar observers of the nineteenth. In *The Unclassed* Sally Fisher, a good-looking country girl in the bloom of youth, came to the city at seventeen and eventually found work making overcoats at seven shillings a week. Wages enough to live on were at least fifteen shillings, and so at night Sally supplemented her income by working in a brothel. She did that because of economic pressure alone, and for that reason Gissing gave her story a happy ending. She fell in love with a grocer, married him, and became a loving wife and business partner.

Fisher's life of hardship prompted Gissing to indict unscrupulous employers who exploited women. However, laws of supply and demand sometimes left even a well-intentioned employer unable to keep his girls off the streets. In "Phoebe," a short story published in the same year as *The Unclassed* (1884), Gissing addressed that problem. Phoebe's employer, a good-hearted man with genuine concern for the welfare of his workers, struggles in vain to find work for his girls during the off season. He knows they should be allowed

to labor the year round, but when fashion decrees that feathers will be in vogue instead of flowers, Phoebe loses her job.

Without a source of income, without relatives to fall back upon, the girl in Phoebe's predicament often became a prostitute. But here Gissing stresses alternatives available to those of strong character. Phoebe becomes a servant, a babysitter in today's vernacular, looking after the children in a large family for almost no salary. It is strenuous work but better than selling her body on the streets and dying young. In this way Gissing dramatized his belief that exceptional women of the working class, could rise above the lure of the pavement. Yet when faced with starvation, he was certain they would choose the streets. Time and again he insisted that no woman in the capital of the wealthiest nation on earth should have to make that choice.

A nation oblivious to the welfare of working women, he declared with warm conviction, was courting self-destruction. He was not alone in voicing this sentiment; it was a cry he shared with social scientists and other thinkers. A number of charitable organizations in the 1880's were trying to rescue women. One of them placed this advertisement in the London *Times* for January 5, 1889: *"The Christian missionaries of the Female Mission to the Fallen and the Female Aid Society go into the streets at night, and in the day-time we visit work-houses, hospitals, lodging-houses, police-courts and other places. No penitent woman is*

refused help." However, many women who might have received such help were intimidated by the staid righteousness of these middle-class missionaries and shied away from them.

An important goal of Gissing's early novels was to bring to the attention of readers the victimization of working-class women. Though he may have been mistaken in his opinion, he viewed all prostitutes as belonging to the working class. It was beyond belief to suppose that upper-class women or even those of the middle class might sink to prostitution. It was pressure that drove a woman in that direction, an awful pressure that bordered on desperation. On the whole, Gissing's portrayal of London prostitutes was photographic in its realism, but often exaggerated for effect. For a number of years he had known a woman of the streets as lover, wife, and tormentor. Other women he had viewed as possible characters in his fiction.

Night after night insomnia as well as curiosity drove him to stalk the streets where "unfortunates" stood in the glare of the gaslamps. He scrutinized their faces and noted *"the eyes encircled with rings of dark red, the drawn lips, the cheeks whereon the paint lay in daubs."* Most of the women who worked as prostitutes in the fashionable West End, the *"painted women"* as journalists called them, wore tawdry makeup as a kind of mask. Beneath the mask was the misery of a wasted life. Gissing sought to lift the masks to show the faces of a women needing help.

Chapter Four

Working Women and Factory Girls

For the working poor, who were paid very little for long hours of grueling work, Gissing had notable compassion. Residing in a squalid neighborhood during those early years in London, he needed only to look outside to see poverty and its effects upon people in dire need of support. His sympathetic portrayal of lower-class working women near the end of the century was corroborated by Charles Booth, a leading social scientist. He sometimes exaggerated the plight of slum women, but their long hours and low wages he reported exactly. He placed emphasis on the over-long hours (sixteen a day) and the low wages (nine-pence a week) of needlewomen. He emphasized the insecurity of seasonal work, such as making artificial flowers for hats. A woman's livelihood, even her survival, depended upon the vagaries of fashion.

Choosing his words with characteristic care, he described working women as *"silent victims of industrialism."* More than once he expressed a conviction that overwork, or no work at all, drove many of them to the brothels. In his early novels Gissing was savage in his condemnation of those economic forces that brought misery to hard-working women and left them without hope. He could and did work himself into a rage over the social inequities that made them suffer. Yet while viewing working women generally as exploited, he could observe the girls who worked in factories with quiet and detached amusement. In several of his novels, he presented the factory girls as young, sensual, aggressive, boisterous, earthy, outspoken, warm-hearted, and free to live happy lives.

One may see at a glance that working women in Gissing's fiction echo the influence of Nell. Emma Vine in *Demos* (1886) is vividly drawn in direct contrast to Nell. She earns her living sewing, and she makes her machine hum all day and far into the evening every day of the week. Yet despite her endless toil she doesn't earn enough to buy food and shelter and must supplement her meager earnings by working as a charwoman. The lowly job erodes her social status and damages her self-esteem, and yet it represents a triumph over forces that threaten to destroy her. Emma was created to emphasize the indolence and irresponsibility of Nell. We know she hated work of any kind, shunned the

sewing machine that Gissing sacrificed to buy her, and eventually pawned or sold it.

Emma's sister, Kate Clay, is a meticulous study with Nell in mind of feminine deterioration. Gissing is saying that heredity in a given environment is never stable or predictable. A person such as Emma Vine may have a sister such as Kate Clay who is the opposite in character. Never graced with the sweetness of disposition that went to Emma, Kate exhibits under hardship a violent temper and becomes a shrew. Then showing unmistakable characteristics of Nell, in secret she begins to drink heavily and sinks irrevocably downward: *"She was more slovenly in appearance than ever, and showed all the signs of extreme poverty. Her pallid face was not merely harsh and sour, it indicated a process of degradation."* The same environment that made Emma strong had the opposite effect upon her sister. It is one of the caprices of human life.

Though he viewed himself as living in exile, Gissing spent the first decade of his career living in cheap lodging-houses. They were located in run-down working-class neighborhoods fast becoming slums. These crumbling locales were in the vicinity of Tottenham Court Road not far from the British Museum. They were urban areas showing a mosaic of shops and houses and small businesses. Gissing's neighborhood was inhabited by people of varied backgrounds, including poverty-bitten intellectuals and aspiring artists. It offered a dreamer hoping to

become a well-known writer an abundance of source material.

Daily he roamed the streets, pausing to view window displays of wholesome food that he was not able to buy. There behind the glass was half a large cheese beside a tasting knife, a boiled ham, American beef, and German sausages, After a dinner of lentil soup and stale bread, the expensive food must have made his mouth water. The pleasure he felt describing a well-laid table, in the early novels and even later ones, was largely vicarious. But the people he came to know in his neighborhood were depicted with uncompromising realism and candor. The social scientist Charles Booth, in the initial stages of a monumental study of the laboring classes in London, wrote that *Demos* was one of the few novels he had ever read that presented an accurate picture of London's poor. Booth could have praised in similar terms two other slum novels: *Thyrza* and *The Nether World.* While the latter is dark and powerful, *Thyrza* is memorable for its factory girls.

Some of the girls who earned their living in factories perhaps had harder lives than shown by Gissing, but many factory girls were happy just to be in good health and alive. Totty Nancarrow of *Thyrza* is a good example. She is so pleased with her life as a factory girl that she refuses to give it up for a more secure existence. Her uncle would like to take her into his house and make a lady of her. But squealing with laughter and double-entendre, she exclaims: *"He'll wait*

a long time till he gets the chance!" In robust good health, Totty is keenly alive, boisterous, earthy, outspoken, laughing, and seldom overworked. Convinced that her way of life is right for her, she is wholesome and happy and and eager to accept whatever comes her way. Always humming a tune, she is a lover of crowds and vigorous activity. She takes pleasure in being jostled on the sidewalk, and delights in scenes of revelry which gather momentum in the joyous merry-making of a crowd.

Despite what must have been a hard life, Gissing's factory girls are in their prime. They enjoy life fully and embrace it eagerly. Because of features that remind one of Georges Bizet's opera *Carmen* (a large crowd of people laughing, singing, flirting, dancing, drinking), his portrayal of factory girls might seem at first more romantic than realistic. Yet Clara Collet's factual account in Booth's *Life and Labour of the People in London* nicely corroborates his realism. Miss Collet, who became his loyal friend in 1893, wrote that the factory girl could be seen on Sunday afternoons, decked out in her finest apparel, promenading arm in arm with other girls. Later one could find her having a rousing good time in one of the many taverns of the East End. In almost every detail Collet's description of London's typical factory girl supports Gissing's realistic presentation of Totty Nancarrow.

A short time later, in *The Nether World*, the potyrayal of working women was not so pleasant. His

intention in that brooding novel was to emphasize the hopelessness of their existence. Describing overworked needlewomen, he emphasized their unhealthy appearance, unrivaled exhaustion. and ultimatedespair. Also he tried to understand the root causes of their condition. Pennyloaf Candy toiled with needle and thread *"sixteen hours a day for a payment of nine-pence."* Booth's researchers showed that only doing irregular work during the winter months did needlewomen draw wages so low. Gissing called attention to the very low wages and made them even lower, thus dramatizing for his readers the anguish of women who barely kept themselves alive even as they worked themselves to death.

Margaret Hewett in *The Nether World* illustrates that situation. As a single woman Margaret worked as *"a needle slave"* for only four shillings a week. On that she managed to eke out a bare existence but lived in utmost penury. When work was slack and when she could no longer buy even the crudest of food, she was driven by desperation to steal from her employer. Caught at once, she was immediately tried for her crime, found guilty, and sentenced to prison. Margaret's ordeal is a chilling reminder that Gissing himself had endured a similar experience with a similar sentence.

Describing the courtroom scene in realistic detail, Gissing stresses with controlled detachment the need for compassionate change in the economic system. His technique is to reproduce a newspaper

account of Margaret's trial. Starkly impersonal in tone, the newspaper report with its air of brutal indifference is based perhaps on a real one. Carlyle and Arnold had spotlighted the misery of the poor in the same way. Gissing may be imitating one or both of them. All three disliked the objectivity that newspapers of the day tried hard to achieve.

Before Margaret went to prison and before she married John Hewett, overwork and poor nutrition had damaged the woman's health. For years society had placed an intolerable burden upon her, and prison was the last straw. *"There's such hard things in a woman's life,"* she exclaims on her deathbed. *"What would a' become of me, if John hadn't took pity on me! The world's a hard place."* If not for John Hewett, circumstances would have forced Margaret into a brothel, or resisting she would have died of hunger in the streets. An ex-convict, not even the workhouse would have taken her. Luckily, but too late (Gissing savors the irony), she gains the security of a good marriage but dies while still a young woman. Her angry husband, shaken by grief, speaks her epitaph: *"Nothing but pain and poverty."*

In *The Nether World*, its title a powerful metaphor for the hellish existence of the poor, the talented and confident Clara Hewett tries to escape the world into which she was born. Rather than merely adapt, her goal is to pull herself up to a better world and become famous. Her reward, when the struggle is over, is to be broken by bitter defeat. In books before 1889 and in

several afterwards, Gissing placed emphasis on this theme of feminine deterioration and defeat. Those proud women who cannot adjust to the bondage of class and environment are stricken by forces greater than they and sink downward like a heavy stone in water. Sometimes, as in the case of his own wife, other factors are present and trigger self destruction.

Clara Hewett, illustrates this theme of loss and defeat. Her sad but powerful experience also underscores Gissing's belief after 1884 that social class placed ambitious persons in bondage. He knew how easy it was to sink to a lower class, and his years with Nell convinced him that climbing above one's class was all but impossible. Mysterious forces apart from the mandates of society, perhaps heredity or environment or fate itself, seemed to stand in the way. To be born into poverty was the luck of the draw. An unlucky card doomed the person, even those of intelligence and talent, to poverty and hardship for life.

As she attempts to escape her position in the working class, Clara Hewett is penalized in ways she cannot understand. At seventeen she has worked too long as a needlewoman and is sick of it. Her father declares: *"The girl can't put up with the workroom longer. It's ruining her health, and it's making her so discontented she'll soon get reckless."* She abandons the workroom and becomes a waitress, but the change brings no great improvement. The hours are more than one hundred a week, and from morning to midnight she is on her feet,

moving quickly from table to table with heavy trays, in a noisy and crowded *"factory for the production of human fodder."* Without notice she quits the restaurant and goes in search of other work, hoping to improve her condition. She discovers that the world doesn't care whether she lives or dies.

Torn by anxiety and anger, she enters at that time into a *"feud with Fate."* Unseen forces, quite mindless but seeming to act with malice and direction, strike out against her. Returning feverish and exhausted to her stuffy room, her emotions bordering on despair, she breaks a cracked pane as she flings open the window. A shard of glass cuts deep into her palm. Spellbound for a moment by the sight of her own blood, she watches it trickle slowly like molasses to the floor. Beside herself with pain, she flings her bleeding body onto her bed and sobs until her pillow is soaked with tears and red with blood.

After a night of sleeplessness, her emotions raw with agony, she tells herself she understands her unseen opponent, the entity struggling against her. Why had she suddenly quit her job? Why at that time rather than countless other times previously? Was it not the prompting of fate? Was it not her destiny or some other force? *"It was not her own doing,"* Gissing remarks. *"Something impelled her, and the same force – call it chance or destiny – would direct the issue once more."*

She decides she will no longer resist, and though

fate remains her enemy, she finds herself *"relieved from the stress of conflict."* Despair gives way to an amorality that makes her laugh at convention, at social rules that govern human behavior. She has discovered that only the law of the jungle demands obedience, for she lives in a state of nature where only the fittest survive. She will have to look after herself and be ready to take the advantage whenever she can. She must think only of herself. For a time Clara drops out of sight, and the reader is left to wonder what kind of life she is living. Later we discover she has become an actress, but the new life and work have brought little satisfaction. Bitterly she recalls her struggle and concludes: *"There's no such thing as friendship or generosity or feeling for women who have to make their way in the world. We have to fight for everything, and the weak get beaten."*

Working an actress, Clara seizes without hesitation and without compunction the opportunity to wrest the leading role from another competing actress. She tells herself she can't afford to give a moment's thought to the emotional pain she has delivered upon a colleague. Had the identities been reversed, the other woman would have done the same to her. On her way to the theater she is not exulting in the new and important role she is to play, but thinking how the next role will have to be bigger and better. Near the entrance, a veiled woman steps from the shadows and flings a liquid into her face -- *"something that ate into her flesh, that frenzied her with pain, that drove her shrieking she knew*

not whither." Gravely defeated, her pretty face burned hideously with acid, she goes home to the slums to spend her days in a dark room. There she lives out the remaining years of her existence in pain and despair, looking forward to the end of life.

Clara's aim was to achieve success, to be recognized as a talented actress, and to climb into another class. She wanted to escape the oppression of the working class and live in a world of wealth. She dared to dream of glamor. But the obdurate and despicable *"nature of things,"* as Gissing explains, decreed otherwise. To dream of escaping was to commit an effrontery that angered fate. To expect more in her life than basic survival invited disaster. An element of retributive justice was also present. Willing to victimize others, in time she herself became a victim. In his portrayal of Clara Hewett, Gissing was working with the fatalistic concept in the manner of Hardy as influenced by Mill. In *A Life's Morning* (1888) he had tried presenting characters caught in a fatalistic web and was pleased with the result. In later novels he turned increasingly to the dark and unpredictable role that fate plays in human life, viewing it always as a mysterious force beyond understanding.

Clara Hewett returns to a shabby room of the type Nell had rented in Lambeth on coming to London. In similar lodgings during those early years with Nell, Gissing himself lived and worked. His landladies were vulgar and often difficult to endure. He tried to

give them the benefit of the doubt, but they proved themselves coarse, arrogant, and greedy. He soon came to loathe them. Their loud and high-pitched voices grated on his nerves, and he tried to avoid them whenever he could. Nell, on the other hand, enjoyed their spicy conversation, their fierce independence and energy, their bawdy gossip, and their apparent love of life in a dangerous and difficult world.

When her husband was hard at work and had no time for her, Nell invariably went looking for their companionship. Her husband thought that with each encounter they exerted a damaging effect upon her. They were dishonest, drank cheap liquor whenever they could get it, and were sometimes out of control and cruel. Accepting Nell on terms of earthy equality, they laughed and joked with her. But they also inflicted emotional pain on her and quarreled with her fiercely. Those scenes of unbridled anger, scenes that threatened violence, fastidious and alien Gissing found unbearable. They forced him to move frequently from one vile lodging-house to another. In his fiction he depicted landladies with scathing realism. Without exception they were loud and vulgar.

In his early proletarian novels, written mainly during the 1880's, women who recognize the law of survival and fall into step with it, his rapacious landladies for example, tend to flourish. His dismal life in poor lodging-houses roused anger, and he depicted London landladies with unforgiving realism. In later years, even

when comfortable and free of them, he sketched them harshly and without sympathy. All the same, he could envy their strength and their incomparable instincts for survival. In their world they made it their business to reach the pinnacle of the pecking order and stay there. When threatened by those who would topple them, they defended themselves fiercely and violently.

The first of the fictional landladies, and one of the most repulsive, is Mrs. Blatherwick of *Workers in the Dawn*. Motivated by a grasping and greedy self-interest, she fastens upon the denizens of her house like an evil bird of prey. Gross and ugly, she is similar to Mrs. Pole, the landlady who exerts a strong negative influence upon Carrie Mitchell. Pole drinks heavily, screams angry abuse in a gin-thickened voice, wields a club expertly, favors low prostitutes, brawls with other harridans, and uses the language of a fishwife with no regard for society's rules.

Arthur Golding's opinion of the redoubtable Mrs. Pole is Gissing recalling a counterpart in his own life: *"Arthur had never much liked her appearance. At present she was slatternly in the extreme, and had the look about the eyes which distinguishes persons who have but lately slept off a debauch. He noticed that her hands trembled, and that her voice was rather hoarse."* The hoarseness of voice, a trait shared by most of his landladies, was a sign of the alcoholism that afflicted most of them. And of course they had a tendency to shout and scream rather than talk. Gissing thought women should be soft

of voice and gentle in manner, but London landladies were often the opposite.

On a slightly higher level, but with comparable instincts for living comfortably in a state of nature, is Mrs. Pettindund of *Workers in the Dawn*. She displays, as the young Gissing knew from experience, *"the inimitable ferocity of the true London lodging-house keeper."* Her voice is thick and coarse, her face ugly and evil, her tongue a purveyor of lies and calumny. Her sloven appearance and meandering gait are signs of perpetual drunkenness. Dangerous even when she is sober, too much of *"the brave, thick, medicated draught"* turns Pettindund into a savage who recognizes only the law of the jungle.

Another vile lodging-house denizen, Mrs. Peckover of *The Nether World*, is at all times a savage. In a world where only the fittest survive, she and her daughter Clem have reverted to a more primitive strain. Having survived *"the basest conditions of modern life,"* their social behavior is marked by *"splendid savagery."* They have acquired the strength, cunning, ferocity, and amorality of the tiger. To defend their position, they practice those qualities daily in human society, not as splendid animals, however, but as savages. Their surname implies an aristocratic place in the pecking order, yet on occasion they tear and claw not a common enemy, but each other. Gissing's portraits of the London landladies he had known are etched in acid from life.

In his fiction they acquire strength and substance from the evolutionary idea.

The novels written in the first decade of his career portray with unrivaled accuracy the laboring classes of London. Women in particular demanded attention; they became prominent in his narratives. Always they drew from him a strong reaction, which accounts in part for the power of his work. Living in exile, he was able to study objectively and minutely the women of the working class, and they came full-blown into his fiction. The one quality that makes his proletarian novels so durable and so readable is their unflinching realism.

That particular view of life came not from the hours he spent in the reading room of the British Museum (even though he was there often and long), but from the people he lived among, a social class not his own. Even though he didn't like his life in exile and laboring alone to write his books, he knew he had the talent and preparation to produce powerful books of uncompromising realism. And so with a practiced eye, he drew upon his surroundings for his art. Under Nell's influence and the neighborhood in which they dwelled, he wrote dark novels of social criticism, of people brimming with human affliction. On occasion, however, satirical thrusts lightened the mood with humor.

Chapter Five

Mrs. Gaussen's Friendship

In the summer of 1884, after the publication of his second novel and after Nell had gone to live elsewhere, Gissing had the rare good fortune to meet Mrs. David Gaussen. At a formative and dreary time in his career this active woman of the leisure class, intelligent and cultivated, came cheerfully and generously into his life. She liked him as soon as she met him, and she wanted to use her connections to help him become a well known writer. Even though she did little to augment his income, she exerted a positive personal influence. With customary efficiency, she soon arranged for him to tutor her three sons. In late summer, Gissing traveled by train to her home in Gloucestershire to meet her sons and to determine if tutoring them would be of mutual benefit. He had come on business, but the family urged him to spend the weekend as their guest.

In their luxurious house, quite foreign to his experience, he found it difficult to relax before losing

himself in the lady's quiet charm. He was captivated by the wealth and manners of his attractive new friend, by the surroundings in which she lived, and by the lively stories she told him. Brought up in India, she had traveled in many countries and was sophisticated and worldly without flaunting it. She knew famous and accomplished people and maintained friendships with persons of rank and title. To his amazement, she spoke both Hindustani and Armenian. "We had lively times," he observed in a letter to his brother Algernon. It was dated the day after he left the luxurious home in the country. He enjoyed describing the luxury of her world and the widespread beauty of the countryside. The rural way of life of those who lived in the area seemed to come from a long-gone era. *"The country is rural to a degree that I never imagined."*

After he returned to London, Mrs. Gaussen remained in steady contact with him. In September she told him she would divide her time between a townhouse in the city and the manor house, Broughton Hall, in the country. In London their friendship progressed rapidly. Her son of thirteen soon became Gissing's favorite pupil, arriving at 18 Rutland Street in mid-afternoon and leaving at eight in the evening. Sharing his knowledge with the boy was at first rewarding, but the long hours soon left Gissing hard pressed to find time for his writing. Later on, after acquiring several more pupils, he would teach all day with only one hour reserved for

lunch and rest. By suppertime he was finally alone and ready to write until midnight.

He would attempt to write from six to twelve and arise early the next morning (with not enough sleep) to begin another day of tutoring. To his family he complained that the *"pupil business"* was robbing him of his best time, and yet he had to make money for food and to pay the rent. He said the routine had become loathsome, and he would have to put an end to it if his literary labor were to continue. But he liked the Gaussen boy, and particularly the boy's mother, praising her as *"one of the most delightful women imaginable."* Gracious and lively of manner, this married woman with children seemed to him the most womanly woman he had ever known.

She appeared to be in her early to mid-thirties but was actually ten years older. The passing years had been kind to her, leaving her well-preserved and happy. She had married a wealthy man when quite young and had been an outstanding member of Anglo-Indian society. Her colorful tales of faraway places, in a well-modulated and musical voice, impressed Gissing. As they grew closer, she invited him to supper parties, dinner parties, and even tennis parties. To his sister Margaret he said in a letter of October 26, 1884: *"Here is one for a tennis party next Monday, which I shall certainly not accept! There is a line to be drawn somewhere."* Was he already beginning to withdraw from her world, or was he flaunting his popularity, bragging a little, after

years of lonely obscurity? He couldn't resist letting his family know his good fortune.

Gissing wouldn't have turned down invitations so soon from such a woman, but the chance to complain of too much attention delighted him. He went to the party after all (or one like it) to sit on the sidelines and watch his friend play. The description of supple and pleasant Mrs. Bruce Page in *Isabel Clarendon* owes much to Mrs. Gaussen: *"She walked with the grace and liveliness of a young girl, and, as she shortly showed at tennis, could even run without making herself in the least ridiculous."* In the 1880's women were daily becoming more active out of doors, yet seldom did they run. Gissing himself liked to walk half a day for exercise, relaxation, and rumination but never once in his letters does he mention engaging in an activity that required him to run.

The invitations offered him the rare opportunity to observe up close and firsthand the leisured existence of upper-class women. His friendship with Gaussen, however, was founded mainly upon her visits to his spartan lodgings. Her husband, an ardent sportsman, spent much of his leisure time in Ireland. That gave her the freedom to visit her friend whenever she chose. When he first became acquainted with her, he was living in two rented rooms at 62 Milton Street, the Grub Street of Samuel Johnson's day. After she began to live in London for the season and visit him regularly, he moved to better quarters in Rutland Street to entertain her more graciously.

When Christmas time came, because he wanted to receive her in surroundings as pleasant as he could possibly afford, he leased for three years (later extended to six) *"a good set of chambers in Marylebone Road."* Known as 7-K Cornwall Residences, the rooms were clean and well-appointed and more expensive than any he had previously rented. They were also more comfortable. He liked the convenience and the seclusion of the place, and he exulted in being able to come and go as he pleased. Athough he would remember them in his fiction, he was no longer subject to *"the thralldom of landladies."*

His letters suggest that for a time Mrs. Gaussen came to his residence two or three times a week. Invariably he spoke highly of her. Despite the opinion of Morley Roberts, there seems to have been no impropriety in their relationship. The gracious woman encouraged him to talk about his writing, examined his photograph album, and made kind remarks about his mother. To his sister Ellen he confided that his new friend was often in his thoughts. Her warm personality struck chords within him that no other woman had touched. In times of stress he took comfort in the thought of her, remembering her attractive face, her musical voice, her refreshing smile, and the wholesome way she embraced all of life.

Outspoken Morley Roberts believed the friendship became a love affair, but there is little evidence to support that conclusion. Moreover, by June 1885 Gissing

was looking for a way out. He was ready to reject this woman of wealth even though she had tried to accept him as her friend and equal and wanted to advance his career. He complained that he was tired of the never-ending struggle to establish himself as an author. He was thinking about returning to America to work as a farm hand. He could improve his health by working on a farm and forget he had ever been a professional writer who had peeked into the world of polite society. Typically, when he came to like a woman of his own class or higher, his thoughts rested on running away.

Before the summer had ended, he was attempting to sever all relations with Mrs. Gaussen. He was deliberately struggling to close doors of opportunity she had opened for him. As early as October of 1884, he complained in letters to his family that her world and her parties were stealing too much of his time: *"I used to suffer from loneliness; now the difficulty is to get any time at all to myself. I am beginning pugnaciously to refuse invitations."* In the summer of 1885, fretting over time lost and literary work not done, he decided he would have to make a clean break with his friend. It was the price he would have to pay to continue his career as a man of letters.

To validate the wisdom of his decision he began to find fault with her friends. The upper-class ladies and gentlemen who once seemed so lively, congenial, and clever had fallen short of his expectations and were disappointing. Their interests were shallow and

uninteresting, and their conversation empty chatter or small talk. Though free of drudgery, and masters of their time, they touched only the surface of life and seemed more concerned with texture than substance. When he tried to discuss English literature with them, he discovered that few of them had read anything other than the newspapers and a frivolous magazine now and then. In letters to his family he allowed that he was finding it very difficult to sustain the empty chatter and nonsensical tone present at the social gatherings of these people.

H. G. Wells, who really liked the easy chatter among gentlemen in smoke-filled rooms, was convinced his fastidious friend lacked "social nerve." Closer to the truth is that Gissing placed high value on his time and couldn't bear to lose so much of it in frivolous and unproductive activity. The premium he placed on time and work puzzled his new friends of the leisure class. Their main concern was to pass agreeably the hours of each day. They claimed some knowledge of Carlyle, who had preached the doctrine of work and was *de rigueur* reading for even the dullest among them, but they knew little of struggle and the fruits of labor. Wells was middle class and knew all about struggle and labor. After they met near the end of November in 1896, Gissing viewed Wells as one of his closet friends and admired him. Wells, on the other hand, went out of his way to find fault with Gissing. When they met, Wells had been a professional writer for four years and

enjoyed an income of £1,056. Gissing after sixteen years earned only £289. Wells tried to Gissing to write for the market, something he couldn did. H. G. Wells did write for the market and is far better known today than Gerge Gissing.

As the end of 1885 was closing, Gissing's relationsip with Mrs. David Gaussen and her affluent upper-class friends had run its course. He had entered their world as if beckoned by fate and initially had enjoyed it very much. He left it abruptly for reasons shared with his family and for personal reasons not shared with them. Fond thoughts of the remarkable middle-aged woman who appeared to be much younger lingered on and on. Years later, on September 29, 1889, after returning from Chiddingfold in Surrey, where he had lunched with Edith Sichel, another woman of wealth, he wrote a gracious letter to Mrs. Gaussen. Her lasting influence upon the novelist is worth our notice.

At the peak of their friendship Gissing deserted his chosen subject matter to begin a new kind of novel. It was about people of the leisure class living far away from the slums of London and the working class. In manuscript he called the new book "The Lady of Knightswell" after the central character. Sometime before its publication in 1886, perhaps persuaded by his publisher, he changed the title to "Isabel Clarendon" to place emphasis on the main character. Modeled after Mrs. Gaussen, the character stands out in public or private the same way clarendon type asserts itself on

the printed page. And her last name is suggestive of anything that is clear and bright or brilliant.

When he met Mrs. David Gaussen, Gissing was on friendly terms with Frederic Harrison, a writer whose shallow definition of culture had angered Matthew Arnold. Harrison was less talented than Gissing, but moved among influential and affluent people. At one of his parties or social gatherings, he introduced Gissing to Mrs. Gaussen. When they met, Gissing lacked any real knowledge of upper-class women. They lived in a different world, and his view of them was limited to pictures in fashionable magazines. In his first novel upper-classe women were stereotypes. Mrs. Gaussen suggested a fluid set of standards: education and cultivation without affectation, intelligence without pretense, and knowledge of the world bereft of bitterness or cynicism.

She convinced Gissing that women of the leisure class could be charming and gracious, not vacuous and silly. Also he saw that women her age could demonstrate in maturity an appealing femininity free of posturing. Gaussen was, moreover, a sincere and friendly person and very much alive. In her daily life, she was known to be energetic and in motion. It was an image vastly different from the gray, static pictures of fashionable women in the popular magazines of the day. Her sexuality, originating in flesh and blood rather than the curve of a gray line, exuded warmth. Her easy, lilting, idiomatic flow of language, her subtle modulation of voice, her

exquisite taste in dress and manners charmed him. These qualities Gissing imparted to Isabel Clarendon. She was the first of his upper-class women really to come alive as a very attractive person worth reading about and getting to know.

While Isabel Clarendon is perhaps a composite figure based on several upper-class women, she is mainly an imaginative and realistic apprehension of Mrs. David Gaussen. The similarities between the two women are striking. As Gissing was moved by the beauty and grace of Mrs. Gaussen, Bernard Kingcote is captivated by the charm, elegance, and youthful beauty of Isabel Clarendon. When Kingcote writes that *"Mrs. Clarendon is to me a new type of woman – new, that is, in actual observation,"* Gisssing is speaking from his own experience in phrases found in letters to his family and Eduard Bertz. Near the end of 1884, thanks to Mrs. Gaussen, he found himself meeting a steady stream of upper-class people at the parties he attended. To his brother Algernon he wrote in November: *"Eheu! Visits to tailor of late for dress suits, etc. A party the other night in Devonshire Street, Portland Place, and now again a private concert in Kensington Gardens Square tomorrow night."*

The remarkable woman depicted by Gissing throughout the book, and carefully described by Kingcote in a long letter, is sketched directly and lovingly from life. *"She is a woman of the world,"* Kingcote tells a friend. *"I was never before on terms of friendly intercourse with her like, and she interests me extremely. She is beautiful*

and has every external grace." The passage blurs the distinction between fantasy and reality. It produces the eerie effect of having been lifted verbatim from one of Gissing's letters. It is fiction elided into fact. Following his return to Germany on Easter Sunday 1884, a steady correspondence sprang up between Bertz and Gissing. In some of his letters Gissing revealed secret emotions, as well as thoughts and opinions regarding women, that he would never have sent to any member of his family.

When he finished writing *Isabel Clarendon* in August of 1885, he noted he had done his best to make the novel as realistic as possible. As one remembers that remark, one can see that Kingcote's description of Mrs. Gaussen is accurate. In maturity the woman is more delightful than she must have been in girlhood, more sensual and more beautiful. Her *"exquisite openness"* allows her to speak from the heart on any subject and conceal nothing. In spite of every indication that she reads nothing at all, her mind is alert and active and capable of sound judgments. Her manner, reflecting an impish personality and a vast love of life, suggests extensive self knowledge. All of Kingcote's remarks are positive except one: *"Alas, she does not read."* The comment seems based on Gissing's assessment of his friend. The same observation is repeated with Mrs. Boscobel, a social butterfly in *Demos*. Most of these women of the world are too busy with the life around them to relax with a book.

Kingcote finds the woman's intense femininity

vastly restorative: *"Her presence refreshes me, her talk is like the ripple of cool waters, her smile makes its healing way to all the hidden wounds of my wretched being."* Poised and elegant, Isabel Clarendon is gentle but not weak, womanly but not womanish. Wealth, family, leisure, and the advantages of a superior education have made the object of Kingcote's adoration a near-perfect specimen of well-preserved English womanhood. In all that Kingcote has said Gissing is surely thinking of elegant Mrs. Gaussen. The character's effusive praise of Isabel Clarendon seems at first somewhat satirical. Then we see he is not at all speaking with tongue in cheek. His ingenuous worship of a dream woman seems a bit ludicrous in a more cynical age, but Gissing intended it to be taken seriously. It prefigures his own worship of Gabrielle Fleury.

That tribute to womanly perfection is not an isolated example. In his first novel (1880) he paid homage to his ideal woman through his portrayal of Helen Norman, in his second (1884) Ida Starr, and in his third (1886), Isabel Clarendon. *A Life's Morning*, published in 1888 though written immediately after *Isabel Clarendon*, portrays both Emily Hood and Beatrice Redwing as women quite worthy of admiration. He lavished affection on both of these fictional women and originally called the novel "Emily." In *Demos*, published anonymously in 1886 just two months before *Isabel Clarendon*, Adela Waltham was a peerless symbol of angelic womanhood. He was chided by his sisters, who

judged the character far from perfect. As he directed his attention to Thyrza Trent, the pure-minded protagonist of *Thyrza* (1887), he wrote with *"fever and delight,"* falling in love with his creation. Later in settings of unswerving realism he managed to idealize Jane Snowdon of *The Nether World* (1889) and Irene Derwent of *The Crown of Life* (1899). Each of these characters he placed on pedestals beyond his reach.

Lyrical admiration, tempering though never diluting his realism, is extended to scores of women. They range from Hilda Meres, a delightful teenage girl in *Isabel Clarendon* to crusty Lady Ogram, an opinionated but mentally sharp woman in her seventies in *Our Friend the Charlatan.* His gallery of feminine characters is remarkable for its color, variety, and sympathy. Near the end of his career, in letters to Gabrielle Fleury, Gissing often described himself as an incorrigible idealist in all matters relating to women. Two hellish marriages had caused him to produce dark portrayals of feminine types. Women such as his deplorable slum landladies he often sketched in dark tones. But woman in the abstract, woman transcendent and silver, was to his mind and heart a mysterious and noble creature to be absolutely adored.

As most of his prostitutes derive in some measure from Nell, most of Gissing's *"women of the world,"* as he was fond of calling them, show the influence of Mrs. Gaussen. They are usually in their late thirties (but always look younger) and are wealthy, leisured,

intelligent, traveled, and charming. At times these women are pictured as intruders in the lives of others. Mrs. Boscobel in *Demos* is such a woman. The wife of an artist, she moves at the center of a little world, inhabited by well-known people, that views the larger world as its satellite. She has lived in all the capitals of Europe, where she has acquired enormous experience, and enjoys having young men of promise seeking her advice. The woman in many ways is similar to Mrs. Gaussen: *"Mrs. Boscobel was a woman of the world, five-and-thirty, charming, intelligent; she read little, but was full of interest in literary and artistic matters, and talked as only a woman can who has long associated with men of brains."*

Mature women who meddle in other people's lives become agents of fatalistic forces. They appear in Gissing's novels from 1886 to the time of his death. In the novels of the 1880's most of them are *"well fitted to inspire homage,"* but in the fiction of the 1890's some take on ominous qualities. Several of them, such as Ormonde (1887), Damerel (1894), Strangeways (1897), Borisoff (1899), and Toplady (1901) are well fitted to inspire dread. In the characterization of these women he was consciously working in the Mephisthophelean tradition, perhaps in imitation of Hardy. The women exihibit a close resemblance to some of Hardy's "Mephisthophelian visitants" in Hardy's phrase. For good or bad, they interfere with the lives of ordinary mortals. Gissing maintained a friendship with Thomas

Hardy from 1886, visiting him at Max Gate in 1895. During the intervening years a fatalistic strain similar to that in Hardy's novels, and surely owing a debt to the older novelist, made its way into Gissing's books.

Mrs. Gaussen also influenced the portrayal of Mrs. Boston Wright -- the American experience summoned her name -- in *New Grub Street*. Wright is a woman of tremendous vitality with an extraordinary past. Born in a faraway place, she is well-traveled, well-educated, and broadly experienced. She has been at various times a newspaper correspondent, a farmer, and a social worker in the slums of Liverpool. Now she attracts attention in the literary world as she edits a popular magazine. She goes about charming everyone with her chatter, vivacity, and vigorous good looks that appear at times more masculine than feminine.

An encyclopedia of the day's small talk, Mrs. Boston Wright has at the tip of her tongue all the current gossip. The magazine she edits, *The English Girl*, is not a scholarly, religious, political, or feminist organ, but a circumspect little publication directed to upper-class young ladies. Its mission is not to improve the world in any way at all; it is produced merely for entertainment and to make money. Wright has no interest in the sufferings of the lower classes, the oppressed workers of Britain, and is not a reformer. Another characteristic directly related to Mrs. Gaussen is the woman's perpetual youth. In the bloom of good health, she is fifty but looks half her age, or maybe thirty.

Most of Gissing's worldly women establish close and confidential ties with handsome and promising young men and seek to become their counselors. In *Thyrza*, Mrs. Ormonde, whose name echoes worldliness, attempts to direct the future of Walter Egremont. In *A Life's Morning* Mrs. Baxendale offers guidance and understanding to Wilfrid Athel. Her power is almost hypnotic: *"In a day or two the confidence between them was so very complete as if their acquaintance had been life-long."* Mrs. Damerel of *In the Year of Jubilee* has a similar relationship with Horace Lord, and Lady Revill in *Sleeping Fires* is disturbed by Mrs. Tresilian's spellbinding influence upon Louis Reed.

As a young adventurer in America Gissing had considered the advantages of coming under the influence of an older and wiser woman of worldly experience. In his notebook he recorded a story outline about a matron of high standing in the community who takes an interest in a young man of promise and attempts to polish his manners to make him a gentleman. He broke off the note with no indication that her efforts would fail or succeed. On the same page he noted how pleasant it was to converse with educated American girls. He was young and lusty in America, and he was lonely. He had every right to look at the girls, chat with them, and enjoy interaction with them. He left all that when he gave up his teaching job and went alone to Chicago.

With greater skill than most who attempt to write realistic novels, Gissing drew the materials of his

art from the life around him. When the circumstances of his life threw him among people pressed by poverty, he observed them and wrote about them with keen insight. As he came to know upper-class people living in town houses and on landed estates, he wrote perceptively and fairly about them as well. *"I am getting to like the atmosphere of cultured families,"* he admitted in a pompous letter to his brother Algernon. *"I study the people, and they are of use."* Then later, in several well-crafted novels, he chose people of the middle class for analysis, scrutiny, comment, and memorable characters.

Mrs. Gaussen became the prototype for Isabel Clarendon, for his women of the world, and for many of his women of leisure. As late as 1899, as he described a woman of social distinction in *The Crown of Life*, he was sketching the wealthy, cultured, and charming English lady of Gaussen's type: *"Consummate as an ornament of the drawing-room, she would be no less admirably at ease on the tennis lawn, in the boat, on horse-back, or walking by the sea-shore. Beyond criticism her breeding; excellent her education."* Kingcote had said exactly the same of Mrs. Clarendon. *"She will pass on her way and leave me with a memory as of a cool, delicious summer day."* For Gissing the legacy of Mrs. Gaussen was a delicious memory, and yet it also became a reservoir of source material which he could and did use effectively as a leading novelist.

Chapter Six

Edith Sichel and Her Influence

On Saturday, September 28, 1889, a day he would remember, Gissing met another woman of leisure. Her name was Edith Sichel, and she lived in the midst of wealth and refinement. But instead of using her time and money in selfish pursuits, she practiced a personal philanthropy among the poor. Gissing knew that she had appraised his social novels in *Murray's Magazine* for April of 1888. The essay, "Two Philanthropic Novelists," contrasted George Gissing with Walter Besant and concluded that neither had a workable solution for the conditions they described. Gissing readily agreed with that judgment but was uncomfortable being called a philanthropic novelist. His definition of the term was different from hers. Even allowing for a laxity in semantics, he preferred to think of himself as a novelist of ideas rather than one engaged in active reform to achieve social and political change.

Nonetheless, he evaluated her discussion and

found it competent. He could tell it came from a person who knew from experience the poor neighborhoods of London and the misery of human life in them. Even though Edith Sichel's article had appeared before Gissing published *The Nether World*, his most powerful novel of poverty, she had shown in the piece a genuine interest in his work. Moreover, when *The Nether World* was published the following year, she read the book carefully, judged it abundantly better than his previous books, and sent him a note to that effect. That began a hesitant and polite correspondence. In September Gissing visited her at her home in Surrey. The young woman shared a small house in the village of Chiddingfold with another woman named Emily Ritchie.

Sichel and Gissing had lunch together and afterwards explored the countryside. All the while they indulged in *"a vast amount of talk."* He returned to London recalling the pleasantries of the visit and feeling glad he had gone. The next day in a letter to his sister Ellen he exulted in the beauty of the place. The downs were blue against a gray sky, and the foliage dazzled the eye with bright colors: *"One tree I saw on which every leaf was the most brilliant scarlet."* In a letter to his friend Bertz, he described only the woman: *"Miss Sichel is about eight-and-twenty, of Jewish face, distinctly intellectual. She belongs to a circle of wealthy and cultivated people."*

Edith Sichel was a vital young woman known for

her wit, ability. and independence. An heiress of high social standing, she had chosen an active life of the intellect in preference to the idle dignity of others in her class. When Gissing met her she had already become a fledgling writer. Eventually she went on to publish studies of the French Renaissance and the French Revolution as well as biographies of Mary Coleridge, Emily Lawless, and Alfred Ainger. Her extensive intellectual interests were similar in some respects to Gissing's own. She had an interest in Greek and read Plato and Sophocles in the original. She was a student of modern literature and a lover of poetry. She was active in social reform among the poor in London's East End. In later years she established a home in the country for orphans and was a regular visitor to Holloway prison, where she helped rehabilitate inmates.

Such a woman was certain to win Gissing's admiration. He paid a visit to her in November, and was moved by the sumptuousness of her London apartment. He learned that she had inherited £20,000 from her father, had invested the sum wisely, and was free of financial worry. As they talked he surveyed the woman carefully and took mental notes. Later he confided to his ever-present diary that her face and manner were quite pleasing, more so than when he first visited her. On this second visit, looking her over and not missing the smallest detail, she seemed almost beautiful. Her presence and his response produced *"a troubled state of mind."* Their first meeting in Surrey had awakened his

sensitivity to nature and the colors of autumn, and was very pleasant. Their second meeting in London in the privacy of a richly appointed apartment brought him into perilous emotional waters to be navigated with caution and concern.

The apartment and its furnishings caused him to compare his poverty to her wealth, his insecurity to her independence. The result was a feeling of painful inadequacy. It was impossible even to think of a romantic relationship; all he could hope for was a casual friendship. In *The Emancipated*, the novel Gissing was working on when they first corresponded in the summer of 1889, he observed that only the rare upper-class woman would risk living in poverty with a struggling writer. Also no writer worth his salt would ever marry an heiress to be supported by her money. Gissing's sense of honor, painfully restored after the Owens College debacle, stifled even the promise of happiness with such a woman. In later life the people close to him agreed that in worldly matters he elected to suffer hardship and deprivation rather than compromise his code of ethics. H. G. Wells, who was often critical of Gissing, called him "one of the most clean minded and decent of men."

Edith Sichel took a personal interest in the young writer. He was thirty-two, tall and slender and good-looking; courteous, sensitive, well-read, thoughtful, talented, and very bright if not brilliant. She admired his literary endeavor and saw a steady progress toward

maturity with every novel he published. She wanted to be a good friend and perhaps more, but by June 20, 1890 he had made up his mind never to see her again. On that day, according to a diary note, he rejected entirely the prospect of finding a wife belonging to the middle or upper classes. On June 22, the day he declined an invitation from Miss Sichel, he confided to Bertz, writing from Wakefield, that he had very little hope of finding a woman in England. Though hope was fading, he was thinking he might discover a young woman on the Continent.

The chance encounter with a sympathetic, intelligent, educated, marriageable woman of secure financial and social position had brought more pain than pleasure. With women of her stamp he felt strangely inferior. In their presence he was awkward, reticent, and not true to himself. Perhaps the searing pain of the Nell episode influenced his behavior. Perhaps he thought such women recognized him as an author and expected response in that identity rather than accept him as a living man with ordinary faults. And so he was stiff and artificial around them. He couldn't imagine himself offering marriage to an heiress, to a woman such as Edith Sichel. Like Mrs. Gaussen, she had come unbeckoned into his life and had put down his loneliness, but she was no match for that feeling of unworthiness that made him run from her.

The lively correspondence that sprang up between Gissing and Miss Sichel allowed him to classify

and categorize her by type. He could see immediately that she was something of a new woman, for she had all the characteristics of the type. She was well-educated, active in social reform, busy with other interests, and beginning to make her voice heard. She was also a good example of that particular type of woman who paid little attention to religious doctrine, accepting for spiritual guidance a broader sense of moral strength. That was the subject of *The Emancipated*, the novel he was currently writing. Knowing this real new woman helped him apply characteristics he saw in her to the fictional women he struggled to create. Most of the feminine characters in the novel, are seeking emancipation from their traditional role in society as well as from evangelical dogma, itself a tradition.

Eleanor Spence, created with Sichel in mind, is a good example of the type. Levelheaded and softspoken, to be influential she studies the art of saying the right thing in the right words to the right person at the right time. Although she is fully emancipated and her own person, she has liberated herself not through advanced study, but through practical and sometimes painful experience. *The Emancipated* (1890) had already been accepted for publication when Gissing visited Edith Sichel in the autumn of 1889, but she could have been in his mind as early as her first letter to him and before the book reached its final form. Also he would have had time and opportunity to make changes in the proofs

to reflect her influence. Moreover, he may have chosen Eleanor Spence, to project the initials of Edith Sichel.

After he came to know Miss Sichel, she influenced his image of the fashionable advanced woman in much the same way that Mrs. Gaussen had shaped his portrayal of the womanly woman. She helped make his new woman less severe of line, less harsh, and more graceful than the picture of Ada Warren in *Isabel Clarendon*. Miss Sichel's influence would have been far reaching had he not gone off to Italy near the end of 1889. The trip interrupted their incipient friendship and the writing he was currently doing. The warm and colorful scenes he found in Italy, and the heightened activity he enjoyed there, brought new and different ideas that placed earlier work in foggy England on the back burner.

On October 10, 1889, about a month before meeting Edith Sichel, Gissing began a novel he called in preparation "The Head Mistress." The plot involved middle-class life in a provincial town and was built on themes related to *"the female education question."* He had strong views on that subject and thought he could weave his ideas into the fabric of the female education question to create a strong book. By the third of November, he had finished outlining the story and had the character names already selected. However, a week later, only two days after visiting Miss Sichel in London, he was on his way to Italy. The work with its promising and popular subject was laid aside.

In the novelty and excitement of his travels abroad he put the new writing project out of mind and didn't pick it up again until his return to England more than three months later. By then he had only a vague notion of the patterns he had intended to weave, and on March 15, 1890 he reluctantly abandoned the book. It is one of several abortive books that cost him precious time and infinite labor but were later lost or destroyed. The central character of the book could have been based on his friendship with Miss Sichel. Gissing may have seen her as standing in stark contrast to the falsely educated woman whom he despised.

In April of 1890 he was working on another book, but interrupted his labors to visit Paris with his sisters. When he returned with them to Wakefield, he resumed his writing but with great difficulty. He was suffering from anxiety and depression and for many days was unable to summon creative capacity to full duty. During the summer he destroyed one abortive story after another. At the end of June he aborted a novel set in Sark and Guernsey because he thought some of the chapters might offend his sisters. After reading *The Emancipated*, they had sent him angry letters in which they accused him of creating negative characters fashioned after them. In carefully conrolled language he defended his work. But try as he might, he couldn't convince them that their anger was unfounded. He wanted to avoid another row.

In July he was writing a satirical piece called

"Storm Birds." The next month he destroyed that manuscript too. Near the end of August, back in London, he began another project: *"Made a beginning of a new novel, a jumble of the various ones I have been engaged on all summer."* He entitled the new book "Hilda Wolff" after its main feminine character and completed the first volume. Then for reasons unknown, he put it aside and abandoned it. Hilda Wolff, another abortive character of the middle or upper class, could have been modeled after Edith Sichel. His state of mind during the summer of 1890 was raw and painful. Sexual frustration was causing the trouble, but to talk about it with anyone other than Bertz in Germany was out of the question.

In the fall of 1890, after many unproductive attempts during the summer, he put on paper the opening paragraphs of *New Grub Street*. Somewhere in the midst of all this struggle, all the false starts, the plan to draw upon Edith Sichel as the model for a sprightly new woman was lost. Her identity as a female philanthropist, however, remained in mind. Although Gissing viewed female philanthropists with ambivalence and sometimes bitterly satirized them -- referring to them once as *"visitants from other spheres"* -- he admired the unobtrusive and productive work of Miss Sichel. Though part of a movement which seemed frivolous at times, he viewed her philanthropy as exceptional. It was the product of intelligence, planning, and hard work. It differed from the more popular philanthropy wealthy ladies, known as slummers, were doing.

Influenced by the resurgence of the philanthropic movement that gained momentum after its appearance in the early years of the century, affluent women ventured outside their drawing-rooms and found the world less than perfect. In the cities children were wild and ragged and unschooled. Hundreds of children worked in the mines and seldom saw the light of day. In the mills they labored to exhaustion near machinery that could injure or kill them, and they slept beside it at night. Whole families lived without basic privacy in a single room -- eating, drinking, evacuating, and reproducing. Men, women, and children in social classes labeled *"the lower orders"* toiled long hours for wages often too low to sustain life. Little girls scarcely into puberty were selling themselves in the streets, or in bordellos they called home.

It had become fashionable by the 1870's for wealthy women of romantic impulse to *"go among the poor."* Encouraged by the Biblical rhetoric of John Ruskin, they tried to help the poor in the larger cities as best they could. While some worked long and hard for lasting reform, others were dilettantes or dabblers trying to escape boredom. These latter went among the poor to satisfy their curiosity and to assuage the monotony of dull lives. Gissing had seen their kind in his neighborhood and despised them. Even though by the time he met Edith Sichel he was losing faith in personal philanthropy, he recognized the worth of her work and held the woman in high esteem. He was pleased to have

her as a friend. Though desirable, she could never be more.

In some of his novels, at the risk of offending her, he couldn't resist poking fun at the efforts of well-meaning, well-heeled ladies in blue stockings who were trying mightily though ineffectually to aid the poor. In *New Grub Street* the indefatigable Mrs. Boston Wright devoted herself at one time to serving the poor, but soon grew bored with that pursuit and went on to intrude on the literary scene. In *The Whirlpool,* Lady Isobel Barker *"did a good deal of slumming at the time when it was fashionable."* Barker later *"started a home for women of a certain kind,"* but soon gave it up for other pursuits. In *Our Friend the Charlatan* a visionary helper of the poor with an abundance of highly impractical plans is the sprightly and memorable May Tomlin.

One of the most delightful of Gissing's young women, May has a full heart but an empty head. *"I take a great interest in the condition of the poor,"* she explains to Lady Ogram. *"I must tell you that a favourite study of mine is Old English, and I'm sure it would be so good if our working classes could be brought to read Chaucer and Langland and Wyclif and so on."* Lady Ogram, practical in her philanthropy to a fault, can hardly believe her ears. But she indulges May, and the girl chatters on: *"We want to train their intelligence. Some of our friends say it will be absurd to give them classical music, which will weary and discontent them. But they must be made to understand that their weariness and discontent is wrong."*

May Tomlin, innocent in her idealism, is one of Gissing's best comic creations. She is deftly drawn with bold satirical strokes, evoking laughter and thought and affection. The novelist would have done well to employ satire such as this more often.

May Tomlin is the happy result of character development wrought at the peak of Gissing's maturity. Helen Norman of *Workers in the Dawn*, the earliest of Gissing's philanthropic females, is so different one finds it hard to believe the same author created both characters. While May is sketched with controlled lightness of touch and appeals to our sense of humor, Helen is awkwardly portrayed with heavy and high seriousness. She is selfless, compassionate, idealistic, and eager to alleviate with a lot of time and money the misery of the poor. But she is also an incorrigible bluestocking who can't speak one syllable without sounding pompous. This is the way she states her mission: *"I shall endeavour to gain the personal confidence of these poor people, so that they will freely impart to me their difficulties, and allow me to help them in the most effectual way."* Though set against a background of careful realism, Helen Norman with the suggestive name is unrealistic.

Later Gissing's upper-class women would trill an easy flow of language to reveal vibrant and believable personalities. Mrs. Bruce Page of *Isabel Clarendon* greets her hostess with an unbroken arpeggio of inquiry, response, and comment. Helen Norman, however -- the

creature of a young author's limited experience -- falls short of such delightful representation. A failure in characterization, she is a good example of Gissing missing the mark with some of his characters. In letters to Bertz he complained that his female characters in particular often defied his efforts to portray them realistically. Yet Helen Norman for all her faults reflects his sympathy in 1880 with many attempts to render aid to the poor. By 1888 when Edith Sichel painted him as a social reformer, his sympathy ironically had begun to sour.

In *The Nether World* plain and hard-featured Miss Lant is not a sympathetic character even though she dedicates herself to the poor with zeal that surpasses Helen Norman's. Her philanthropy has become her religion, and her work among the poor her hope for salvation. She belongs, as Gissing tells us, to *"a class of persons who substitute for the old religious acerbity a narrow and oppressive zeal for good works of purely human sanction."* Her labor in the slums produces few positive results, is beyond her strength, and wears her down to exhaustion. Gissing is saying that the efforts of similar women amount to very little. Elderly Lady Ogram, on the other hand, takes a pragmatic approach to the problems of the poor and manages to achieve something.

Like Richard Mutimer in *Demos*, Lady Ogram is convinced that it is better for the poor to be fed, clothed, and housed than for the wealthy to have a pleasant

landscape to view. To provide employment in a time of agricultural depression, she has built a paper mill, belching smoke, in the picturesque village of Shawe. Even though Gissing, like John Ruskin, deplored the desecration of the countryside by such projects, he could appreciate their economic value. That judgment of practicality became the yardstick by which he measured the worth of lady philanthropists. Spending their time among the poor was not enough. Dispensing pious religious tracts, pamphlets on hygiene, and purple passages from great literature was of no benefit whatsoever. Classical music delivered by the best orchestra in all of Europe would fail to soothe the spirit or elevate the soul of that enigma the politicians called "the masses."

Only money wisely spent could improve the lives and living conditions of the poor. It would provide better health but would do little for their souls. Gissing was convinced that would-be reformers among the poor sometimes did more harm than good. Those who substituted curiosity for compassion, and had little sympathy for the poor, were seen by Gissing as disgusting dilletantes. An entry in his Commonplace Book is a good example. There he recorded an ugly incident involving *"two smug middle-class females"* in conversation with an old and ragged woman on the pavement. The woman was expressing her weariness and longing to die. In response one of the middle-class do-gooders chirped, *"Oh, that's very nice!"* The scene

symbolized for Gissing a brutal lack of compassion that could do nothing but harm. Near the end of his career, he used it to satirize ineffectual philanthropists in *Will Warburton*, the last novel he would write.

In that final novel the slummer is not a person, but a portrait. She is the idealized focal point of a painting. A *"tall, graceful, prettily clad young woman, obviously a visitant from other spheres,"* she is shown in the act of comforting the poor in a dirty and narrow slum street. One delicate hand displays a book while the other caresses a gaunt and hungry child whose face is illuminated with innocent adoration. Closeby slouches an unhealthy and crestfallen young woman with a sickly infant at her breast. With an awestruck gaze, she is *"adoring the representative of health, wealth, and charity."* Behind them on the curbstone, with dark disgust stamped on his weathered face, stands a swarthy, unemployed costermonger. Every little detail of the picture is complete except for the gorgeous face of the visitant. It remains just a blur of color.

The deluded artist as yet has not been able to capture the purity and radiance the face of this angel of mercy must show. If the man had the courage to speak truthfully, says Warburton who speaks for Gissing, he would paint realistically. He would show not only a rough disgust in the costermonger, but impatience bordering on mockery in the child's face. He would also express curiosity blended with cold contempt in the young mother's face and a look of haughty superiority in

the visitant's. He would paint the visitant from another world as sharp-nosed and thin-lipped *"with a universe of self-conceit."* Art and life would benefit vastly from a realistic portrayal of the scene.

Warburton's cynical, satirical, humorous, and accurate appraisal of personal philanthropists near the end of the nineteenth century is Gissing's own. Between his first novel and his last, Gissing's views on philanthropy underwent a significant change. Between Helen Norman and Will Warburton is a thunderous gulf as wide as an ocean. The friendship with Edith Sichel, established when his opinions were in flux, caused him to re-examine some of his views but not to revise any of them. She never became the model for an interesting character, and yet she had a decisive influence on his work.

Chapter Seven

The Sisters Ellen and Margaret

When George Gissing settled in London in 1878, he began to write expansive letters to his sisters in the role of mentor. Because Margaret and Ellen were a few years younger than he and had not fully reached adulthood, he wanted to give them advice on their education. He wanted to encourage them to spend their time wisely and take their studies seriously. When Margaret expressed weak self-confidence, he instructed her to do her job as a housekeeper as best she could. Then in after hours she could pursue an ambitious plan of reading and study that would give her confidence. Later when she had become a governess in Wales and was suffering from a sense of social inferiority imparted by the job, he advised her to stand on her dignity and simply assert herself. He wanted his sisters to become strong, sensible, independent women, and so he took considerable interest in their personal development.

They in turn were impressed by the scope of

his learning. He had acquired on his own an excellent liberal arts education after the debacle at Owens College. The young women knew their brother's struggle had been long and hard. They knew he was a good person and loved them. They were more than willing to receive instruction and advice from him. In the 1880's he thought their girlhood reading had been too restrictive. And so he recommended liberal books and authors that would broaden their minds as adults. He believed they couldn't become intellectuals, but with an extensive education they could escape the ignorance and incapacity that so often afflicted women of their class. Moreover, since they could look forward to no inheritance from a wealthy relative, they would have to make their own way in the world in the few positions open to women. They would have to support themselves by teaching, and that required preparation.

The education available to young women, he said in May of 1880, should be general and liberal and should expand one's intelligence as its primary aim. This expansion of the rational faculty he considered more important than gaining a thorough knowledge of any one subject. It produced liberality of mind, balance in one's opinions, and soundness of judgment. In 1882 he said enrichment of mind was directly related to *"the process of enlightenment."* The woman who achieved cultivation of mind became an advanced woman, a new and more powerful woman, without even trying overtly to gain that identity.

More important was how the process improved character. It had to do with a sifting and weighing of the old ideas and beliefs and a rejection of those that had ceased to serve. Gissing was not sure his sisters were capable of so radical a change, but if they failed to become enlightened they could settle for self-reliance. To Ellen he said near the end of 1886: *"After all, the self-reliant woman is the best, one that would go from here to San Francisco with perfect ease and simplicity. It becomes any woman to have knowledge of the world, and not be a helpless puppet."* He made this remark while under the heady influence of well-traveled and independent Mrs. Gaussen.

In a letter of 1887 he placed before Ellen the concept of classical education as cherished by the Renaissance. He often thought, he said, of Lady Jane Grey filling her leisure hours reading Plato. He wondered why it had taken centuries for civilization to return essentially to the same ideal of woman's education that was embraced by the Elizabethans. One of his students had expressed a desire to read Homer in the original, and he hinted that his sisters should also develop a love of the classics. They should read as well the best of English and European poets and writers, Shakespeare and Chaucer in particular and Charlotte Brontë.

To Margaret, who had just turned seventeen, he wrote at the beginning of 1880: *"A woman is a mere duffer if she is not able to read Shakespeare with perfect intelligence of his vocabulary. I should advise you to pay*

the same attention to Chaucer too, but of course, you will not have time for everything at once." The excellence of Charlotte Brontë he praised in many letters: *"She is the greatest English woman after Mrs. Browning,"* he said with youthful enthusiasm. *"George Eliot is poor in comparison with her. She strengthens me enormously."*

His praise of Brontë was critically sound, but with Mrs. Browning he was echoing the current high opinion of the female poet. While he respected her position as a moral voice to guide the masses, in none of his letters to his sisters did he praise her poetry or single it out for special discussion. Even so, he wanted Margaret and Ellen to become acquainted with contemporary poetry and with current intellectual opinion. In short, if they were to become liberally educated, a wide range of reading would be necessary. It would exercise their minds, stimulate their imaginations, and leave them with little time for the sour religious tracts he despised.

Even as he offered instruction, Gissing suspected his sisters would never become women of liberated opinion. On holiday with Margaret he enjoyed the sensuous beauty of Sark and Guernsey, but found himself becoming irritated with the cast of mind his sister often displayed. To Bertz he confided in a tone of weary resignation: *"My sister is a Puritan, and we can talk of nothing but matter of fact."* In his Commonplace Book he noted how impossible it was to talk with either of his sisters about anything that had to do with the private acts of one's life. Their *"innate*

puritanism" prohibited any reference to sexual matters in any context. It stifled even the innuendo permitted other middle-class families and demanded vagueness of speech that promoted verbal games, a situation he found intolerable. Margaret and Ellen viewed the human act of reproduction as foreign to their world and quite naughty.

When he admired in authorial comment the candor of Miss Rhoda Nunn, the protagonist of *The Odd Women*, he was thinking of his sisters: *"No Grundyism in Rhoda Nunn; no simpering, no mincing of phrases."* Miss Nunn was a liberated woman in that respect and sure of her sexuality, but Margaret and Ellen were not. While he relaxed with Ovid on the island of Guernsey, under gorgeous blue skies that reminded him of Italy, Margaret (moving into her late twenties in the summer of 1889) plodded through "some dirty little pietistic work." He was dismayed by her reading tastes as she moved into full womanhood, and he wondered with a hint of sadness and anger whether his teachings had not been wasted on her. For the younger sister Ellen he was more hopeful.

As the summer of 1889 began, Gissing was hard at work on a novel based on his Italian journey. It dealt with a colorful group of cultivated intellectuals of British extraction living in Naples. In varying degrees these people were emancipated from the dogma that had shackled his sisters. He saw it as a strong story, full of color and passion, and he wrote with delight.

In the early stages he thought he would call it "The Puritan" after the central character, Miriam Baske. Later he called it "The Emancipated," a reference to all the characters. At the end of May he went to the home of his mother and sisters to continue work on the novel and to bring himself closer to his subject. From Wakefield he wrote to his friend Bertz in the German city of Potsdam, informing him that the book was going well in *"this home of Puritanism."* He added that he expected to remain there until most of the job was done.

The phrase *"home of Puritanism"* was deliberately ambiguous, for Gissing knew it could refer with equal accuracy to the household or to the town. His mother and sisters were devoutly protestant. To a great extent they endorsed the puritan attitudes that touched every page of his new novel. Wakefield for more than two centuries had been a home for dissenters of every stripe and a refuge of puritanism. What better place, therefore, to write a treatise attacking the puritan way of life but showing also its strength and tenacity? He was able to observe the puritanism that was becoming an important force in his book not only within the family house, but also outside among the townspeople. Close proximity to his subject was the impetus he needed. It allowed him to work unimpeded without painful false starts, and it even provided some degree of pleasure as he worked.

The term that became the title of the book, "The

Emancipated," referred to those people who had freed themselves of all puritan views of morality. Specifically, it referred to Miriam Baske, young and lovely, rigidly puritan, but delivered from stringent dogma after much soul-searching. Although both of his sisters influenced the character, the original for puritanical Miriam was primarily Margaret. However, when Ellen read the book in 1890, she angrily accused her brother of using her as the model for his fictional character. *"Nothing of the kind,"* he replied. *"You have grown up in a far more liberal atmosphere."* For the sake of peace he was willing to compromise, and yet he felt sincerely that if Ellen fell short of emancipation, she was certainly more liberal than either her sister or the fictional Miriam Baske.

Four years younger than Margaret, Ellen had been exposed to his teachings earlier and to his way of thinking had been more receptive. She had read more widely than Margaret, seemed to retain more, and displayed a personality more flexible. He was able to talk with her more easily than with Margaret. As the years passed he wrote more letters to Ellen than to Margaret. On the whole he considered her far more enlightened than the older sister. Yet both of the sisters, though not so stern as Miriam Baske, were good examples of the repressive morality displayed by that character in the first half of the novel.

Both had been reared in a stronghold of puritanism, and neither had been able to throw off entirely the dogmas of the past to live freely in the

present. Both were therefore influential in the formation of those attitudes attributed to Miriam Baske. Without the special knowledge he had gained from his sisters Gissing would not have been able to write *The Emancipated* with gentle understanding and restraint. They helped him develop and depict the complex main character as well as some of the lesser female characters. Particularly, they guided the novelist as he developed the satirical portrait of the comical Denyer sisters.

Shortly after publication in 1890, Gissing mailed a copy of the book to his sisters in Wakefield. Enclosing a letter inside the package, he cautioned them not to read *The Emancipated* too literally or take any of the characters too seriously. The freedom of behavior all the characters seem to enjoy, he explained, is something of a sham, for the oppressive past continues to weigh heavily upon them. If you were to scratch any one of these people, he advised, even one as fully liberated as Cecily Doran, you would find a puritan beneath. Under stress, he suggested, most of the women in this seemingly sophisticated group of expatriates would revert to past conditioning in puritan England and lose every shred of liberation. they had struggled to obtain.

The best example of the reversion Gissing mentions, a return to the dogmatic principles that guided behavior when she was younger, is Zillah Denyer: *"One by one all the characteristics of an 'emancipated' person had fallen from her. Living with a perfectly conventional*

family, she adopted not only the forms of their faith but at length the habit of their minds." This reversion ironically frees Zillah from pretense and brings her peace of mind. The change in the minds and hearts of the other characters suggests the beginning of a fruitful but fragile process that could require three generations to complete. It could take that long to ween themselves of puritan influence, and even then they could falter and find themselves puritans again. The process was not irreversible.

In the first chapters of *The Emancipated*, Miriam Baske is seen writing stern and gloomy letters beside a window that overlooks a scene of rare beauty, the Bay of Naples. But the bay and the city of sunshine and color have little effect upon her. Incredibly she confides to the person who will receive the letter, *"You need not envy me the bright sky, for it gives me no pleasure."* The cold and resolute puritanical spirit will not permit her to show interest in anything Italian, not even the sky. She is not able to enjoy the color that surrounds her, the street sounds and music, the sunlight and laughter. The ringing of church bells is a sad reminder of a centuries-old adversary, Catholicism.

On Sundays there can be no wandering through streets to admire the sights, no piano playing, no reading for pleasire, no joyful chitchat, and no smiles or laughter at the dinner table. In Naples to recover from an illness, Miriam concentrates on her plans to build a dissenting chapel in her hometown, allowing herself no

other activity. As an unyielding puritan unable to enjoy anything Italian, her character is exaggerated and not easily believable. With plans to have Italy transform her, Gissing didn't question Miriam's believability as she first appears. Also, having grown up in Wakefield, he saw the portrait he painted of her as realistic though enhanced by satirical strokes.

In time, as the subtle influences of her surroundings begin to affect her, Miriam puts the chapel plans out of sight and becomes more flexible. Her spiritual progress can be seen as a steady movement from strict hebraism to enlightened hellenism. Her love of beauty awakened, she finds herself reading Dante on Sunday, listening to music whenever she can, and experiencing for the first time the pleasure of books. Her severe puritan attire yields gradually to colorful and casual dress. Her eyes lose their worried look and shine as brightly as her smiles. Above all, she gives up her *"silly desire to build a chapel at Bartles"* and begins to think of a project more useful.

After three years -- such conversion does not come quickly --Miriam Baske is able to free herself of the trammels imposed upon her by an outworn creed that has ceased to serve. Slowly and carefully she assimilates Matthew Arnold's definition of culture, the details of which Gissing had studied as early as the American days. But even with the new hellenism to support her, the sculpture of the Renaissance alarms her. In front of a nude statue, even when telling herself

the human form is quite beautiful, she is not able to conquer her feelings of shame. Even so, she uses the money reserved for the chapel to build public baths in Bartles, a secular facility to comfort people and afford them pleasure. With that accomplishment she is able to tell herself that she has completed her journey from hebraism to hellenism.

Gissing wanted his sisters to follow a similar path. If they could free themselves from what he considered a restrictive religious faith and become more worldly, they could attain in time their full stature as fully grown women. In Ellen he saw greater promise than in Margaret, but to a liberal mind both fell short. Though on the surface they seemed more enlightened than other women of their region and class, at the core where it really mattered they were puritans. That was obvious in any conversation that revealed their ideas and beliefs, and surely in the way they conducted themselves.

After reading *Born in Exile* shortly after its publication in 1892, they expressed in argumentative and scolding letters a deep regret that their beloved brother had strayed so far from righteousness. They were dismayed that he could so completely reject the foremost teachings of Christian wisdom and find so little to replace them. How could anyone disbelieve the Bible, they asked in a tone of reproach, simply because it was not written in the latest scientific jargon? How could anyone deny the existence of the spiritual world simply because it could not be seen? Why did he persist

in risking the loss of eternal life? The stubborn piety of Margaret's letters particularly annoyed her brother, but Ellen too had failed to gain liberation of mind and heart.

Yet their puritan practicality time and again held the sisters in good stead. They lived long and productive lives and unlike the Madden sisters in *The Odd Women*, they were never beaten by circumstance. Both were good-looking women and could have married. Any number of young men in their social circle, if given the nod, would have come to court them. But from their brother's example they were convinced that courtship and marriage often brought misery, and marriage to them was permanent. If they were to entertain thoughts of matrimony and act upon them, they could find themselves in a dire position they would forever regret. They opted in mutual agreement to take no chances. In none of their letters do we learn that either ever had a love affair.

Their attitudes were similar to those of Madeline Denyer who rejects handsome and personable Clifford Marsh in *The Emancipated* because the young artist lacks earning power. Calvinistic and middle-class concepts require Madeline to think and behave in terms of money. *"Your talk of art is nothing more than talk,"* chides her suitor. *"You think, in truth, of pounds, shillings, and pence."* She replies that she would be an idiot not to think in that way: *"What is art if the artist has nothing to live on?"* In the real world those who

strive for high-mindedness must also pay the rent, buy warm clothing, and eat to sustain life. Madeline quite understands that marriages which ignore reality often founder.

As he tutored his sisters by mail, Gissing assumed their lot in life need not include marriage. Provocative and thoughtful Mrs. Lessingham of *The Emancipated* spoke for him when she said of Cecily Doran: *"She seemed a human being to be instructed and developed, not a pretty girl to be made ready for the market. My object was to teach her to think for herself, to be self-reliant."* Gissing's unmarried sisters soon gained self-reliance, and they were able to live independent of men to a ripe old age. They were able to think for themselves and to support themselves in a complex and changing environment in a world indifferent to individual struggle. They lived comfortably and free of want. They attained in their lives a semblance of the happiness that so often eluded their brother. In maturity they amply demonstrated that his loving service as a surrogate father had not been entirely wasted.

Chapter Eight

Odd Superfluous Women

Gissing examined the problem of superfluous women in England in one of his best books, *The Odd Women* (1893). Earlier he had shown hard-working men supporting huge families with many girls. In this book he examined the predicament of such a family when the father dies by accident, leaving as many as six daughters to shift for themselves. The time is 1872. Protective Dr. Madden is forty-nine, but already planning to insure his life in uncertain times so as to provide security for his daughters. He enjoys good health and expects to live well into his sixties. Then before he can talk business with an agent, he is thrown from his vehicle at the end of the first chapter and dies of his injuries. Gissing was perhaps thinking of his own father as he planned the untimely death of Dr. Madden. Thomas Gissing, a chemist, had died prematurely in 1870, leaving behind a wife and five children.

The doctor's estate cannot provide an income for his daughters, and they have no male relatives to fall

back upon. Necessity demands they support themselves. Their genteel education, intended to prepare them for marriage and a middle-class social life, has not equipped them for the world. Therefore, all they can hope for is to become governesses at low salaries, companions to older women at even lower salaries, or perhaps they can marry. The question as the opening chapter concludes is whether any of the Madden sisters, so ill-equipped to find safe haven in an uncaring world, will survive.

As chapter two opens, the time is fifteen years later. Half of the Madden sisters have died; three of six have survived. Virginia at thirty-three makes her way in 1887 to a lodging house in London to be near her sister Monica. There she rents a tiny room at the back of the house and lives alone, preparing her spare vegetarian meals in a saucepan. Later on Alice (thirty-five) comes to live with her. Monica, the youngest at twenty-one and the only sister with employment, labors in a shop more than thirteen hours a day and sixteen on Saturdays. All three are losing strength, good looks, and hope. The future looks bleak.

Alice had worked as a governess for sixteen pounds a year, and Virginia had been a companion at twelve pounds. As 1888 begins, they sit in their shabby little room, a universe away from the comfortable house in which they grew up, waiting for the chance to work again. They find it hard to believe that work may never come to improve their lives because thousands of younger women are in competition with them. A harsh environment has

made the sisters nervo Sheus, fidgety, eccentric old maids on the brink of failing health. As the months pass, Alice turns to the Bible to shield herself against *"the barrenness and bitterness of life."* Her sister Virginia, in the same predicament, turns in secret to the bottle. She drinks whenever she can but lacks the means to buy even cheap gin. Her poverty saves her from becoming an alcoholic.

The two older Madden sisters, products of Gissing's imagination and living only in the pages of a book, share obvious similarities with the author's own sisters. All four are pietistic, conventionally educated, unmarried, and superfluous. The elder Gissing sister was already thirty, and both seemed to be aging rapidly. Like the Madden sisters, they were supporting themselves as overworked and underpaid teachers. At the beginning of 1898 Ellen complained that her life as a teacher was not as good as she would like. It was in fact becoming insufferable, and the low wages were outrageous, intolerable. *"Yes, it is a monstrous thing,"* her brother replied, *"that you should work so hard for so little. Yet I suppose people will not pay more."* So what seemed to be a workable solution? Perhaps circumstance would allow them to open their own school.

When the Madden sisters are not able to find employment of any kind, Rhoda Nunn, principal character of *The Odd Women*, advises them to use the last of the money their father left them and open a school. The suggestion becomes their dream to be nurtured day by day: *"We shall certainly open the school. We have*

made up our minds; that is to be our life's work. It is far more than a mere means of subsistence." However, they fail to realize their dream. Worn and discouraged and given to procrastination, afraid of losing their money and not certain they could manage a school, they are not able to act. As the book ends, the original six have been reduced to only two. Alice insists that she and Virginia will open their school soon, but the reader knows they never will. The Madden sisters and the Gissing sisters share numerous similarities, and yet a main difference must be emphasized. Margaret and Ellen were made of sterner stuff. Gissing was delighted when they opened their own school and saw it doing well.

The Gissing sisters were often cautious, indecisive, ineffectual; but they knew how to endure. Like the Barmby sisters, Lucy and Amelia, of *In the Year of Jubilee*, they lived as unpretentious women of the middle class who read sour evangelical periodicals, suffered from indigestion and headaches, and spent most of their time at home. Try as he might Gissing was not able to imagine a brighter future for either of them. Though very decent women, and capable of doing work more lucrative than teaching, they lacked nerve. Their brother felt they also needed distinction, dedication, direction, strength of mind, and more energy. He was greatly surprised, therefore, when they informed him early in 1898 of their plan to open a school. In his reply he expressed approval of the idea and praised them for their independence of thought and action.

As usual, he was strapped for money but managed to contribute five pounds to the enterprise. Also he composed a lengthy, carefully worded advertisement that reflected his theory of education:

> *The Misses Gissing, after some years' experience in private teaching, are about to open a Preparatory Day-School. Their course of instruction will comprise the usual English subjects (grammar, history, geography), arithmetic, French and Latin. Extra subjects: Music and Drawing. In all their teaching, the Misses Gissing will aim at the thoroughness and method that are of prime importance in the education of children. It will be their endeavour to provide sound intellectual training.*

Later Gissing enrolled his son Walter, who grew up to be killed in World War I. Every month without fail he sent a small check to cover the boy's support. In 1902, the sisters suggested that the boy's tuition be absorbed by the school. They knew their brother's income, even as late as the evening of his life, was quite low. Also he had medical bills to pay. Gissing replied, saying he was pleased with the offer, but would have to turn it down. Although their school was a splendid result of intelligence and hard work, he said, it was not so profitable that he would be able to accept. He sent them a small check and warm words of encouragement. Until his death in 1903, he was proud of their achievement.

Chapter Nine

Teachers From Low to High

His sisters were in Gissing's mind as he fashioned some of the many teachers in his fiction. They range from an angry but exhausted woman, who teaches piano at sixpence an hour, to an overly aggressive high-school teacher with a university degree. In "A Song of Sixpence" (1895) frail and sallow Miss Withers reflects some of the stress and worry the Gissing sisters encountered in their teaching. Like Ellen who seemed at times on the brink of collapse as a young teacher, the rapidly aging music teacher is plagued by hardship in the present and constant fear of the future. Like the Madden sisters, she has no alternative but to do whatever she can to maintain life. Unlike them, she is able to provide a service to others to meet her daily needs. However, she must cater to people who are also poor, and so her income is pitifully small.

Better educated than the parents of her pupils and superior in social standing, economic distress has left

her humble and compliant on the surface but furious and frustrated beneath. With no connections, her livelihood is dependent upon poor people of unsteady income who are willing to pay for music lessons to benefit unresponsive children. Their unruly parents are her customers, and Miss Withers must please them or lose them to another teacher. In obedience to their vulgar tastes, she must take shortcuts in her teaching and do violence to the music she loves: *"When are you goin' to teach her a toon, Miss Withers?"* asks a mother. *"Her father says that kind o' plyin' makes his 'ead ache."* The satire in this story is gentle and sometimes humorous. But at the heart of the story is the specter of human suffering and pain. Miss Withers has become the victim of an uncaring world.

In a world different from that of Miss Withers is the protagonist of "Miss Rodney's Leisure." The self-loving and self-confident teacher is modeled after Miss Rachel White, whom Gissing met at the East Anglian Sanatorium in the summer of 1901. In a letter to his friend H. G. Wells, he expressed expansive admiration of White, describing her as *"a very vigorous type who will serve me one of these days."* He was implying she would become the model for a main character in a novel he planned to write. However, because of failing health and sensing he was near the end of his career, Gissing placed her in a fast-paced short story.

Miss Rachel White was a liberally educated new woman, witty and talkative, quietly confident,

intelligent, and expert in Gissing's favorite field. A teacher, but no ordinary teacher, she was for many years a lecturer in the classics at Cambridge. When he met her she was thirty-four, afflicted with tuberculosis, and in the early years of her career. She left the sanatorium with the disease in remission and lived a long life. With her memory in mind, he penned satirical "Miss Rodney's Leisure" in 1902. In almost every detail, except for the satirical exaggeration, his character projects the personality of the real woman.

The highest-ranking teacher in Gissing's work, Miss Rodney is vastly energetic, opinionated, and purposive. Even though she works endless hours and seldom gets to bed before midnight, she faces the challenge of each day with enthusiasm and vigor. About twenty-eight -- Miss White looked younger than her years -- and dressed in tailor-made clothes, Miss Rodney walks faster than anyone in Wattleborough but never seems hurried. A happy university graduate, she knows many important people. According to Gissing himself, she is *"the friend of everybody one can mention."*

Miss Rodney has earned a dubious reputation for being clever and independent. Instead of casting her glance demurely downward in the presence of men, she looks them full in the face and speaks with decision, mincing no words. She is seen as direct, honest, outspoken, cheerful, and aggressive. Her hobby is to motivate the unmotivated, and so she dabbles in the lives of others. Gissing's readers found her a little

hard to take (and still do), but it seems obvious that he admired the strength and will of Miss Rodney and found her amusing.

In the story "At High Pressure" (1896) written before he met Miss White and before his sisters opened their school, the novelist portrayed Linda Vassie, a busy would-be new woman, with no sympathy whatever. Similar to Miss Rodney, both are busy-bodies who meddle in the affairs of others and generally make a nuisance of themselves. They are self-centered as they engage in their frenetic activity and driven by a need to gain attention as they assert themselves. But the telling difference is that one acts with purpose and direction while the other does not. Miss Rodney's efforts bring about lasting and positive change. Linda Vassie, on the other hand, moves at high pressure during all her waking hours to accomplish very little. She is idle even when most busy. For that type of woman Gissing could find no sympathy. In his Commonplace Book he was contemptuous of idle women who filled the hours of each day not with work or service, but with silly and worthless "projects."

A good example of such a woman is Mary Abbott of *The Whirlpool*. Once a clever high-school teacher supporting herself and contributing to society as a competent teacher, she quits her job when she marries a wealthy man in poor health. She displays in her social circle an air of superiority conditioned in the classroom but makes no attempt to lead. Comfortable financially,

she is smugly married to a man who has ceased to serve as his health declines. Once a vigorous achiever but now idle and unproductive, under his influence she too becomes unproductive. Peevish and impatient when things do not go exactly right, her best qualities emerge shortly after her husband dies. On her own again, without the luxury of another person to make her decisions for her, she must do her own thinking to direct the course of her life. Looking for something to do to occupy her time, she converts a house in the country into a girls' school and becomes a teacher working long hours again. In that way she rediscovers contentment and a sense of worth. Apparent here is the tramsmutation theme, frequently used by Gissing.

Struggling as teachers, his sisters would complain of long hours and exhaustive work at salaries too low. In letters to their brother they complained of the unfairness of life, particularly how reality made a woman's life tougher than a man's. Then against greater odds than Mary Abbott ever faced they would somehow find the strength to meet the demands of a productive life. They worked sensibly to realize a plan requiring much thought, and eventually the result of their work was a successful school. At a time when thousands of unmarried women were passively dependent upon male relatives for support, they found a way to live on their own while doing good work in the world. It was no small achievement. If Gissing had lived longer, he

would have likely brought them into a thoughtful book to celebrate their success.

Margaret and Ellen Gissing surely knew as they read his books that he was fashioning some of his characters after them. At times, as when they sternly objected to his using them as models for puritanical Miriam Baske, they sent him angry letters. But most of the time, because they were close to their brother and loved him, they were willing to serve as the writer's source for unflattering fictional characters. Some good examples are the Madden, Denyer, and Barmby sisters. They were also models for some of Gissing's major characters. Many womanly women in his work show the influence of the sisters. They were the source also for some of his teachers, and they won his lasting respect by opening a school of their own. All the fictional women who owed a debt to Gissing's sisters were presented boldly, realistically, and satirically, but with a dusting of idealism.

Another woman who might have become a teacher, had she not become an heiress to live well without a formal job, was Edith Sichel. She influenced his feminine portraiture at a critical time in his life. She was free of dogma, intellectual, and eager to serve him, as well as serving others, any way she could. Though willing perhaps to become his wife, had he shown even slightest interest in marriage, his sense of honor regarding the money she had inherited would not allow it. She influenced his opinions of the so-called advanced woman of the day, but he never

modeled an amusing new woman after her as he did with Rachel White. He had her in mind, however, when it came to sketching those upper-class philanthropists who visited the poor and sometimes helped them with money, goods, and a better place to live.

Regarding people of wealth, Gissing was aristocratic of temper and admired the upper classes. Their women he viewed with fascination and longing. The sight of them, well-preserved and reflecting the good life, kindled his imagination. In his fiction some of these women were rendered as nearly perfect as he could make them. He fell in love with Isabel Clarendon. Resplendent in evening dress, her neck and shoulders gleaming above the dark richness of her gown, he desired that woman as though she were alive. Even the air surrounding her seemed warm and sweet and her world the essence of romance. Yet she was modeled after Mrs. Gaussen, a woman of middle age whom he deeply admired.

In 1891 he admitted that too many of his women were depicted as too good, and he couldn't explain why. One explanation would be the idealism that he never quite lost. Another would be the fact that all his life, even as a boy, the opposite sex fascinated him. To put it bluntly, Gissing loved women but could also see their faults. His teachers do not fall into the category of idealized women. Even so, he disparages none of them even when having fun with them. His unrestrained admiration of women from working girls to wealthy matrons explains why.

Chapter Ten

Edith Underwood

Although the summer of 1890 began well enough, it was not a happy time for George Gissing. In March he had made plans to go to Wakefield and complete a long novel in the family residence as he had done during the previous summer. At the end of March, *The Emancipated*, written during the summer of 1889, was issued by a good publisher and gave promise of a positive reception. In April he spent two weeks in Paris with his sisters, and from Paris they crossed the channel and traveled to Wakefield. With memories of Greece, Italy, and France to sustain him, he worked for a while with a steady hand without faltering. Then the specter of endless labor in that pedestrian place began to trouble him. In his early thirties, he wanted to relax and enjoy life. He wanted to talk, laugh, drink wine, listen to music, and savor the opposite sex. But each day demanded that he become a writing machine to make a living. Scribbling tiny words in black ink on

special paper meant isolation and solitude even when the imagination was most active.

Yorkshire, moreover, was in the grip of bad weather and the town of Wakefield with its memories of a happy childhood was not the right place for him. Also he was mortified to learn that his satirical novel, *The Emancipated*, had failed to show its satire to the shallow critics who pronounced it a failure. He suffered from alienation and a mild paranoia. There seemed to be afoot a deliberate attempt by persons unknown to silence him as a writer. He knew that his novels were better than most of the stuff that poured from the presses every day, even that receiving high praise. And so he couldn't understand why they invariably failed, one after another, even as the steady flow of trash succeeded.

As he struggled to put together his ninth full-length novel, the days were gloomy and lonely and the nights sleepless. He was on the brink of convincing himself that serious changes would have to take place in his life if he were to get on with his work. To survive as a writer, and as a man with normal human needs, he would have to leave England altogether. To continue his work, he now believed, he would have to find a companion on the Continent to feed his hunger. He revealed very little of this mounting frustration to the Gissing family. He said nothing to any of them about the parched emotional desert he was trying to cross, not even his brother Algernon. That tended to make the

condition worse. Gissing found some relief in a steady stream of letters to Bertz, himself a struggling writer in Germany. He was also corresponding with others. According to the diary, he wrote three letters at a single sitting in June. To Bertz he confided: *"It won't do. I shall never be able to make myself at home again in England. The days are infinitely wearisome to me, and I work only in the hope of getting away very soon."*

At the end of June he was telling himself that he would surely be able to finish his book by the end of August. But one abortive attempt after another burned like a red-hot poker, drained his creative power, and left him exhausted. With each sheet of paper covered with scratchy and tiny words, then crushed and tossed into the waste basket, the job became more impossible. When the month of August in 1890 settled upon Wakefield, he was angry and utterly depressed. Confused, weak, and sexually frustrated, he was experiencing an emotional slump that bordered on despair. It was affecting his health as well as his career.

In that unsteady condition he met a local girl named Connie Ash and promptly fell in love with her. He spent an evening with the Ash family, and the girl charmed him with her magic: *"Connie sang a good deal, and beautifully."* In August, he went to their house a second time, and again seems to have enjoyed himself greatly. But then abruptly, for reasons unexplained, he returned to London. He never mentioned the girl's name again, either in his diary or his correspondence.

As he had done with Edith Sichel, he was running from possible involvement with any respectable woman who seemed likely to be thinking of marriage.

The image of Connie Ash was at work in Gissing's imagination as he was writing *New Grub Street*. He began the book soon after their meeting, and the girl entered obliquely into his novel. It is said of Biffen, a struggling novelist specializing in the new realism -- in some respects Gissing's alter-ego -- that at one time he had been much in love with a gentle, intelligent, good-looking, middle-class girl. However, because of his poverty, establishing and sustaining a relationship with the girl was impossible. So in headlong flight he ran away. Biffen would like nothing better than to be married to a loving woman, but because of his poverty he believes even the dream of marriage is a waste of time. Sentimental and sensitive, *"a woman's love was to him the unattainable ideal."* That estimation applied with equal accuracy to Gissing himself. Whelpdale, another writer in *New Grub Street*, has been engaged four times, but each time the girl has jilted him because he was honest enough to tell her he lived in poverty and bad no money.

The day after his visit to the Ash residence, Gissing complained in a letter to Bertz that middle-class girls were not willing to risk living in poverty with anybody. He added that he had been ill in body and mind and could no longer endure his self-imposed solitude. *"In London,"* he confided in the same letter,

"I must resume my old search for some decent work-girl who will come and live with me. I am too poor to marry an equal, and cannot live here alone." That anguished remark, intensely personal and surely alarming to Bertz who knew about Nell, suggests that as early as 1885 Gissing had roamed the streets of London in feverish search of a female body to share his bed. He was not looking for temporary gratification, as Bertz was thinking. He wanted a partner, a *"decent work-girl"* who could possibly be trained to his way of life. He had raised his sights after the debacle with Nell, and he hoped to target a gentle and respectable girl of the working class who would be willing to live with him out of wedlock.

At that time, before Nell's death in 1888, he would have explained that he needed her in his life, but was unable to marry her because he had a wife who had deserted him. So if the girl would agree to live with him, they could establish a domestic arrangement but go their separate ways if conflict developed. Gissing convinced himself that a girl of the working-class with an economic difficulty and no close family ties, might consider such a proposal. The morality of the lower classes, he knew from experience, was often in tandem with survival and not so stuffy as that of the middle class. A girl might want to escape a dull or brutal life of dire poverty for a better life with him.

However, in the autumn of 1890 when he resumed in earnest the search for a partner, like Biffen scarcely

able *"to walk the streets where the faces of beautiful women would encounter him,"* his wife was no longer alive. He couldn't claim with looks of desperation that he was already married but separated. The safety net of an earlier time was no longer available in 1890, had indeed been removed. In his reply, Bertz kindly agreed that solitude and sexual deprivation could undermine any man's health, but he urged his friend to think twice before choosing a girl he might possibly have to marry.

Gissing insisted that his scanty income, would effectively prevent any attempt to marry well. *"Educated English girls will not face poverty in marriage,"* he commented, *"and to them anything under £400 a year is serious poverty."* In 1890, after writing and publishing eight full-length novels, Gissing earned only £150. By 1892 his yearly income had risen to £274. But as late as 1903, the year of his death, he complained to Bertz: *"I earn so little, so little! Last year my income was not quite £300, all told."* Gissing had good reason to complain. His close friend, Morley Roberts, a gadfly journalist writing on any subject that would sell, had a larger income. Other men he viewed as novices were earning more. H. G. Wells, a good friend, earned far more even in his first year as an author. Wells theorized that some fault in Gissing prevented a decent income.

Gissing knew too well the danger of becoming involved a second time with a woman of the working class, but felt there was no hope at all of marrying any woman of a higher class, *"no real hope whatever!"* He

persuaded himself that his low income required him to search for a poor but healthy working girl who could adjust to genteel poverty without complaint. In "A Lodger in Maze Pond" (1894), Henry Shergold speaks for Gissing when he declares: *"Perhaps it is my long years of squalid existence. Perhaps I have come to regard myself as doomed to life on a lower level. I find it a truly impossible thing to imagine myself offering marriage – making love – to a girl such as those I meet in the big houses."* In 1894 Gissing was living in misery with Edith Underwood but had met Mrs. David Gaussen, an upper-class woman who became his friend.

In 1890 he was the author of many short stories and eight novels. He had acquired a literary reputation among intelligent readers but very little money. Returning from Italy in February of that year, he traveled in economy class, but was known among the ship's affluent first-class passengers as a celebrated author. The parson of the ship in conversation with him revealed that news to him. Departing, the parson said he would take the time to seek out and read some of the celebrated author's books. Gissing knew the parson was lying, merely trying to be pleasant. In that bitter-sweet revelation, he read the writing on the wall. It was his fate to have his name on the lips of first-class passengers even as he traveled below decks among third-class passengers. There in the least desirable part of the ship the noisy engines made talking to one another difficult, ventilation was poor, and it was often

too hot or too cold for comfort. Steerage was also rife with foul odors.

Economic distress would require Gissing to take a second wife from the working class. That would mean withdrawing entirely from all the influential friends he had made among the affluent. The lesson of his brother Algernon, woefully poor and struggling each day also to live by writing, Gissing failed to learn. He must have seen that Algernon was happily married to a supportive woman of the middle class in spite of having little money and no discernible future. But Algernon had not suffered the grave indignity of being branded a thief at a time when he hoped to distinguish himself in the academic world. Years later the searing pain of that experience made his brother George feel unworthy among his peers. He lived in exile in a world bereft of joy, and he found his salvation in work. He was happy only near the end of his life.

In London, after spending the dreary summer at Wakefield, the early fall weather of 1890 was comfortably warm but crisp. Skies were blue, the air was keen and fresh, and the parks were at their manicured best. People were outside to enjoy the weather, but it was not a pleasant time for Gissing. He haunted the streets and squares of the big city alone and miserable. For seventeen days, except for his cleaning woman who came once a week, he spoke not a word to anybody. Morley Roberts, his comrade and confidant of many years, had gone to the seaside. In all of London there

was no one else he cared to visit. Edith Sichel had sent him two politely feminine invitations which he rejected. He was running from women of her stature and class. He had decided also to avoid women of his own class. Roaming city streets, he was looking for an attractive, uninhibited, uneducated but intelligent young woman of the working class. She would assuage his loneliness and satisfy his needs. In time he would find her.

Gissing became acquainted with Edith Underwood on Wednesday September 24, 1890. She was young, no older than eighteen, and she was perhaps already unstable. She would become his second wife, the mother of his two sons, and the source of more unrest than was ever perpetrated by Nell. Her presence would invade his fiction before they married, and become a dominant force in his later novels. Exactly where they met one can't be certain. It could have been in a restaurant, in one of the shops in Oxford Street, in Marylebone Road, or in Regent's Park. Gissing didn't record where or the circumstances of their meeting, and the account by Morley Roberts though believable may not be entirely accurate. We know when they met if not where; the precise location in the streets of London is unimportant.

In *The Private Life of Henry Maitland* (1912), the roman à clef based on his long association with Gissing, Roberts wrote: *"One Sunday when I visited him he told me, with a strange mixture of abruptness and hesitation, that he had made the acquaintance of a girl in Marylebone*

Road." Roberts thought that Gissing had reverted to the behavior of his college days, and acting on impulse had picked up a prostitute in some neighborhood street. Later he learned as they talked that the young woman was from a respectable working-class family of good reputation. In the summer of 1890, Roberts had urged Gissing to abandon England altogether and take up residence on the Continent. There he might find a suitable wife with less difficulty than in England. Gissing half believed him and asked his German friend Eduard Bertz about it. Roberts had been advising Gissing since their college days.

"I could stand it no longer," Gissing reportedly blurted, *"so I rushed out and spoke to the first woman I came across."* Although the comment sounds fabricated or exaggerated, it reflects the emotional tumult that Gissing was suffering in the autumn of 1890. Aiming at the truth with a cavalier flourish, Roberts sometimes missed it. Yet often in this strange though engaging quasi-biography, Roberts hits the mark when we least expect it. In its pages he makes no claim to maintain the integrity of true biography. Yet when reporting intricate details of his friend's life he can be surprisingly accurate. He based his book mainly on the letters his long-time friend had sent him.

As for Edith Underwood, it is likely Gissing felt no love whatever for her. He was seeking sexual gratification only and companionship. She was aware of what he wanted and must have thought he was a better

catch than the working men she knew. She liked his good looks, gentle manner, and the way he talked. He was clearly from another class but seemed quite willing to live among people of her class and adjust. Near the end of October, he informed Bertz that he had met *"a work-girl"* who would perhaps come live with him in the country when his lease expired at Christmas time.

Then he added: *"I must consider nothing but mere physical needs."* He had made a similar confession to Roberts, and both men dreaded the step Gissing was about to take. Both knew that when it came to women Gissing lost the reasonable control that characterized him most of the time. They knew that he had made a fool of himself with Nell and had paid dearly for it. He was now about to embark on a similar dangerous course. It was a case of body suppressing mind, of blood undermining spirit. To put it simply, his masculinity was demanding femininity, and neither he nor his friends could oppose it.

Edith Underwood's father, a shrewd working man, sensed that Gissing's intentions were somewhat less than honorable. For several weeks he refused to meet the man from another class who wanted his daughter. He had heard the stories of higher-class "gentlemen" preying upon working girls, and he was suspicious. Once he bluntly announced that Gissing was not welcome in his home. And yet he seems to have given his daughter freedom of choice. It appears he didn't object, at least strenuously, to her visiting young

Gissing at 7-K Cornwall Residences in Marylebone Road. Shortly after they met, she began to go to his rooms alone to spend her free time with him till late in the evening.

Even though she didn't hesitate to spend intimate evenings alone with the young author, she was not so easy of virtue as he had hoped. He made advances, no doubt, but she resisted. *"Our relations are as yet platonic,"* he admitted to Bertz in January of 1891, *"and if anything is to come of our connection it will have to be marriage."* The girl was listening to her father, who had told her to hold out for matrimony. She was not willing to live out of wedlock, even with a handsome young man of taste, education, and promise. She expected to marry the man to avoid stigma and be protected by the new marriage laws. The woman was flawed, but she was not stupid.

Roberts claimed that Edith Underwood wasn't very attractive of face and figure and had only her gender to recommend her. Yet at the time she and Gissing met, her sexuality was all that mattered. He had gone in search of female response and had found it. When he was able to relax a bit, he began to see the spiritual side of the young woman, a dimension beyond the physical that he could perhaps develop. They took long walks together, talked and laughed, and shared simple meals. On occasion they enjoyed a bottle of wine as a special treat. He read to her some narrative poems he felt she would like, and she seemed to respond thoughtfully

and with sensitivity. He had no way of knowing what lay beneath the surface, nor did she.

He liked her docility and gentleness, and thought he might be able in time to mold her to his way of thinking. She had what it pleased him to call *"a certain natural refinement,"* and she seemed flexible in her attitudes and quite adaptive. He wanted her to read his books and study other books he would recommend. That way she would know the world, its issues and complexity. They were married on Wednesday, February 25, 1891. It was the same day his letter on the pronunciation of Greek appeared in *The Times*. From the brief ceremony, they drove in a fog to Paddington and caught a train to their new residence in Exeter. It was the first time Edith had lived outside London. The winter weather was cold, windy, murky with little promise of warmth. It was emblematic of their future together.

Chapter Eleven

Edith and Domestic Life

The marriage to Edith Underwood was strictly utilitarian. For a time, in those halcyon days of youth and hope, he had loved his first wife with desperate intensity. However, the feeling he harbored for Edith was at best only physical. He believed they might be able in time to base their relationship on something more than sexual release, or sexual need, but for the present that alone was paramount. Edith proved a good partner. The emotional and physical relief he gained in the next few weeks was so invigorating that he soon developed a genuine affection for his bride. Always the idealist, he began to think he might be able to educate his new wife so that she could live comfortably in the middle class. He had taught high school in America and pupils in London, and had proved himself a competent teacher. He knew that other men of letters had schooled their wives, including some of the major poets, and he felt he could do the same with Edith.

The early days of their life together were

exhilarating. In *"vastly better health and spirits,"* Gissing felt himself becoming cheerful, even optimistic. Yet within a month he was sounding a note of complaint, an echo of the first marriage: *"Intellectual converse is of course wholly out of the question."* Later when Edith was big with child and undesirable as he viewed her, he described her in terms he would have used for a servant. *"Edith does very well,"* he wrote, *"improves much in every way. I am more than satisfied with her. The house is orderly, everything punctual. She has many very good qualities."* A letter to Algernon of November 6, 1891, echoed the same sentiment in these words: *"Edith, as you must know, is uneducated, but I am more than satisfied with her domestic management. She has many very good qualities, and most distincly improves."*

During her pregnancy they tried to maintain a cordial relationship that grew cooler each passing day. After the birth of Walter Leonard on December 10, 1891, Edith began to show the first signs of bad temper. By then, in addition to physical pain, she felt herself put upon and was beginning to rebel. Before that time she had done all she could to please her husband, had cooked for him and washed his clothes, had gone on long rambles with him in the countryside when pregnant, had stood by him in his aloofness when he didn't like their neighbors. She had made an effort even to read and appreciate his latest book, *New Grub Street*.

To Ellen, he wrote with humor he thought she would appreciate: *"Edith declares* New Grub Street *the*

most pleasing book she ever read." It is likely that Edith had never attempted to read entire books at all. But she was eager to supply emotional support when persuaded as well as physical comfort. Though pregnant, she went on long walks with him -- laughing, talking, hooting -- in search of wild flowers. At Clevedon she heard tales of the Coleridge circle, not enirely understanding any of them, and remained quietly in the background as her husband finished composing his current book. She felt that was the least she could do, for surely she wanted the marriage to work.

After she gave birth to their first son she began to suffer from neuralgia. The intense pain occurring along a nerve put a damper on her attempts to fit her personality to that of her husband. The physical pain was augmented by emotional torment as she found herself the butt of Gissing's behavior. His demeanor of gentlemanly breeding, snobbery in her opinion, began to wear thin. His aristocratic demeanor opposing her democratic temper rubbed her the wrong way. It caused friction, which Gissing despised. Often without notice she exibited a display of violent temper that reminded her husband of Nell.

Gissing's air of superiority, suggesting a conflict of class as well as personality, had infuriated his first wife. It was now beginning to irritate his second. He behaved as he thought other authors behaved, drawing attention to their achievements in the literary arena. Also he may have mentioned, with no intention to hurt

or sound mean, their lack of formal education. In all likelihood he thought he could help them rise to his level, and naively believed they would want to make the attempt. The results with both women were destructive. Both women interpreted his behavior as insufferable, insulting, and intolerable. In time they reacted with galling anger and heaped upon him a torrent of verbal abuse.

Living with Gissing drove his first wife into drunken stupors and eventually to the streets. It was enough to change Edith, *"a gentle and pliable girl,"* into an unrelenting shrew. Though earlier she had chosen her words carefully, showing as much refinement as she could muster just to please him, before the end of their second year together she was bombarding her fastidious husband with gutter language. Unlike his pietistic and reticent sisters, Edith didn't hesitate in her anger to hurl four-letter words, saturated with bitter contempt, at her bewildered husband. She took comfort in their effect.

Gissing surely must have wondered where she had picked up the vulgar and abrasive idiom she flung at him. Had she not been sheltered by a gruff but solicitous father who insisted on moral rectitude? On the other hand, she could have grown up in the midst of domestic violence punctuated by strong language. Perhaps she was reprising what she had heard in her formative years; Gissing had no way of knowing. Not only was her language foul, harsh, and abusive as she vented her

anger, but sometimes for emphasis she lobbed crockery at her hapless husband.

The year 1892 though comfortable financially was a monument of *"domestic misery and discomfort."* The torment had arisen despite the fact that he was renting a pleasant house (rather than rooms) for the first time in his life. In letters to his friends and family he described their dwelling as a house with a good view and every convenience, but clearly the house had not become a home. His diary carefully describes the mounting conflict within, the constant bickering, and the daily increase in his wife's ferocity. It reveals that he was incapable of understanding the cause of her behavior and unwilling to accept blame. He came to believe her constitution was weak like some of his fictional characters, for example Harriet Smales. She was therefore inherently unstable. He believed a negative heredity had left its indelible mark upon Edith.

Convinced he was losing all power to control her, he sought the help of Eliza Orme, a friend of his publishers, and Clara Collet. The latter had been his friend for two years and was earning a reputation as a social scientist. To Ellen he wrote at the end of 1895: *"We see but one visitor – Miss Collet; who knows the extraordinary circumstances of the establishment, and puts up with everything."* The interference of these two well-meaning women appears to have caused more harm than good, for Edith resented them. She was now the mother of two healthy sons -- Alfred Charles was

born in 1896 -- but even motherhood couldn't mitigate her wrath. So *"vixen-haunted,"* Gissing was forced to abandon his family to live elsewhere. At the beginning of 1897, he tersely and sadly observed: *"I have simply been driven from home – chased away with furious insult."*

Because he didn't like living alone and missed the children, the separation didn't last. His health beginning to break and under the care of Dr. Philip Pye-Smith, Gissing went back to Edith near the middle of June 1897. In compliance with the doctor's orders, the family moved at the end of July to Yorkshire. The climate there was thought to be more agreeable, but the new location brought no improvement. Their life together was like a runaway train. After describing what appeared to be a pleasant outing on a fine day near the end of August, Gissing added: *"Of course everything spoilt by E's frenzy of ill temper. I merely note the fact, lest anyone reading this should be misled, and imagine a day of real enjoyment."* Gissing was conscious of posterity. He knew that in time his biography would be written. He wanted any future biographer to avoid the abundance of misinterpretation he had seen in other biographies.

Approaching forty with an impressive number of good books to his credit (though poorly reviewed and not widely read), his position as a novelist was at best precarious. With a family to support and little or no financial security, he had only the prospect of endless labor ahead of him. That could have caused a bit of bad temper on his part. One would like to hear the

story from Edith's point of view. Did she really spoil the outing mentioned in his diary? If so, for what reason? What could have caused the *"frenzy of ill temper"* in the midst of their deliberate attempt to enjoy themselves? As a seasoned novelist, Gissing knew all about point of view, and yet he records for posterity just his own.

Less than a month later he fled once more from Edith and made plans to leave for Italy. His older son Walter was living at Wakefield, but Alfred remained with Edith in London. Gissing would worry about the future of his little son, but would never again live with Edith. The breakup that came in September 1897 was final. He confided to Bertz that he would leave England on September 22 with no plans for a prompt return. For the next several months, until April of 1898, he lived in Italy and worked at his writing there. After he departed that country to return home, he spent four days in Potsdam and Berlin with his German friend Bertz. He arrived back in England on April 18, 1898. The cold of winter was passing away, the trees were in tiny leaf, and spring was turning the countryside green.

While in Rome Gissing wrote to Wells to describe not the beauty of that eternal city, but the ugliness of Edith's behavior at home: *"Things are going on very badly. My wife has carried uproar into the house of the friend [Miss Orme] who was kind enough to take her; insult and fury are her return for infinite kindness and good-will. But for the poor little child who is with her, she might go where she liked and rage to her heart's content.*

As it is, I fear I may be obliged to return to England much sooner than I mean to." The tone is of sadness and alarm. Gissing had gone to Italy to immerse himself in the ambiance, warmth, color, and beauty of the sunny country, but mainly to forget his troubles.

He wanted to remain there until some pleasant event might bring him home with a sense of triumph, but that was too much to ask. Also in the letter of January 6, 1898, he says he will accept full responsibility for the welfare of his wife and children. He didn't try for a divorce because he thought the proceedings would place Edith in charge of the two children and deny him all rights as their father, even the right to visit. Eliza Orme cared for Edith and Alfred for a sum of £50 a quarter, but eventually because of Edith's irrational and unpredictable behavior, she had to place them elsewhere.

He went on to say in the letter to Wells that Eliza Orme knew a working-class woman who would be willing to rent part of her house to Edith. Perhaps in that environment, away from educated people and once more among people of her own class, she would calm down and find contentment. But someone would have to keep a close eye on the woman for the sake of the child. He was now convinced that in one of her tantrums, losing all control, Edith was fully capable of abusing the toddler. By then he was comparing her erratic behavior to that of a lunatic and believed she was perhaps already mad.

She was unstable to be sure, and was probably unstable at the time he married her. But at twenty-six Edith was too proud and too strong to be looked after as an incompetent by such women as Orme and Collet. They were as helpful and as kind as they could manage, but they were not her friends. They belonged to another class and reminded her of the man who in her mind had reduced her life to a shambles. Too late Gissing seems to have recognized that a chief cause of her fury was alienation from her relatives and former friends and even her own social class. He had required her to live in a class not her own, and she was not able to handle that. Even though she was young and lively, outgoing and gregarious, her husband insisted on withdrawal, isolation, exile from her class and his. It was more than she could take.

After returning from Italy Gissing went into hiding in Dorking. In Potsdam he had poured out to Bertz the whole sordid story, and once more he confided: *"Of course I must hide myself, in constant fear of attack by that savage."* He had heard from his family that she was determined to find him, and he feared that any moment she would pound on his door, screaming abuse. *"Nothing settled yet about my wife and the little child,"* he wrote again on Friday the first of July. *"She does not know where I am, but is trying hard to discover, and threatens to give all possible trouble."* That threat of confrontation worried pacific Gissing day and night. He lost sleep over it.

His lawyer was attempting to make the separation legal, but couldn't persuade Edith to sign the necessary papers. Although she was now living among her own kind, she was asked to move away because of frequent and violent outbursts. Her behavior upset other residents in the house, and they complained. Gissing had thought she would calm down in sympathetic surroundings, but by the time he was to act upon the idea his wife's ferocity was out of control. Early in 1898, her fits of temper, set off by the smallest of incidents, had become so frequent they suggested serious derangement.

When on several occasions she received official notice to move elsewhere, she went beyond screaming abuse to physical violence. On August 10, 1898, in a tone of high agitation, Gissing informed Dr. Harry Hick that Edith, just prior to moving, had assaulted her landlady. The police had been called to the house, and were about to arrest her when she seemed unable to calm down. But seeing them, she fell silent and sulky. Convinced that his wife was mad, he feared for the safety of the child she insisted on keeping. On September 4, in a letter to Bertz, he expressed anxiety for the child and called the marriage criminal. Bertz saw Gissing as a mentor and never argued with him. Now he could only listen. Once more and too late, in spite of those who had advised him to proceed with caution, his English friend realized he had made a second mistake in matrimony as calamitous as the first. Though he wanted to serve

Gissisng as a good friend, there was not a thing Bertz could do.

Those letters to Bertz and the letters placed in a literary setting by Morley Roberts and later published, share almost identical words and phrases. The similarity shows that Roberts was not so careless with his sources as some have supposed. From *Henry Maitland* comes this: *"All work impossible owing to reports of mad behaviour in London. That woman was all but given in charge the other day for assaulting her landlady. My solicitor is endeavouring to get the child out of her hands. I fear its life is endangered, but of course the difficulty of coming to any sort of arrangement with such a person is very great."* The style and tone are clearly Gissing's, and the words appear to be a verbatim quote. Roberts carefully saved the letters from Gissing and had them before him as he wrote. A grub-street author writing biography in the guise of fiction would have dismayed George Gissing. A friend in whom he frequently confided, Roberts seized any opportunity to advance his career.

On September 7, 1898, Edith discovered Gissing's hiding place. With little Alfred in tow, in balmy weather on a Wednesday afternoon, she assaulted the safe haven he thought he had found. Her mission was a confrontation that would force her husband to take her back. With dark eyes blazing she demanded he live up to his responsibilities as a husband and father as the law required, but he refused to quarrel with her. To his

surprise, though severely agitated and on the brink of losing all self control, she withdrew without causing a scene. Later he recalled that in his own agitation he had not even noticed his little son, had not spoken a single word to him. He never saw Alfred again. That meeting in September was the final tumultuous encounter with Edith.

At the beginning of 1898, Gissing had complained to Ellen that he was having *"terrible trouble"* with the angry woman and was baffled by her behavior. *"E's latest statement is she will go before a magistrate, and declare I have 'deserted my family'! I am really afraid she will end in the lunatic asylum."* Four years later, in February of 1902, the prediction became reality. To Bertz he disclosed that Edith had been arrested for ill-treatment of Alfred. Upon examination by the proper authorities, she had been judged insane and committed to an asylum. With a sense of relief, he added: *"Well, this has surprised nobody."* From the time of her commitment in 1902 until the day of her death fifteen years later, Edith remained in confinement. She received no visitors, certainly not from Gissing's family. According to her death certificate, she died on February 27, 1917 in Fisherton House of *"organic brain disease."* It was a catch-all phrase for mental patients. Edith may have died of severe nerve pain caused by advanced, incurable neuralgia. Her age was shown as 45. She was described as *"Wife of — Gissing, occupation unknown."*

The death certificate indicates she was fifteen years younger than Gissing.

It has been suggested that if Edith suffered from brain disease during their marriage, it alone could have been the cause of their bitter domestic conflict. A better explanation is the theory of Dr. Harry Hick. He believed Gissing's refusal to introduce Edith to his friends brought on most of the misery. Gissing's first wife, Nell, deeply resented the same treatment. His third, Gabrielle, of his own class and presentable by any definition, also complained that he was trying to keep her too much in seclusion. All he needed for relative contentment was the challenge of finishing his current book and a female companion to feed him. But the women who shared his bed and board, his emotional life -- Nell, Edith, Gabrielle -- were sociable creatures and needed more.

Edith in particular wanted interaction with neighbors and hoped to acquire friends in her daily life, but she was very sensitive about her working-class background. Her dislike of upper-class people flamed into hatred when she thought they saw her as scarcely better than a servant. Her husband's aristocratic temperament also added fuel to the flames. Married to a man of her own class she might have been obstreperous and difficult some of the time though obliging and tolerant. Sharing her home with a solitary intellectual, who treated her like a housekeeper and never placed her on an equal footing with his relatives or friends,

was more than she could bear. Yet to be fair to Gissing, it is certainly possible that Edith's behavior got its start in childhood.

Even so, with limited experience in a complex world, she viewed learning, culture, and refinement with leisure and wealth. She believed that playing the gentleman without wealth to support the role was a sham. Because her husband had struggled for years against poverty and was anything but wealthy, she reasoned that he was a base pretender. Because he had not completed the college courses he surely must have told her about, all his knowledge seemed invalid. To her mind his talent as a writer, his cultivation and learning, his literary status that brought prestige but little recompense were all an act, a simulation that made him a hypocrite. Brought up to be honest, she hated hypocrites.

Certainly if a man's economic position were no better than that of his neighbors, he had no right to snub them, as Gissing invariably did. *"The people in the house do not suit us,"* he confided in a letter during happier times, *"and we merely keep on civil terms with them."* Also if one had friends in high places one should have the courtesy to introduce his wife to them, as Gissing never did. That attitude convinced Edith that her husband, like Alfred Yule in *New Grub Street*, was ashamed of his wife. The fictional wife (an imaginative ideal) suffered in silence. The real wife, in torment and anger, screamed her suffering to the world.

Inevitably, because Gissing always found literary material from the life around him, Edith had a tremendous influence upon his work. Their tumultuous marriage soon became a misery for both of them, but as a writer of realistic social novels he placed that misery, along with happier times, in his work. In October 1890, just a week after meeting Edith, he made a new start on the novel that was soon to become *New Grub Street*. He worked smoothly and rapidly, completing the novel in record time the first week of December, 1890. In a small gnarled hand, he wrote approximately four thousand words a day in black ink. Chapter after chapter went into manuscript with little hindrance and without needing the extensive revision of past novels. It quickly became known as the best of his novels.

Chapter Twelve

Edith's Enormous Influence

Edith Underwood may not have released George Gissing entirely from the sexual frustration that left his earlier work in shambles, but she did assuage his loneliness. Until they married she was little more than a companion who offered solace. Yet that was enough to open the gates of his creative power. She gave him the peace of mind he needed to seize and bring out his best talent. She extended the kind of womanly support he needed to replace his depression with emotional strength. They were not intimate in courtship, as he reported to Bertz, but the promise of gratification made him feel alive and masculine and confident. She gave without stinting the sympathy and promise of better times he needed to do his best work. As a woman showing an interest in him, she provided assurance that he was warm and human. She let him know without a doubt that he was not a bloodless, mechanical, writing machine.

After working all day in the solitude he never learned to like, he could look forward to the company of a young woman who would listen when he talked. We know she had some trouble appreciating his wit, detecting and understanding the sardonic quality that characterized his speech, but she often laughed at his jokes. As he planned and wrote the chapters of his most famous novel, Edith's influence was immense and pervasive. Yet one should not forget the long and tedious months of preparation, the painful effort, and the numerous false starts. All that snapped into place, came nicely together, and brought rapid completion of all three volumes. The materials he had thrown away returned in bright moments to be reshaped by a rekindled imagination.

For years after Nell's death Gissing pondered the type of woman a writer with an uncertain income should marry. The subject, clouded by emotion, nagged him before he met Edith Underwood. Now it pushed its way into *New Grub Street* in the guise of rigorous self-examination. His ideas on the subject were presented as the novel progressed almost as a formal debate, as an argument with himself. At issue is whether a man of letters with some reputation but a precarious future should marry a woman of social distinction or a working-class woman with a domestic bent. To reach a valid conclusion, he had to examine the question in scrupulous and minute detail.

With many examples to strengthen his resolve,

he decided that while a lower-class woman would most likely become an *"unpresentable wife"* to restrict any social advancement, she was nonetheless the only type he could choose. If she proved able to accept her lot with patience and understanding, she would make a better wife by far than any girl of a higher class who would never endure poverty. The working-class girl would have few friends to help her husband advance his career, and possibly no desirable friends at all, but the right person would be able to face poverty (and perhaps isolation) without complaining.

An unsuitable person from an undesirable background, a person impulsively chosen, could become a shrew to make his life miserable. She could interfere with his work, embarrass him at home and in public, and largely diminish his earning power. On the other hand, a quiet love of domesticity and a gentle nature imparted by a healthy heredity could abort all that. One could not expect the woman to provide intellectual stimulus, but that wouldn't hinder a busy author, not even one enduring isolation. Tender support, good housekeeping, a bit of laughter now and then, and a dutiful satisfaction of physical need would suffice.

Marriage to a woman of rank and privilege and the comforts of a luxurious life would be disastrous without a handsome income. Even if he were lucky enough to win the love of such a girl, the poor man of letters would soon lose her affection and see her turn into a negative force to destroy the marriage.

In this connection Jasper Milvain in *New Grub Street* thoughtfully speaks of the novelist, Edwin Reardon: *"A man in his position, if he marry at all, must take either a work-girl or an heiress, and in many ways the work-girl is preferable."* And why we might ask. Because Gissing believed no man with an ounce of self-worth would be willing to live on the money inherited by a wealthy wife. To do so would mean not only losing face with anyone inclined to question his integrity, but losing every shred of self respect.

Edwin Reardon, Gissing's bumbling alter-ego, was on dangerous ground even to dream of marrying a woman of his own class or higher. If the dream were realized by some fluke of chance or destiny, misery could follow. In June of 1889, writing Volume One of *The Emancipated*, Gissing explored that possibility and convinced himself that women of the middle class could never function as wives of poor, struggling artists with small and unpredictable incomes. At that time he penned a passage that prefigures in surprising detail the marriage debate of *New Grub Street.* As he was writing the 1891 book, the passage penned in 1889 could have been in his mind as residual matter or even as reference material. Practical-minded Madeline Denyer breaks her engagement to Clifford Marsh, a talented painter, because at the end of each week he cannot show that he has earned money from a steady job.

A talented painter eager to experiment with the new principles of impressionism, he falls in love

with Madeline. She returns his love but flatly states that marriage is out of the question. In no time at all her husband would find himself forced into *"some kind of paltry work"* just to support her, and what would happen to the marriage then? What would happen to the dream of doing good work as an artist and achieving a reputation? *"You know perfectly well that lots of men have been degraded in this way. They take a wife to be their Muse, and she becomes the millstone about their neck."* That comment came more from Gissing than from his character Madeline. It was written a year before any thought of *New Grub Street*, and it described exactly what happens to Edwin Reardon in the novel of 1891.

The man marries a pert and stylish middle-class girl who seems to return his love, but in dismay he watches his ideal marriage disintegrate when he can't support her in the style she requires. His failure as a husband and as a novelist is directly related to his choosing the wrong woman. She causes him to work harder but does not inspire him. Like Browning's Andrea del Sarto, he works mainly to earn money which he turns over to her for spending on herself. Although he drives himself to finish quickly one piece of work after another, his artistic impulse (out of step with the times) will not allow him to work fast enough to earn the income Amy requires.

Then as if to confirm his worst fears, Reardon enters upon a period of spiritual dryness, creative paralysis, and cannot write at all: *"In these last few*

months, I must have begun a dozen different books. I write altogether twenty pages, perhaps, and then my courage fails." His materialistic wife advises him to view his art as a trade and write for the market, but to prostitute his talent in that way is for Reardon quite unthinkable. He would rather die of starvation than drag his precious work through the commercial mire. In those attitudes he is similar to Gissing himself, whose well-meaning friends insisted that if he wanted a decent income, he would have to study the market and write for it.

As Gissing resisted the materialistic and money-making approach, so does Reardon. With each passing day the promise of his becoming a successful author fades away. Alarmed that her husband will never taste success, Amy begins to nag and complain: *"I can't bear poverty; I have found that I cannot bear it. And I dread to think of your becoming an ordinary man."* Her brother, crass and cheeky Jasper Milvain, has heard of middle-class wives who sometimes work outside the home and hints that Amy could do the same. But the saucy young woman is horrified at the thought of working for money even as an author or editor. Reared in a traditional setting and expecting a life of leisure, she believes it is the husband's duty to earn a good income for the support of his family.

In addition, as the husband struggles to gain wealth and prestige, he should be ever mindful of keeping up appearances. When she learns that Edwin has taken a part-time job as a clerk to bring home a

steady income, Amy's pride of class triggers a heated quarrel. Her measured and musical vocal tones slip into a raucous and rasping scream. She will not be humiliated by such boorish behavior. She will not be known as the wife of a petty clerk who is paid at the end of each week. She will not be dragged downward into a lower rank of life: *"I am ashamed through and through that you should sink to this."* That is the beginning of the end. Her well-meaning husband, dumfounded and beside himself with anguish, reluctantly reaches the conclusion that he has failed her.

As a social butterfly, Amy Reardon (née Milvain) flitted across the flower gardens of her world and touched only the surface of life. She lacked the depth and the flexibility to cope with hard times. Her creator, viewing her as representative of middle-class women, found no way to blame her. He believed, moreover, that an heiress with plenty of money would have reacted similarly. Losing the prestige of association with the literary world when her husband fails at what he strives to accomplish, she would have found her lot unbearable. But under no circumstances would Edwin Reardon have married an heiress. Old-fashioned scruples illustrating integrity, dignity, self-respect, snd self-worth would have governed his behavior. He would have chosen to die rather than live dishonorably on a woman's inherited wealth.

Neither Reardon nor Gissing could have lived as parasites on a wealthy woman's inheritance. Only a

blatant opportunist such as Jasper Milvain was capable of that. So a struggling writer with principles would never be able to accept either an heiress or a middle-class woman as a wife. The only choice, therefore, was a good-natured, pleasant girl from a lower class. Enduring poverty with an ignorant though uncomplaining wife was better than living as a parasite upon an heiress, or in tumult with an educated but unhappy woman of one's own class.

Alfred Yule, another of the many grub-street authors in the novel, married exactly the kind of woman Gissing hoped he was getting in Edith: *"His marriage proved far from unsuccessful; he might have found himself united to a vulgar shrew, whereas the girl had the great virtues of humility and kindliness."* Though Yule is discontented with his lower-class wife and can see only her faults, Gissing views her through her suffering, and his own wishful thinking, and admires her. He sees a patient, humble, loyal, quiet, and calm wife with a noble heart. He justifies Yule's marriage to the young woman in the same way that he rationalized his own forthcoming marriage. The writer met her in a chandler's shop, saw her take pity on his longing and loneliness, and persuaded her to share his garret. The time had come when he could not live without a partner, and fate allowed him to find the right one.

Alfred Yule didn't love the girl, but like his creator Gissing, he felt he could live no longer without sexual gratification. He told himself that other men in his

condition, literary men with brains but lacking money, had taken the same step. Yule avowed it was not a pleasant situation and was potentially dangerous, but it was necessary to maintain health and earning power. Also, because of his precarious financial situation, it was the only door open to him. *"Educated girls," he complained, echoing* Gissing, *"have a pronounced distaste for London garrets; not one in fifty thousand would share poverty with the brightest genius ever born."*

That complaint coming from Alfred Yule, a fictional character with whom Gissing quite clearly identified, differs little from a confidence expressed earlier by the novelist himself in a letter to Bertz: In a tone close to resignation, Gissing declared: *"Marriage, in the best sense, is impossible, owing to my insufficient income; educated English girls will not face poverty in marriage. They remain unmarried in hundreds of thousands, rather than accept poor men."* Even the dogmatic conviction is identical to that of the fictional character. English women of education and good family will not marry men of uncertain estate regardless of promise and talent. The rare one who does lives to regret it. With that argument, Gissing convinced himself that his decision to marry Edith Underwood was the right decision.

In the portrayal of Alfred Yule, he hinted that lower-class women who marry grub-street writers, particularly women of conscience and sensitivity, also run the risk of living in turmoil and misery. Yule's wife

is a good example, and so is Mrs. Gorbutt, a former nursemaid: *"Mrs. Gorbutt rued the day on which she had wedded a man of letters, when by waiting so short a time she would have been able to aim at a prosperous trades-man."* In rebuttal Gissing declares that many writers in similar circumstances live with unpresentable wives in peace and relative comfort. He sketches several examples worth looking at.

Mr. Hinks is married to the daughter of a washer-woman. After thirty years of living with a man of letters, she continues to speak *"the laundress tongue."* Yet the wide difference in class and education has not prevented them from achieving peace and harmony in their marriage. Mr. Christopherson, married to the daughter of a butcher, wrangles with his wife in public but shows an obvious affection for her. If these men of letters had waited to marry a social equal, Gissing observes, waited until they were fifty or sixty or more, they might have produced better things, but probably not. Even an artist willing to sacrifice for his art, willing to live as much as possible in his art, must also live as a human being and satisfy human need. Gissing would marry Edith Underwood soon.

Certainly he knew he was taking a great risk looking to a lower level for a partner. Yet repeatedly he told himself it was the only avenue open to him. He would have to shoulder the risk and hope for the best. Before the end of their first year together his fears were confirmed. As he was completing *The Odd Women*

in 1892, he had to admit that in two years or less the marriage had gone sour. Published in 1893, echoes of Edith in that book are already bitter. He was beginning to rue the day he had ever met her. One can trace his disillusionment in the misery and misfortune of several memorable *Odd Women* characters.

Mr. Poppleton, a minor character, is memorable for reflecting the distress Gissing was beginning to feel. The man is driven insane by having to explain his jokes to a dim-witted wife. A person of intellect who carefully cultivates wit, he is married to the dullest woman anyone could have found. She lacks a sense of humor and cannot understand even the broadest of jokes. Only flat, simple, declarative statements are intelligible to her. If Gissing had his own wife in mind as he described Poppleton's wife, he was being unfair. Edith may have missed some of the subleties of his discourse, but we know she laughed when he joked (at least early in the marriage), and she tried to appreciate his wit. She even tried to read his books, and she was not stupid.

Mr. Orchard, another of the book's minor characters, has married a pedestrian woman whose eyes are closed to any way of life beyond the practical, materialistic, and mundane. On an outing in fine weather to view the landscape near Tintern Abbey, she complains constantly of her incompetent servants and ruins what could have been a very pleasant walk. To avoid suicide, for he knows he can't divorce his wife, Orchard becomes a restless wanderer. A friend,

hearing that the man is haunting the shores of the Mediterranean Sea and living from hand to mouth in failing health, speaks a terse and tragic epitaph: *"A pity; he might have done fine work."*

Near the end of 1892 Gissing was complaining that one thing was keeping him from doing his best work.: domestic discomfort. The house was so often in an uproar that he found it difficult to concentrate. When Edith wasn't picking a fight with him, she was venting her temper on the hapless servant. Although his income was much too small to hire a servant, Edith insisted on keeping at least one. Not able to pay them a good salary and believing she had the right to order them about, she had troubles with one servant after another. They came and went regularly as if on schedule. Later Gissing would bring the problem into his novels. In the meantime he pushed himself to create realistic female characters in the likeness of Edith.

Mrs. Tom Barfoot in *The Odd Women* projects an accurate image of Edith as Gissing saw her at that time. She is selfish and shrewish and lacking in affection. Her husband suffers poor health and longs for the countryside, but she must live in London. To live anywhere else, even a few miles away, is to place her in exile. Try as she might, Edith Gissing could not adjust to living in the town of Exeter. Its impressive cathedral dating from the Middle Ages, its reputation for being a seat of learning, and its country vistas had no effect on her. Its peace and quiet made her long for urban noise. A

woman who had spent her entire life in the streets and squares of the city, she lived for the day when she could forget the country and breathe London air once more.

Unable to persuade her husband to return, she began to show the vulgar side of her nature which he despised. Edith's counterpart, Mrs. Barfoot, is said to possess a hot temper and *"a disposition originally base."* After the death of her husband, she spews venom in all directions. When Gissing in time separated from Edith, she behaved in the same way. But, remarkably, Mrs. Barfoot was created five years before the Gissings' bitter separation in 1897. As he had done when prefiguring Nell in the early novels, he plays the prophet here. He is forecasting accurate prediction regarding Edith years before events happen. One might call this ability to see into the future uncanny or weird, and yet we have in Gissing's work many examples of it.

In 1892 Gissing had some hope of salvaging his marriage, but during the next year when he was writing *In the Year of Jubilee*, his growing disillusionment weighed heavily upon him. Ada Peachey in that novel is the bitter embodiment of all the defects he had found in Edith. Notably inept at managing a household, Ada has personality traits that exactly reflect Gissing's negative opinion of Edith. She is vulgar, loud, pretentious, and ill-tempered. She has a violent temper and is a vessel of smoldering anger. Without warning the anger flares into fiery abuse. Without restraint and without remorse, she tongue lashes her husband, servants, and sisters.

Ada Peachey's fury is most evident in the powerful climactic scene that forces her husband to take his child and flee. Arthur Peachey is so uncomfortable in the miserable house he calls home, he spends most of his time at the office. At quitting time he can't expect to relax in a peaceful domestic setting. Each day he worries about uproar. Then one evening he returns home to find a uniformed policeman in the doorway. A servant, under arrest, has stolen marked money. Sent upstairs to put on her coat, the hysterical girl seizes a pair of scissors and slashes her throat. Ada, beside herself with anger and showing no sympathy, stands over her victim and screams abuse.

As Arthur helps restore the servant to consciousness, his enraged wife turns upon him, accusing him of sexual relations with the girl. Pushed to the limit, he seizes Ada by the shoulders and flings her from the room. On the other side of the door she screeches insults in *"the language of the gutter and the brothel."* Arthur Peachey huddles in a fetal position against the bed, his hands clasped over his ears. Their child screams in terror. When Ada leaves the house to file charges against the servant, Peachey bundles up his three-year-old son and escapes. He tells himself he will never again live under the same roof with such a woman as Ada. Is Gissing thinking of Edith as Ada screams? Scenes such as this strongly suggest that in her rages she used language that made her husband shudder. In many letters to Bertz, he hints of vulgar

language deliberately used to sting him when she was angry.

The devastation in the lives of Arthur and Ada Peachey is another example of accurate prediction of events in the author's own life. Their intense and bitter story, told with surprising vividness of detail, reflects with unusual fidelity Gissing's own. Yet the final separation from Edith did not take place until three years later. As he had earlier projected the outcome of his wretched first marriage, he showed again a shrewd accuracy in predicting the failure of his second. Once more, whether he knew it or not, he was writing with the power of prophets.

Scarcely a month after the separation from Edith in the autumn of 1897, he was hard at work on the book that became *Charles Dickens: A Critical Study.* The chapter on female characters targeted the *"foolish, ridiculous, or offensive women"* in Dickens' novels. With the memory of Edith stirring him to temporary misogyny, Gissing penned this passage: *"These remarkable creatures belong for the most part to one rank of life, that which we vaguely designate as the lower middle class. In general, their circumstances are comfortable; they are treated by male kindred with extraordinary consideration. Yet their characteristic is acidity of temper and boundless license of querulous or insulting talk. The real business of their lives is to make all persons about them as miserable as they can. Invariably they are unintelligent and untaught; very often they are flagrantly imbecile."*

Gissing also discussed *"a very familiar female type, known as the shop-girl."* When Dickens was living and working as a story teller, the shopgirl had just begun to appear on the scene. That allowed Gissing to discuss her, but in terms of present-day rather than past shopgirls. He listed her personal characteristics as misguided ambition, selfishness, vanity, ignorance, and frankness of speech to establish a very negative portrait. Earlier, in *The Odd Women* and elsewhere, his portrayal of the shopgirl had been more sympathetic. They worked long hours at low pay, were constantly on their feet, and were not secure in their jobs. Though of higher rank in the world of work than needlewomen, they were oppressed and in need of a champion. Monica Madden in *The Odd Women* was a shopgirl before her unhappy marriage.

He declared also as he sketched the shopgirl in acid, that women of this sort could be found in the London of his own time in almost every household. Moreover, their number was steadily and vastly increasing. The new education, he believed, had improved such women very little. The democratic ideal and greater freedom had brought only negative results. The extended liberty achieved by the feminists had promoted aggression and a confident sense of equality at odds with reality. It had exacerbated *"the evil characteristics in women vulgarly bred"* and had made them worse than ever.

It had produced in great numbers *"the well-dressed shrew who proceeds on the slightest provocation from*

fury of language to violence of act." Gissing surely had Edith in mind as he penned these words. Only weeks before he had fled just such a woman as described here. She had hurled insults in his direction, vulgar language, and epithets of violence. The harshness of her language now returned to haunt him. The memory flooded his brain and senses with vitriol. There is little doubt that the savage vehemence of this chapter on a particular type of woman as portrayed by Charles Dickens is a product of that experience.

Chapter Thirteen

Rebellious Wives and Edith

Though Ada Peachey is arguably the best example of the unruly wife in Gissing's work, she is not the first to appear there. The earliest of the rebellious wives is Maud Gresham of *Workers in the Dawn* (1880). A spoiled society girl, she marries ambitious John Waghorn for money and social position. Although they live under the same roof, they have little in common, do not share a bedroom, and lead different lives altogether. When Helen Norman, main character of the novel, expresses surprise at that arrangement, Maud stifles a sigh, feigns sophistication, and laughs. With exaggerated nonchalance she explains that all marriages with any degree of elegance are conducted that way.

In the privacy of their affluent, well-appointed home Maud and her husband quarrel without restraint: *"I demand that you understand one thing,"* he tells her. *"You may be as damned sulky as you please when we're alone together; for that I don't care a snap. But when we're*

obliged to be seen in each other's company, I'll thank you to show me politeness." Little by little the intimidating husband tightens the screw of male dominance. His wife exerts counter-pressure by means of a willful, expensive extravagance. Before long her excessive spending creates a smoldering conflict in the marriage, and eventually a showdown.

Confronting his wife with a savage temper unleashed, Waghorn flings her roughly across the room. She springs to her feet and fires a pistol at him. He pounces upon her and dashes the shrieking woman to the floor. In a rage he dominates her with brute force and demands that she mend her behavior. Presented here, in Gissing's first novel, is the implicit advocation of force to put down a rebellious wife. It has been said that the concept appeared first in *New Grub Street* in the famous scene between Amy and Edwin Reardon, but that is not correct. Gissing dramatized the theory of force in his first novel (1880) and again in *Demos* (1886) years before it came into the pages of *New Grub Street* (1891). The trouble Gissing had with Edith seems to have created the supposition that a dominant husband (such as he was not) could solve the problem of the unruly wife with force. In *The Whirlpool* (1897) Sibyl Carnaby, a new woman in tune with current events, asserts that when a man is too weak to control a woman, she finds ingenious ways to make his life miserable. Gissing once more is speaking of his own life.

In *Demos*, exercising a deliberate plan, Rodman

seizes his wife like a sack of potatoes and pitches her into a chair. The act demonstrates his power to assert his superior strength. In *New Grub Street* Gissing speculates that Edwin Reardon could have used the same behavior with similar results. *"He had but to do one thing: to seize her by the arm, drag her up from the chair, dash her back again with all his force."* Though hating violence and despising male dominance, fierce male strength to put down a rebelllious wife must have crossed Gissing's mind more than once. It is the idea that in domestic conflict physical strength properly used can be effective. Similar in disposition to Edwin Reardon, Gissing was too mild a person to use force of any kind. He could only imagine how such behavior might work.

In *Workers in the Dawn* the Waghorn marriage is terminated by divorce. At the beginning of his career Gissing knew little about the divorce laws in England, and so fashioned an easy divorce. In later novels, after he saw how difficult it was to obtain a divorce in England, Gissing stressed the permanency of the marriage bond. *"It was hateful,"* he observed in *The Emancipated "that she should remain the wife of such a man as Elgar, but what refuge was open to her?"* Antiquated laws of divorce were so expensive and unwieldy in Gissing's day that even affluent people hesitated to make use of them. Reuben Elgar was openly unfaithful to his wife, but the double standard made cynical allowances for his infidelity, and he knew his wife would never leave him.

That repulsive double standard Lionel Tarrant of *In the Year of Jubilee* explained in some detail: *"Infidelity in a woman is much worse than in a man. If a man really suspects his wife, he must leave her, that's all."* Liberal Mrs. Travis of *The Emancipated,* believing in the equality of of the sexes, vowed she would never return to her gruff and unfaithful husband. In time, however, she did return because mere separation was not strong enough to keep them apart. Divorce was necessary to make the severance complete, but at that time any divorce was seen by the populace as scandalous. Rather than risk even trying for that way out, Travis returned to an unhappy home and a loveless marriage.

In New *Grub Street* by means of pithy comments by Amy Reardon, Gissing continued the discussion of divorce. In conversation with Edith Carter, she poses a question of great importance for the 1890's: *"Isn't it a most ridiculous thing that married people who both wish to separate can't do so and be quite free again?"* She contends that in America, more progressive than England in its legal system, divorce is obtainable when two people cannot live together. *"And does any harm come of it? Just the opposite I should think."* She is advocating divorce on grounds of incom-patibility, a daring speculation for the time. In this country in the 1890's a divorce on those grounds was available in only a few states.

In the same breath Amy is attacking England's obsolete Divorce Law of 1857, which granted divorce

only on proven adultery after much legal manipulation at great expense. She and her husband would like an amicable divorce, one that would allow them to remain friends in later years, but in England *"idiotic laws"* will not permit that kind of civility. To divorce they must humiliate one another, air their dirty linen in public, and make a spectacle of themselves. The law demands that their unhappiness be placed on display at high cost for the amusement of strangers. It's a nasty, stupid, and ineffective law, Amy believes. She is speaking Gissing's exact language. Right-minded people of influence should have changed the law a long time ago.

During those years of living apart from his first wife, Gissing thought often of divorce. With his second marriage, his reluctance to exile himself from his children prevented action in that direction. Not until 1898, after he had met Gabrielle Fleury and wanted desperately to free himself of his second wife, did he look seriously into the matter. He did research on the subject and sought advice wherever he could find it, even as far away as America. Later he confided to Bertz that Edith would never comply with the terms of a generous or favorable divorce. Her one remaining consolation, he avowed, was knowing that as long as she lived he would not be free to marry another woman. That last particle of power she was unwilling to give up for any price.

In anguish and bitterness Gissing described the divorce law in England as insensate and vile. A man is

outraged by an unstable wife and literally driven from home by violence and insult, but the law will not allow him to rebuild his life. In desperation he sought the advice of friends as far away as Baltimore, but none were able to help. The more he explored the complex legal maneuvering necessary to free himself of Edith, the more distant the dream became. At length he was forced to realize he would never be free of her. She was younger than he and would live longer. He would go to his grave bound to her. Unlike the ancient mariner whose albatross slipped from his neck into the sea, his albatross would burden him to the end of life.

It is clear from abundant evidence that even at the time Gissing was courting Edith he feared marriage with her would not work out. He also knew that divorce for a man of his means was all but impossible. That in turn led him to consider the current laws pertaining to divorce, and to bring into the novel he was writing a detailed discussion of the subject. In some of the later novels the injustice of the divorce laws, sounded first in *New Grub Street*, became a minor theme touching the lives of several characters. We can look at some of these characters to see how Gissing develops and presents the theme. The issue is how does he state his views on marriage and divorce in England, and what are they? In fluid and changing times do the old laws suffice?

As one might expect, most of the married couples in Gissing's fiction are less than happy. In fact his novels on the whole constitute a severe indictment of marriage

in fast-changing times. It is surprising, however, when a marriage turns sour and fails, it is often the husband who is to blame. A prime cause of trouble, seen in many of Gissing's novels, is the husband's inability to accept the democratic spirit of the times and view his wife as an equal. Many of his husbands practice male dominance until their suffering wives somehow muster the strength to become rebellious. The weaker ones endure their affliction in frustrated silence, losing their good looks overnight and growing old quickly. The rare subjugated wife, drawing upon emergent inner strength, is able to endure the trauma without visible signs of wear.

Edmund Widdowson, starchy, opinionated, and old-fashioned, has always believed in the sanctity and permanence of marriage. But when his union to Monica Madden in *The Odd Women* begins to disintegrate, his reflections are shown as much the same as Gissing's own. *"Perhaps there ought not to be such a thing as enforced permanence of marriage,"* he declares. *"Perhaps, some day, marriage would be dissolvable at the will of either party to it."* Repeating the stated views of Amy Reardon, he is speaking also for Gissing. Any marriage that has failed, Gissing asserts as critic and commentator, should be legally terminated by a fair divorce at moderate expense without scandal. That observation shows him not in tune with his times but ahead of them. However, he hoped his voice would eventually be heard.

Adela Waltham in *Demos*, during the first months

of her marriage to Richard Mutimer, likes her husband's masculinity. However, living with him soon becomes *"an unnatural horror."* Mutimer heaps upon her one indignity after another, but the gentle, delicate woman accepts her lot without complaint. Believing in the old ideal of marriage, Adela tries to lose her identity in that of her husband, submitting to him entirely. *"If ever he and she began to speak at the same time,"* Gissing observes, *"she checked herself instantly."* She is depicted as a womanly woman under the thumb of a coarse and domineering husband. Because she is strong and flexible, she endures the ugliness of a bad marriage with patience, grace, and courage. In so doing she proves her moral superiority and wins the admiration of everyone close to her, even Gissing himself. To his sister Ellen he wrote shortlhy after finishing the novel: *"The heroine, by name Adela, you will think delightful."*

Mutimer's sister, on the other hand, is destroyed by the male ego. Nicknamed "the Princess" because of her regal good looks and haughty manner, she marries a brute of a man named Rodman whose word is law. *"You've got to learn,"* he asserts in a tone of command, *"that when I tell you to do a thing you do it – or I'll know the reason why!"* He takes much pleasure in taunting her, needles her sadistically, and leaves her alone for days on end. Eventually, like a rag doll left in the rain, she begins to fall apart. *"She had fits of hysteria with senseless laughter, alarming screams. Reading she was no longer equal to; after a few pages she lost her understanding of*

a story. Her glass – as well as her husband – told her that she suffered daily in appearance."

In *Thyrza* the feisty will of Paula Tyrrell is subdued by Victor Dalmaine, a practical-minded politician. When a girl she seized the ideas of others and repeated them as her own. After marriage she continues the habit. Because such talk is potentially damaging to her husband's career, he demands that she speak only on subjects without controversy unrelated to politics. As master and despot, he tells her what she can and cannot talk about: *"If you take my advice, you'll cultivate talk of a light, fashionable kind. In fact, I say, keep to the sphere which is distinctly womanly."* Then he reveals an attitude similar to that of Helmer in *A Doll's House* (1879) by Henrik Ibsen: *"How well you look in that dress!"*

Since *Thyrza* was published in 1887 and Gissing didn't read Ibsen until 1888, the similarity here between Victor and Helmer has to be coincidental. But one should remember that the attitudes displayed by Victor and Helmer were prevalent in earlier years both in England and on the Continent. The difference is that Nora left home, slamming the door of her doll house behind her, while Gissing's Paula meekly assents to being treated as a willowy and fragile doll. In 1887 his sympathy lay with Paula. A decade later, bruised by the feminine will, he would show admiration for the strong man who was able to control an unruly wife with *"benevolent despotism."*

The cogent doll analogy deserves further

comment. While Ibsen is often given credit for originating the analogy, he was not the first to use it. His influence, however, was soon felt in England and imitated. Victor Dalmaine views his wife as a talking doll, a decorative and amusing object, a mere toy. In *New Grub Street,* Welpdale attempts to view Dora Milvain in the same way. He tells her that Biffen's realistic novel is too ugly for her to read. It becomes her, he insists, to show an interest only in beautiful things. Annoyed by that attitude, the lively girl retorts: *"But why will you imagine me such a feeble-minded person? You have so often spoken like this. I have really no ambition to be a doll of such superfine wax."* After marriage Dora becomes a responsible adult.

While Dora's personality seems undoubtedly influenced by Ibsen (the name Dora echoes Nora), the doll analogy was popular long before the Norwegian (or Gissing) used it. One may find the analogy in Dickens' *Our Mutual Friend* (1864). In that book Bella Wilfer, unwilling merely to ornament the house of her husband, exclaims: *"I want to be something much worthier than the doll in the doll's house."* That striking reference to the doll figure comes fifteen years before Ibsen's play was presented in 1879. Even more surprising, the metaphor was at work in an English novel nearly half a century before Dickens used it.

Thomas Love Peacock put it to good use it in *Nightmare Abbey* (1817). A witty young man with the unlikely name of Scythrop Glowry tells his father that

the artificial education of women *"studiously models them into mere musical dolls, to be set out for sale in the great toy-shop of society."* Smiling approval, the elder Glowry retorts: *"Your idea of a musical doll is good. I bought one myself, but it was confoundedly out of tune."* The comparison appears to have originated with male writers, and was common in the nineteenth century. It was at first intended as a compliment, as inverse flattery. In the last three decades of the century, when English women were asserting their identity as capable adults on an equal footing with men, it became offensive.

Monica's rebellious behavior, Reardon cautions, goes against the grain of natural law, the timeless law that commands a wife to submit to her husband in brain and body and spirit. The position is clearly that of Ruskin, whom many women admired, but Gissing has Monica reject the Victorian sage on this issue. Though she makes it clear that she will not listen to such arguments, her aging, inflexible, and unyielding husband persists. Under the stress of conflicting opinion the young woman, a major character in *The Odd Women*, becomes sullen, recalcitrant, and ultimately unfaithful. Though the couple sincerely wants their marriage to endure, neither husband nor wife can bend to the other. Their May-December marriage, shining with hope and promise when it began, slips irrevocably and rapidly into corrosion and ruin. Two failed marriages caused Gissing to bring into his novels a surprising number of unhappy marrages that ultimately fall apart.

Chapter Fourteen

Marriage and the Servant Problem

The failure of the union with Edith stirred bitter memories of Nell and shaped Gissing's pessimistic view of marriage. Their turbulent domestic life also influenced his opinions on the servant problem. When he lived in callow poverty with his first wife, they couldn't afford a servant. His second marriage was more comfortable financially, and Edith needed someone to help her with the children. Reluctantly he hired women to help her, but in numerous letters he complained that she was incapable of supervising a servant. She was either too friendly or too demanding and frequently lost her temper wih them. That would often cause the servant to quit without notice. Then with her usual incompetence she would hire and try to train another. The next servant would come into their home, chafe under Edith's temper, and leave to make

way for yet another. It was a cycle without end, and it wore on Gissing's nerves.

At the end of 1895, a year that saw a steady stream of publications from Gissing's pen but also a year of *"domestic misery,"* he lamented in a letter to Ellen: *"Our last three servants (wages £20 to £25) have stayed one month each, and all declare there is work for three strong women and a boy! We are now going to have back a loutish creature who was here a year ago; the only one who ever did her work (however badly) without grumbling or insulting. Her tart-crust had to be broken with hammers – but we can't help that."* In the fall of that year, in a letter to Algernon, he expressed the opinion that on the servant problem he had *"exhausted all possible utterances."* He was convinced that in just a few years, unless special schools could be established to solve the problem, many middle-class couples would find it necessary to do without servants. He was, of course, absolutely correct in that prediction. Eventually the middle-class family in England would lose its servants.

In the meantime constant bickering between mistress and servant in his own home interfered with Gissing's work and left him agitated. He thought the person who pays the servant's wages should deliver calm and authoritative commands and expect obedience. However, Edith somehow lacked that ability. When dealing with her servants, she lost her composure as well as her dignity. As head of the house, Gissing could

have exercised a quiet authority, but remained aloof and fretted and fought off depression. Try as he might, losing sleep as he pondered the question, he couldn't devise a workable solution. As far away as the southern tip of Italy he wasn't able to escape domestic wrangling; even in his travels the ugly reality assaulted him. On his Calabrian journey in 1897, an embattled servant, old and tired before her time, tearfully complained to him of unjust treatment. As a guest in the hospice for travelers, all he could do was listen and nod his head.

In *Will Warburton*, his last novel published posthumously in 1905, an unpleasant and bossy woman of the middle class, aptly named Mrs. Cross, mistreats one servant after another. She is surely modeled after Edith. The woman is arrogant, selfish, parsimonious, hot and acrid of temper, not very bright, and incapable of supervising other women. Like Edith, she can never find a servant willing to stay very long: *"To say that she 'kept' one would come near to a verbal impropriety, seeing that no servant ever remained in the house for more than a few months."* In time the woman manages to hire a docile girl named Martha, who seems untouched by the democratic spirit that was spoiling servants.

Martha is willing to work and willing to follow orders, and day after day all goes well. Mrs. Cross gives her servant a place to live, food to eat, and a salary of £15 a year. For a a month or so the arrangement seems a good one. But as more and more work is thrust upon her, the young woman's pleasant disposition changes to

sullen resentment. An accident in the kitchen becomes the catalyst for open revolt. When her employer scolds her for setting fire to a towel, she dashes the crockery piece by piece to the floor. Then furiously she chases the hapless Mrs. Cross with an iron poker. The scene is too vivid to be entirely imaginary; it came in some measure from Gissing's own experience.

Employers agreed that the most irksome aspect of the servant question was finding and keeping a capable servant. In later novels Gissing comments at length on the problem, for after 1890 he was increasingly caught up in servant difficulties. When Edith failed as a supervisor of servants, he concluded that her problem was one of class; she was too close in class to the people she hired to work for her. They sensed the affinity and responded with rebellion or familiarity. That could not be said of Gabrielle Fleury, who became his third wife. She was educated and refined and distinctly of the middle class. She was capable and confident and spoke with authority, and yet she was not the solution to Gissing's servant problem.

Even though Gabrielle exhibited a superiority of class no servant could possibly deny, in her husband's last years the servant problem in their household was very much alive. Gabrielle seemed all too willing to turn her *"executive power"* over to her mother who lived with them, and that upset Gissing. At the end of 1895 he confided to Bertz that he hoped to draw upon *"immense material"* to publish a book about one

of the gravest issues of his time: *"the whole question of domestic service."* Unfortunately, because of declining health and the struggle to finish a complex historical novel, he never composed what could have become an important book on an important subject. However, he did manage to use the material in smaller pieces.

Leaders of the nation can begin to solve the servant problem, he asserted, by admitting that the average woman hates to have another woman wielding iron-clad authority over her. Before the triumph of *"glorious democracy,"* only those women capable of cool command kept servants, only those who had *"the instinct of authority."* They knew they were superior to their domestics. They chose them carefully, kept them for a long time, and rarely had trouble with them. Their loyal servants took from such women a sense of worth. They were part of the family, believed they belonged, and respected their employers. In the 1890's, however, women incapable of fair and firm supervision were employing other women to wait on them. The results were seldom satisfactory.

Women incapable of rule inevitably brought about *"a spirit of rebellion in the kitchen."* Those women, except for their money and position, were essentially equal to their servants. They often revealed themselves as vulgar and silly. So it was natural for servants to lack respect and revolt against them. In other words, inept middle-class women encouraged revolt. Even though other factors were at work to undermine an institution

in England that had survived for centuries, Gissing thought the main culprit was the democratic spirit of the day. *Equality* was the key word.

In his Commonplace Book Gissing wrote that it was rare to see a woman of his day smoothly exercising authority, for the *"doctrines of equality"* had rendered the servant class more troublesome than ever. That same opinion was repeated in *The Whirlpool*. In the last decade of the nineteenth century, when every person believed himself equal to any other person, dependable servants had all but vanished. Ordinary housekeepers, even those willing to pay a good salary, were at the mercy of a *"draggle-tailed, novelette-reading feminine democracy."* They had become victims of brash and aggressive young women who despised authority, despised working as servants, and despised any woman who presumed to lord it over them.

With the erosion of class distinction, servants male and female had become indolent and insolent. The new middle class, expecting respect from employees but not receiving it, didn't know how to deal with the problem. The woman of the household often couldn't tolerate disregard for her authority, but was untrained in how to assert it. Only the rare woman knew how to keep cocky servants in line. Most women, or so it seemed to those pondering the problem, were incapable of asking for a well-defined performance from their servants and receiving it. The man of the house could

have done better, but traditionally, as in his own home, husbands did not interfere.

In Gissing's novels men without wives have little difficulty with servants. Because they are able to exert the necessary authority with control, their servants invariably respect them. Often one finds mutual respect between master and servant, and the result is a smoothly run, orderly household. In *A Life's Morning,* Dagworthy speaks of his servant: *"Mrs. Jenkins is not as refined as she might me, but she's been with us here for more than twelve years, and I should be sorry to replace her with any other servant."* Though his nature compels him to view Mrs. Jenkins as a piece property, a piece of machinery rather than a human being, he is nonetheless able to appreciate her value. He has imparted a sense of worth and place to his servant, and she performs dependably.

The housekeeper employed by Harvey Rolfe, a gentleman in *The Whirlpool,* shows comparable worth and is also highly valued by her employer. When she announces that she is quitting, Rolfe is thrown into consternation. He knows that the demand for good servants far exceeds the supply. He worries that without his faithful servant the quality of his life will surely diminish. And yet he concedes that she is free to make her own decisions involving her life. She is not his slave and may leave him whenever she chooses. Then it becomes his problem to replace her.

In *The Private Papers of Henry Ryecroft* a thinly

disguised self-analysis written near the end of his life, Gissing pays generous praise to a loyal and dedicated housekeeper. The unnamed woman serves her employer (Ryecroft/Gissing) not merely for weekly wages, but because she takes pleasure in making his life comfortable. He speaks of her in superlatives, praising her as the best of women second to none even as bitterness obtrudes: *"From the first I thought her an unusually good servant; after three years of acquaintance, I find her one of the few women I have known who merit the term excellent."*

In tandem with the thinking of Thomas Carlyle, Ryecroft believes his servant was born to serve. In that milieu, her element, she is happy. Were she educated and trying to do some other type of work, she would find herself unhappy. While living alone at Dorking in 1898, Gissing had such a housekeeper. It was a time of anxiety and apprehension for him, and the servant went out of her way to ease the stress upon him. He showed his gratitude by lovingly sketching her likeness in what has been called his autobiography, *Henry Ryecroft*. She appears in one of his most popular books.

Before the end of his life Gissing attempted to propose a solution to the servant question. He said that girls of the laboring class and even the middle class should be taught from infancy that domestic service is no shame. Female trainees should be taught how to cook, how to keep an orderly house, and how to get along with the woman of the house. Male trainees,

should they decide to go into service, would be ready to serve in the big house of a country estate. To become a cook in a well-equipped kitchen, as Harvey Rolfe points out in *The Whirlpool*, is just as worthy as performing a genteel occupation in an office. The job could lead to a comfortable and secure life in pleasant surroundings. Affluent people of quality would respect and accept the capable servant.

Special schools could be established to train young women as well as men to become dedicated servants. Other schools could teach girls of the middle class cooking and baking. On this subject dear to his heart Gissing spoke out through Henry Ryecroft: *"I had far rather see England covered with schools of cookery than with schools of the ordinary kind; the issue would be infinitely more helpful. Little girls should be taught cooking and buking more assiduously than they are taught to read."* Such training would allow daughters of the middle class to do without servants.

In others it would instill a sense of authority that comes only with having mastered the work done by subordinates. By the time he wrote *The Private Papers of Henry Ryecroft*, the liberal streak in Gissing had all but dried up. Far more conservative than in his youth, he now believed in the old school of thought regarding the duties of women. That brand of thinking, or so it seemed, was more reasonable and more humane than any position which stressed freedom of choice. Rosamund Jewell in "The Foolish Virgin," not at all smug

and secure in the middle class, finds peace of mind and safe haven as a faithful servant.

Gissing's second marriage produced two healthy sons who could have made domestic life happy and complete. And yet living with Edith was a dismal failure as intense in its agony as living with Nell. He chose his second wife out of need rather than love, and that was a terrible mistake. The grim result was a repeat of the emotional and mental and torment endured in the first marriage, a cold and crippling domestic unhappiness. That experience, visceral in its impact, shaped a cynical attitude toward a certain class of women. It established deep within Gissing a caustic contempt for a particular type of woman. A pacific man who prized gentleness, it led him to ponder whether force was ever justified to control an unruly, abusive wife.

Also he was spurred on to question whether marriage was ever intended to be inescapable and whether an inexpensive divorce should not be granted solely on grounds of incompatibility. That led to pungent comment in several books on the injustice of antiquated divorce laws. They were there only for the very rich and could be used only by the powerful. The rank and file of the populace had to endure insufferable marriages in silence, or separate and live alone. Since separation seldom led to divorce, a couple who couldn't live together often were not able to live with anyone else. At a time when men and women of every class were asserting their independence, marriage as an age-old

institution inevitably came under severe strain. In that climate, detrimental to any romantic union, antiquated and unworkable divorce laws needed to be changed without political interference.

Earlier Gissing had taken a liberal view of woman and her place in society, but the years with Edith caused him to swing from the liberal to the conservative in all matters relating to women. When he found that Edith was not capable of supervising even the meekest of servants, he thought about the servant question and attempted to find solutions. He applied calm, rational, persistent thought to the problem and outlined a program that seemed quite workable. Though expressing conservative opinion on the question, he opted for fairness and was not a radical. He was not like Harvey Rolfe of *The Whirlpool*, who would train only men as servants and *"send the women to the devil."* Though cynical at times, even bitter, Gissing was more thoughtful and less emotional.

The practical solution he proposed -- train even middle-class girls to become servants -- raised eyebrows among the influential. Middle-class girls in particular were thought to be made of finer fabric. Gissing's opinions on this and other matters were viewed as neither liberal nor conservative, but flagrant and somewhat dangerous. Closer to the truth, he had moved slowly away from the liberal thought of his youth to an unyielding conservative stance in maturity. Although the feminists would exert a strong

influence upon his work, in time he would put its liberal convictions behind him. The novels of the 1890's reflect this position, particularly those near the end of his career. A decade earlier, however, *"the Woman Question"* as it was popularly called in reference to the feminist movement, had become an important issue in several of his novels. For that reason it deserves our attention.

Chapter Fifteen

The Woman Question and Gissing

George Gissing saw "the Woman Question" as the nucleus of a social and poliical movement that spanned the ninetenth century and brought important results. Achieving lasting change in the lives of women and eventually the vote, the feminist movement persuaded many to give up the old ideal of womanhood for a new one. The process produced in England before the end of the century three distinct feminine types: the womanly woman, the woman in revolt, and the new woman. During the 1890's, and to a lesser extent in the previous decade, all three were simultaneously on the scene. When we examine their representative portraits in Gissing's fiction, we see the impact of the movement upon a thoughtful novelist eager to work with new ideas in a new milieu.

Throughout the century an abundance of

feminine conduct books in almost every home spelled out the rights, duties, and characteristics of the womanly woman. These books stressed the obligations of the old ideal of English womanhood: self-repression, patience, and service to husband and family. In a leading position and quoted respectfully for half a century, were the writings of Sarah Stickney Ellis. Though very conservative in her views, she was a recognized authority on all matters concerning women from young girls to elderly matrons. Her thick, wide-ranging books of similar title -- *Women of England* (1838), *Daughters of England* (1842), *Wives of England* (1843), and *Mothers of England* (1843) -- became standard manuals. Unabashedly and without restraint they promoted the dogma of woman's inferiority to man. *"The first thing of importance,"* the mothers and daughters of England could read in the opening pages, *"is to be content to be inferior to men – inferior in mental power in the same proportion that you are inferior in bodily strength."* That sour message was delivered to female readers as an unmistakable central theme to ponder and remember and act upon.

By the late 1860's there existed three schools of thought on the place and position of women in English society. The conservatives held that woman's sphere was the home, and her first duty was to minister to husband and children. The feminists argued that since half a million superfluous women would never be able to marry, any person who found it necessary should

be allowed to work with dignity outside the home. Another school, willing to compromise, promoted an attitude of inverse flattery that some of their critics called *"woman worship."* They believed more culture should be extended to women whose interests were so inclined, but they drew the line at higher education, the vote, and professional careers. Coventry Patmore, author of "Angel in the House," was an ardent supporter. But it was not endorsed by writers of influence, such as Macaulay, Carlyle, Trollope, Mill, Arnold, and Huxley. In "Emancipation Black and White" (1865) Huxley spoke out against *"the new woman-worship which so many sentimentalists and some philosophers are desirous of setting up."*

Tennyson's opinions were anchored in the conservative position, and so were Ruskin's. Both men believed with conviction that woman's place was in the home. Her function in society was to serve, inspire, and uplift those living close to her at home. A loving woman, Tennyson told his readers more than once, was close to the angels. In the tawdry world of men her duty was that of helpmate, providing support and comfort. She could redeem certain defects in a man by refining his sensitivity. But to do that she would have to be married to the man and know him well. She would have to practice a *"distinctive womanhood"* and preserve it in each of her daily activities. Her presence would then have a softening and civilizing effect upon the entire household.

This sanctification of woman accounted in part for the opposition to feminist views. Most opponents felt that female emancipation would cheapen and eventually destroy important qualities in women. The men of the time differed as to what they wanted in a wife, but most agreed that ambition, achievement, and independence were not in the cards for a womanly woman. Humility, selfless dedication, and purity were most in demand, but also good looks. In *"the marriage market"* a woman's appearance was her most valuable commodity. The women with youth and beauty had little to worry about, but those older and plainer (unless they had money) were ignored. In 1860 it was said that only one young woman in three could expect to marry. In the middle 1870's that figure had doubled. Young women by the thousands remained single.

Although in most cases marriage to a good man offered security and respectability, the promise of happiness was often elusive. For a surprising number the married state fell short of expectation. Wives in particular were unhappy. In 1871, after holding her tongue for more than two decades, an unhappy wife spoke out: *"I have borne for twenty-two years with all humility and gentleness of spirit all the insults of a coarse nature. I have been a devoted slave to the man I swore to love and obey. I have borne insults and hard work and words without a murmur, but my blood boils when I see my innocent girls tremble at the sound of their father's voice."* The editor of the magazine, who must

have been in sympathy, nonetheless replied: *"As your husband is the breadwinner, you must bear it with meek and quiet spirit."* Some female readers expressed alarm over such *"a violent letter against a husband"* and agreed with the editor's reply. In changing times, however, the traditional woman was asserting herself, veering away from the meek and quiet.

For many centuries in England the subordinate position of woman rested upon authority and was accepted without question. According to the Book of Genesis, woman came into the world as man's helpmate. Her subjugation was, therefore, ordained by God and in the order of things. This doctrine was endorsed by St. Paul and later by the church. But the nineteenth century with a tendency to question even self-evident truths gave rise to a feminist revolt. As early as 1792 Mary Wollstonecraft, inspired by doctrines of the French Revolution, published *A Vindication of the Rights of Women.* The book set forth the essence of the feminist ethic and became the manifesto of a movement.

Though the phrase *"rights of women"* was later extended to mean equal rights in all areas of life, in the early nineteenth century it referred mainly to legal rights. During the first half of the century English women had few legal rights, scarcely more than children. A wife's body and soul belonged to her husband, as well as every material thing she owned. Not until 1882, with the passing of the Married Woman's Property Act, was the wife able to keep for herself property she owned before

marriage or any earnings she might gain afterward. The Property Act gave wives greater stature, but husbands had the power. The right of a man to keep his wife behind locked doors was not challenged until 1891, and to the end of the century a husband could beat his wife with a stick *"provided it was not thicker than his own thumb."* Until the year 1839 even the children belonged to the husband, their mother having no right of guardianship whatever. The feminists sought to change all that. They wanted nothing less than full equality under the law.

Early in the new century the movement entered its militant phase. Frequent demonstrations, some close to violence, attracted women of every class and background. Most of them wanted to *"do something"* to improve the lot of women. Some were eager to become martyrs in the cause. Gissing died before this phase came and went, but he lived to see the meek Victorian woman become assertive and aggressive. A novel by his friend H. G. Wells, *Ann Veronica* (1909), presented a vivid picture of this phase. Female voices were loud and strident. Carted off to jail as she demonstrated in the streets, an activist yearned for *"prison duty."*

On other fronts weekly and even daily speeches and publications made formerly docile young women restless and discontented. Before long almost every middle-class family had a rebellious daughter eager to slip the yoke of parental tyranny. Wives were becoming rebellious, beginning even with the marriage ceremony: *"The new lights contemn the vow of obedience,"* the

conservative novelist Charlotte Yonge in *Womankind* (1876) observed. *"Some clergymen say that they find brides trying to slur over the word obey; and the advanced school are said to prefer a civil marriage because it can thus be avoided."*

Abundant evidence indicates otherwise, but both sexes generally thought Ibsen's *A Doll's House* (1879) first incited wives to rebellion. The play was produced ten years later in England, and in the following decade exerted much influence. The feminists claimed Ibsen had written a powerful plea for their cause. They praised the play as good art but also effective propaganda. Their opponents with equal zest attacked it. Ibsen was held responsible for an undue proliferation of rebellious wives, and for a dangerous new morality inspired by Nora's behavior. Walter Besant took up the story where Ibsen left off and dramatized the misery of the young woman's family after she left home. Should women receive encouragement in their wicked demands for independence, his pungent satire preached, any number of English homes could founder. As if in answer to Besant, Ibsen showed in the play *Hedda Gabler* (1890) that if Nora had remained in her unhappy home, submitting to the pressures upon her there, she might have changed radically to become vicious, amoral, careless, and destructive.

An enemy of the feminist movement more formidable than Besant was Eliza Lynn Linton. She launched her offensive as early as 1846 (the date of

the first of many novels) and continued the attack for more than fifty years. *"All women,"* she asserted, *"are not always lovely, and the wild women never are."* In defense of *"the wild women,"* Mona Caird wrote that Mrs. Linton arbitrarily divided all women into two classes: the good, beautiful, submissive, charming, noble and wise on the one hand, and the bad, ugly, rebellious, ill-mannered, ungenerous and foolish on the other. There is little doubt that some of the women in revolt were as Mrs. Linton classified them, but most were sensible women who had a job to do and did it. Dedicated to their cause, they worked tirelessly for reform. The movement would gain steam and show promise in the 1870's, produce favorable results in the 1880's, and change the lives of many conventional women in the 1890's.

During the last two decades of the nineteenth century, mainly from the feminist revolt, *"the New Woman"* appeared on the scene. Similar to the feminists, though in many ways different, she went about advocating the independence of her sex, defying convention, and calling attention to herself. In the 1890's the term *New Woman* was used by journalists to mean the emancipated woman, enlightened woman, and advanced woman. By the end of the century, to describe the new feminine ideal everyone was talking about, the term *New Womanhood* was widely used in newspapers and magazines.

In Gissing's *The Crown of Life*, the central character, Piers Otway, is commissioned by a Russian

journal, *Vyestnik Evropy*, to write a long article on the *"New Womanhood in England."* In 1880 Gissing himself had been asked to write a series of articles in English for the same magazine, but not one of the articles was about the new womanhood. That was because the new woman had not appeared on the scene to receive attention. At that time Gissing was directing the reading of his sisters to have them become better educated, more sophisticated in taste and social activity, and more self-reliant.

Earlier in the century the girl on the threshold of womanhood was carefully guarded in what she read. But John Ruskin, as well as other thinkers, argued for greater latitude: *"Let her loose in the library, I say, as you do a fawn in a field."* By the 1870's British girls were reading with rapt attention in all directions, but British mothers were beginning to utter cries of alarm. One complained of the questionable textbooks the girls in the new classes at Cambridge had to buy. She insisted the books were "not *such as a girl could read with her father."* Others grumbled that the bookstalls had on display *"novels with which no pure-minded woman ought to soil her fingers."*

The establishment of Charles Edward Mudie, known to every reader as Mudie's Select Library, was a leading lending library of the time. It had the power of censorship, keeping what its board deemed unsuitable books from the sight of young women. But the new women deliberately sought books that Mudie would

not stock. Most of George Gissing's books fell into that category. However, middle-class women who didn't call themselves feminists or new women began to read Gissing's novels, extending his readership by word of mouth. A number wrote long and plaintive letters to him, asking for advice.

Brightness of intellect and a desire to parade it were dominant traits of the new women. They took as their motto Juvenal's *"mens sana in corpore sano"* and developed their minds while paying due attention to their bodies. The result was to engage in sports more strenuous than croquet, and in the 1890's they made the bicycle their own. It became an effective instrument of emancipation, for it extended restricted horizons and brought a freedom of movement never known before. The female cyclists were *"no longer prisoners in their own houses,"* a later feminist wrote. *"They could spin off as far as six or seven miles away."*

In the early days of cycling, however, ordinary observers thought women on bicycles were shocking, particularly when some appeared in bloomers. The sight assailed the senses, caused a backlash, and even violence. A bit more than the public could bear, the lady-cyclists were hooted in the streets, and little boys threw mud on their stockings. All the same, they found much pleasure in bicycle riding and encouraged others to try it. The sport was praised in feminist publications, and later in mainstream publications, for its many virtues.

Gissing learned to ride and persuaded Gabrielle to learn. H. G. Wells was his teacher.

In the 1880's when she first appeared on the scene, the new woman with her extreme behavior seemed intent on making herself conspicuous. Although she professed little respect for men, she dressed in a masculine way, aped the manners of men, and pursued activities traditionally reserved for men. She smoked cigarettes in public, raised her voice at meetings, called expectant mothers *"cow-women,"* hunted wild animals in faraway places, went fishing, displayed her body in daring costume at the beach, traveled alone to the cultural centers of Europe, and competed with male students in the universities. Often a plain woman, particularly in the early years, the conventional women with husbands saw the new woman as unlovely and unfeminine.

Near the end of the century, however, this new type sought to nullify the opinion that she was plain, ill-bred, and unwomanly. Aware of the advantages of a pleasing appearance, she began to emphasize rather than minimize her feminine attractions. This left her vulnerable to the kind of criticism leveled against her by Lynn Linton in *The New Woman* (1895): *"Her gown was soft, flesh-coloured silken stuff, fitting as perfectly as if it had been a second skin. Arms, neck, and bust were bare."* It was not an honest criticism of the emerging new woman, but effective. Linton implied the new woman

was a dangerous woman. She had to be shunned by respectable men and women.

She was a jezebel, brazen and erotic. It was her aim, most likely, to arouse prurient thoughts in the husbands of conventional women. Masquerading as satire too thin to recognize, the book was insulting and unfair, for the British new woman was never a loose woman. She set her standards high, stressed improvement of mind, and merged for effective use in her daily life (though it would take time) the best of the old and new ideals of English womanhood. Grant Allen's *The Woman Who Did* (1895) was another widely read book that also lashed out against *"that blatant and decadent sect of 'advanced women' who talk of motherhood as though it were a disgrace."*

There is little doubt that the vital new woman reflected the spirit of the times in much the same way as the new realism, the new humor, the new hedonism, and the new drama. However, she was more than a *fin de siècle* fad, more than merely a sign of the times in the bustling 1890's. The result of a difficult struggle, she came into prominence after the feminist movement had established a new ideal of womanhood. The changes that produced the new woman were soon reflected in English literature. Inevitably Gissing would portray the new type realistically in several major novels. Even though they represented the best he could do, they didn't bring him the money he needed to live comfortably.

He didn't become actively interested in the

women's cause until near the end of 1888. In September of that year, after *The Nether World* was finished and sent to the publisher, he went in search of new scenes, traveling first to Paris and then to Italy. In October at the Salle des Conférences, he attended a lecture by Clémence Louise Michel, a leading militant feminist among the French. Her topic was *"Le Rôle des Femmes dans l'Humanité,"* and George Gissing listened intently. It is doubtful his textbook French allowed him to understand all the subtleties of her lively speech. Even so, he was inclined to accept its substance without criticism. Typically, he didn't care for the speaker herself.

In fact, her looks and her manner tended to offend him. In his diary for October 2, 1888 he observed: *"I had expected to see a face with more refinement in it; she looks painfully like a fishwife. Dressed with excessive plainness in black and wearing an ugly bonnet. Much fluency, of course, and signs of intellect. Demanded absolute equality of women with men in education and rights."* He thought her manner overbearing, and yet he felt sympathy for her when at one point she had to contend with hisses snd hecklers from the crowd. He left the meeting thinking how he might bring her into a powerful fictional scene.

Attending that lecture during his first European tour was clearly a turning away from the memory of Nell and themes of poverty to think about the feminist movement. It had already become an important issue in England and Europe, and he decided it was time to use

it as source material for new books. He would dismiss the proletarian novels he had written during the 1880's to produce in the 1890's novels of social ideas and the problems they generated. He would now look at the middle and upper classes and particularly their women.

Before returning home, Gissing began write *The Emancipated*. The novel was not directly concerned with the feminists, but it echoesd their language in its title and their aims in its theme. Most of the material he had gathered on the movement would be hidden away for a time to ferment slowly until he could use it. He would have to come to terms with his loneliness and isolation and finish *New Grub Street*. He married Edith Underwood for the one, and that helped him with the other.

Denzil Quarrier (1892), written immediately after *New Grub Street* set forth detailed commentary on the woman question for the first time in a Gissing novel. It also presented in his fiction the first died-in-the wool feminist, Mrs. Wade. She promoted the movement to any person who would listen. Moreover, the utterance that later became the theme of *The Odd Women* (1893) appeared for the first time in *Denzil Quarrier.* It was written at the beginning of his marriage to Edith, which promised to be exemplary. He was in good health, no longer alone, and eager to do his best in a field of knowledge that he was just beginning to explore.

The main character's address to the Polterham voters, entitled *"Woman: Her Place in Modern Life,"* is

where Gissing's views are most accurately reflected. In that conservative town even jesting about the woman question is enough to bring on heated discussion. When the townspeople hear that Quarrier is the radical candidate for membership in Parliament, one of them wants to know whether his politics have made him a feminist sympathizer. Phrased in the Polterham cant: *"Are you disposed to support the Female Suffrage movement?"*

If he is, another townsman retorts, *"he mustn't expect my vote and interest. We've seen enough here in Polterham lately of the Female question."* Then Gissing himself adds: *"The woman question was rather a dangerous one in little Polterham just now."* While the town's younger women (and a few younger men) are willing to listen to the new ideas, the older people view anything new as unworkable. Starkly traditional and sternly set in their ways, they vigorously oppose the town's resident feminist and make her life difficult in petty ways. Since Denzil Quarrier has not yet revealed his position on this issue of such great importance, the whole community turns out to hear his speech.

In the classical manner, he opens the address with an amusing anecdote on long hair and gets a few laughs. Then he becomes serious, acknowledging that women are lifting up a collective voice in demand for more freedom, larger opportunity, and political equality. But what is the quality of education that will allow them to secure such aims? The ordinary girl is sent forth into

life with a mind scarcely more developed than that of a child. Her tiny education not only fails to serve her in the marketplace, but also in the marriage market. With little ability to judge for themselves, these girls make *"monstrous errors"* when accepting men as husbands. There is no panacea to make marriages universally happy, but judicious training can put women on guard when the time comes to marry. It will benefit them and the men as well.

Quarrier is speaking mainly of the middle class, though Gissing with Edith in mind is drawing upon beliefs concerning the lower middle class. The statements delivered by Quarrier are precisely Gissing's own. The whole speech, reported in part rather than fully dramatized, could have been delivered verbatim by Gissing himself. He held passionate opinions on the topics brought up by Quarrier, his capable mouthpiece. Whatever content the radical candidate chooses to deliver in his speech is essentially what Gissing would have said. He developed the character as spokesman for his own views on what the feminists were calling *"the greatest movement of our time."*

In 1893, watching his marriage to Edith Underwood unravel, he wrote to Bertz: *"More than half the misery of life is due to the ignorance and childishness of women. I am driven frantic by the crass imbecility of the typical woman. That type must disappear, or at all events become altogether subordinate."* So when Denzil Quarrier talks about England's superfluous women, he

touches upon the subject of Gissing's next novel, *The Odd Women*, and even defines its theme: *"Let women who have no family of their own devote themselves, when possible, to the generous and high task of training the new female generation."* Only then can woman's emancipation become a reality, and it will be the kind that will hurt no one. The new generation will be trained to work outside the home, in offices and elsewhere, to support themselves.

When the meeting breaks up, the townspeople gather in little groups to continue the discussion. What they say in this scene parallels the main points delivered in the speech and is of equal importance. *"Close at hand, a circle of men had formed about Mr. Chown, who was haranguing on the woman question. What he wanted was to emancipate the female mind from the yoke of superstition and priestcraft. Time enough to talk about giving women votes when they were no longer the slaves of an obstructive religion."* The release of women from restrictive religion had been the dominant theme of *The Emancipated* (1890). It was written after Gissing visited Paris in 1888 and heard the feminist Clémence Michel speak.

In that book and in *Denzil Quarrier*, he was in full agreement with Chown. By 1894, with the publication of *In the Year of Jubilee*, some of his thoughts on the subject had changed. He had become a conservative. Ada Peachey was demonic because she had no authority to guide her in moral matters. She had no moral compass,

no religious faith or spiritual sense, nothing to evoke or nourish even a spark of goodness. The bleak misery of the Peachey household, and thousands like it near the end of the century, could be traced to wretched wives bereft of a spiritual life to give them hope. They had *"no love of simple pleasures, no religion."*

In the midst of another group Mrs. Wade, the feminist, is making her views heard. She is saddened by Quarrier's timidity but realizes that boldness is out of place when politicians try to please their constituents. She declares, too, that his speech was so full of chauvinism that it should have been called *"Woman From a Male Point of View."* Even she avows, the politician running for a seat in Parliament stressed some points upon which members of *"the struggling sex"* would certainly agree, for example the comments on girls trapped in monstrous marriages. It is hinted that Mrs. Wade herself endured a similar experience in youth. But somehow she managed to free herself to become a leader in a very important movement.

The position of women, Gissing has the feminist say, has changed very little since the time of the Greeks: *"Woman is still enslaved, though men nowadays think it necessary to disguise it."* And does she attach much importance to voting? It is basic to woman's advancement. *"I insist on the franchise because it symbolizes full citizenship. I won't aim at anything less than that."* Though coming very near to the militant in her feminism, the woman as yet is less demanding.

Since the action of the novel takes place before the Third Reform Bill of 1884, her work would seem to be part of the suffragist agitation that was defeated in that year. Gissing's position is one of careful neutrality.

Later, in conversation with Lillian Northway, Wade brings up the subject of female fashion and restrictive clothing. Pausing beside a lake, she remembers having witnessed a splendid sight on that spot. When a little girl fell off the bank into deep water, a young man, fully clothed, instantly dived in to rescue her. *"If we could swim well, and if we had no foolish petticoats, we should jump in just as readily. It was the power over circumstances that I admired so and envied."* Showing *"signs of intellect"* in everything she says, Mrs. Wade is commenting upon the cumbersome dress of women that mandates inactivity in sports and even daily life. Commentary of this sort eventualy got women out of their houses to participate in sports, tennis for example, and bicycling. For too many years *"foolish petticoats"* had rendered women helpless in incidents of life that demanded action. Women are as capable of acting as men, Wade declares, and just as courageous. But without freedom to act (because of their clothing and not being taught to swim), they are not only incapable of action, but appear to lack courage. In *The Odd Women* a similar discussion takes place between Everard Barfoot and Rhoda Nunn. Both feel cumbersome clothing must go.

In his speech before the Polterham voters, Quarrier spoke of the nation's superfluous women and

the need for the more intelligent of those women to train the rest. In *The Odd Women,* Rhoda Nunn and Mary Barfoot devote their lives to that goal. Rhoda reveals their mission in language that explains the ambiguous title of the book and suggests its main theme. England has half a million more women than men, half a million superfluous women who must be trained to support themselves. *"So many odd women – no making a pair with them. The pessimists call them useless, lost, futile lives. I look upon them as a great reserve for the world's work."* She and Mary Barfoot have set up a school to train the odd women for work in offices. That same concept Gissing extended to other forms of work, including domestic service.

Throughout the century it was thought that women of the middle class were of a station in life that freed them from having to earn a living. Gently bred women were supposed to follow the ideal defined by Sarah Ellis and strengthened by John Ruskin. Their only duty was to concern themselves with things of the home. They were not brought up to become wage-earners and were not supposed to worry about money or economic problems. But the facts of life, as Gissing knew very well, were quite different. When the head of the household died, leaving his family unprotected, any dependents without male relatives to lean upon had to support themselves.

That reality of life is mirrored in the plight of the Madden sisters in *The Odd Women.* They are six

in number, and they represent all odd women in the neighborhoods of London and throughout the nation. They are important female characters, and they are central to the novel's plot. Mary Barfoot, on the other hand, is on the scene to help the superfluous women earn a living. Although she is similar to the histoical Jessie Boucherett, who founded in 1859 the Society for Promoting the Employment of Women, she aims for practical and humble results.

Mary Barfoot and Rhoda Nunn work each day in a commonsense way to advance the condition of women. Their position is defined in a lecture delivered by Mary. She develops her topic, *"Women in the Labor Market,"* against the backdrop of the larger woman question and begins by attacking as insupportable the Ruskinian view of woman. *"Were we living in an ideal world, I think women would not go sit all day in offices. But the fact is that we live in a time of warfare, of revolt. If woman is no longer to be womanish, but a human being of responsibilities, she must become militant, defiant."* She must seize her place in the world.

The old Victorian ideal of womanly perfection, Barfoot insists, does not fit the times. It would have women remain dependent when they have only themselves to depend upon. The old ideal has ceased to serve and must therefore yield to an ideal of strength and self-reliance, a new ideal that will produce a new woman. With the change men as well as women will surely benefit. This new woman should be active in

every sphere of life, performing her share of work though not at the expense of the home. Her character should reflect a range of feminine virtues as well as those too long considered exclusively masculine.

"Let a woman be gentle," Gissing has Mary Barfoot assert, *"but at the same time let her be strong; let her be pure of heart but none the less wise and instructed."* Adopting these so-called manly virtues will make women no less feminine than earning a college degree. As they improve and grow stronger, so will the race. *"The mass of women have always been paltry creatures,"* she continues, *"and their paltriness has proved a curse to men. So, if you like to put it in this way, we are working for the advantage of men as well as for our own."* Barfoot's words could have been spoken by Gissing himself. The same phrases he used in letters to Bertz and Roberts, and to his family in Wakefield.

Chapter Sixteen

The New Woman and More

After 1890 many engaging characters in Gissing's fiction come forward as new women. While some are merely pretenders, others become bona fide new women as soon as they finish their education. These are *"the coming women,"* he puts it, lively young girls eager to become adults and preparing for a vigorous new womanhood. The earliest example of the type is Hilda Meres in *Isabel Clarendon*. Her daily exposure to the new education has made her vocal and immensely learned. *"How much she knew!"* Gissing exclaims, intruding to strengthen the satire. *"She could render you an ode of Horace, could solve a quadratic equation, could explain to you the air-pump and chemical combination, could read a page of Aelfric's 'Homilies' as if it were modern English. And all the while the essence of her charm lay in the fact that she knew absolutely nothing at all."* Gissing is writing with tongue in cheek. Hilda Meres is one of

his best satirical creations, a lyrical and lovable teen for all ages.

Had Gissing met a girl in the same class as Hilda at Mrs. Gaussen's estate? Did he listen to her talk sitting beside her at dinner? And was he amused by what he heard? The character who usually speaks for Gissing in this novel, Bernard Kingcote, reveals impatience with the manners and behavior of young girls: *"I never met one who did not seem to me artificial, shallow, illiberal, frivolous, radically selfish."* That could reveal Gissing's own opinion, but not really. He liked American schoolgirls; he liked females of all ages. He depicts Hilda Meres with gentle satire and likes her very much. Young and vivacious and loving all that life has to offer, he allows Kingcote to say: *"she crossed your path like a sunbeam."*

Similarly portrayed, though with heavier irony, is Cecily Doran of *The Emancipated.* A very advanced young woman, she has mastered the new education and is eager to display her vast knowledge. But like Hilda Meres, while seeming to know a great deal about all kinds of things, she really knows little about anything. We are told she lacks that synthesis of knowledge that brings understanding. With a satirical thrust but with gentle indulgence, Cecily's guardian Ross Mallard sketches the following portrait of her. His voice is much the same as Gissing's:

> *Miss Doran is a young woman of her time; she ranks with the emancipated; she is as far above the Girton girl as that interesting creature is above those of an establishment of young ladies. Miss Doran has no prejudices, and, in the vulgar sense, no principles. She is familiar with the Latin classics and with the newest religion. I am not certain she knows much about Shakespeare, but her appreciation of Baudeluire is exquisite. I don't think she is cruel, but she can plead convincingly the cause of vivisection.*

The tone of Mallard's remarks suggests that he is not altogether pleased with the intellectual accomplishments of his pretty ward, but is amused by them. In his opinion, her education is based too much on the fleeting present. Her knowledge of the classics is thinner than paper, consisting mainly of names; her grasp of history, literature, politics, and the new science is not much better. As a product of the oft-praised new education she lacks depth of knowledge and comprehension.

The Girton Girl was a student at Girton College, a famous college for women. It owed its existence to Sarah Emily Davies (1830-1921), who was a pioneer in higher education for women. The college was opened in 1869 as an independent institution. It became a college of Cambridge University in 1873, but did not gain full

college status until 1948. In 1976 Girton College became coeducational.

As Mallard lists examples of Cecily's expansive knowledge, Gissing can't resist showing off some of his own. He declares that Cecily *"can tell you Sarcey's opinion of the newest play"* or discuss with you *"the merits of Sarah Bernhardt in 'La Dame aux Camelias,' or the literary theories of the brothers Goncourt."* The mention of Francisque Sarcey (1827-1899) is a good example of how Gissing made use of the materials he gathered from experience. Shortly before he began writing *The Emancipated* (1890), he had gone to one of Sarcey's lectures in Paris and was deeply impressed by his discussion of Alphonse Daudet's newly published novel, *L'Immortel* (1888). Sarcey had recently given up a professorship at Grenoble to become a public lecturer.

Taking it upon herself to polish Cecily Doran's education, Mrs. Lessingham of *The Emancipated*, an enlightened woman of the world, has thrown away the moral blinders placed by custom on young women of the upper middle class. The average mother, Mrs. Lessingham asserts, wants to keep her daughter *"pure-minded"* or innocent. But innocence is the opposite of knowledge, and it hinders achieving an education. Girls who consider themselves pure-minded are often blind to the faults of the men they marry, and so bring misery into their lives. This same idea, repeated in *Denzil Quarrier,* was dramatized in *The Odd Women*.

Mrs. Lessingham proudly announces that Cecily's

education is free of hypocritical shame, which passes for modesty among too many Victorians. She has been taught to see the world as it really exists, not as idealists would like her to see it. Then Gissing intrudes with authorial comment, saying her education has been too rapid and too filled with facts. That conditioning of the mind which makes for true education, and ultimately emancipation, he declares, is a process associated with the development of the intellect. It can be gained through books to be sure, but experience -- living daily in the world -- is also required.

In his portrayal of Nancy Lord of *In the Year of Jubilee*, Gissing targets the poor instruction of the new high schools. He tells us that Nancy represents a prominent type near the end of the nineteenth century. She should be studied carefully as reflecting faithfully those pretentious, half-educated girls *"turned out in thousands every year from so-called High Schools."* The daughter of a tradesman in Camberwell, she belongs to the social rank of wage-earners but uses the language well because of her schooling. A high-school graduate, she considers herself educated but has no training for the workaday world. Nancy Lord has no genuine qualifications whatever for getting and keeping a job: *"In the battle of life every girl who could work a sewing machine or make a match box was of more account than she."*

When Nancy enters a shop, the young woman behind the counter, working long hours to earn a living,

smiles superiority. So what good is her fine education, her vaunted *"culture,"* if she isn't qualified even to be a shopgirl? She thumbs through a book on *"employments for women,"* but its contents depress her. She is forced to realize that the so-called new education schools is no better at preparing women for gainful work than those of the old. So in true Gissing fashion, she looks homeward for comfort. He was convinced that girls of Nancy's social position should proudly train for domestic service. With education she could become a superior servant. She could enjoy a good life with a good family in a luxurious home. Nancy wouldn't become *"advanced"* as she performed her work as a servant but would find happiness.

Most of *"the coming women"* in Gissing's novels are girls who in time become genuine new women. However, some of them develop into pathetic or ludicrous pretenders, who merely imitate the advanced women. The earliest of Gissing's would-be new women are the Denyer sisters in *The Emancipated*. Common among the three is the resolve to be modern liberated women or perish in the attempt. They go out of their way to make it clear to every person who meets them that they are not ordinary women and must not be treated as such. Matthew Arnold's definition of culture is their pursut, a perverse distinction their pride. Gissing paints them broadly with patience and good humor.

In their make-believe world each girl has a specific role to play. Barbara poses as the adorer of all

things Italian. Speak to her of Rome and she murmurs rapturously, *"Ah, Roma, capitale d'Italia!"* Madeline claims wider intellectual scope, *"aesthetic criticism in its totality."* She has read not one page in the original Greek or Latin, but from modern essayists has gathered enough to speak of the classics *"with a very fluent inaccuracy."* Zillah has dedicated herself to *"the study of the history of civilization,"* but her mind is slow and her memory unretentive. She is plainer than her sisers and has nothing of their superficial cleverness. Her plainness makes pretense harder to maintain.

Gissing's satirical portrait of the Denyer sisters -- he was at his best when acting as satirist -- pokes fun at those who believe they can achieve happiness by imitating the new women. To find happiness that way is impossible, he reveals as the story unfolds, for the new women themselves often miss their chance for happiness. They assume their mission is of paramount importance and the only endeavor worth living for, but in the end some of them are forced to realize they have wasted their youth chasing a dream. What is more, they often discover that the attempt to become something other than they are capable of becoming is a recipe for discontent and disaster.

Along with Zillah Denyer, who becomes a governess in a Christian and conservative middle-class family and ceases to practice affectation, two memorable would-be new women of later novels illustrate this point. Jessica Morgan of *In the Year of*

Jubilee can no longer take the pressure and begins to fall apart, to unravel in use like a poorly made garmet. The condition is a revival of Gissing's earlier theme of feminine deterioration. Iris Woolstan of *Our Friend the Charlatan* gains enough self-knowledge to recognize how false is her existence and how it can only bring her pain. By giving up the silly pretense she has so carefully cultivated, she manages to escape Jessica's grief and desolation.

Jessica Morgan is a moving study of a girl with slight intelligence who tries earnestly and pathetically to enter the ranks of clever women. Her fond hope is to become a thoroughly educated, exceptional woman of high accomplishment. *"To become B. A., to have her name in all the newspapers, to be regarded as one of the clever, the uncommon women – for this Jessica was willing to labour early and late, regardless of failing health, regardless even of ruined complexion and hair that grew thin beneath the comb."* After failing an important examination, which she believes will place her on an easy road, she yields to frustration and decline, despair and half-madness.

Iris Woolstan, in spite of her conventional domestic background, is persuaded by Dyce Lashmar, the affable charlatan who becomes her husband, into viewing herself as a new woman. But when they are about to be married, Lashmar has a change of attitude and offers a different kind of advice: *"After all, you know, you're a very womanly woman. I think we shall*

have to give up pretending that you're not." Then he adds indulgently, *"It's all very well to be womanly, but don't be womanish."* Gissing knew that readers attuned to current developments would fully understand the difference. Lashmar's instruction was not intended to be subtle. Though a charlatan, a double-dealing fraud, Lashmar is likeable, charismatic, and merits the title of the book, *Our Friend the Charlatan*.

Near the end of his career Gissing believed the new woman at her best was womanly, but when she first appeared in his novels she was neither womanly nor womanish, but mannish. His earliest portrait of a fully realized new woman is Ada Warren in *Isabel Clarendon*. As early as his first novel, *Workers in the Dawn*, he had given to Helen Norman some clearly recognizable traits of the new woman. However, she was shown mainly as a blue-stocking philanthropist, angelic at heart but seizing the podium whenever she could to pontificate on the needs of the poor. Not until 1886 in *Isabel Clarendon* did Gissing create a realistic character to open commentary on the woman question.

Ada Warren is intelligent and accomplished but complex, intense, and emancipated. She is unpleasantly strident and the opposite of the ideal womanly woman as Gissing saw her. She is plain and severe while Isabel Clarendon of the book's title is beautiful, gracious, and charming. Ada's masculine manner is clearly in contrast with Isabel's feminine womanliness. Her searching, probing, trenchant mind is the backdrop to Isabel's

calm serenity. While Isabel is *"a woman to the tips of her fingers, a womanly woman,"* Ada as a new woman willfully suppresses her femininity and parades her plainness. She is clearly a foil to Isabel Clarendon and was not meant to assume an important role. But as the novel progressed she claimed more and more of Gissing's attention.

Though aware of her shortcomings, and ironically suffering from a sense of inferiority, Ada Warren is consistently intellectual. Invariably she chooses reading matter considered too difficult for the conventional woman. Her literary tastes include the *Fortnightly Review,* a prominent and influential magazine, and *The Nineteenth Century* of similar stature. The narrow, frivolous, empty femininity of *The Queen* is unworthy even of her scorn. Her book of the moment is by the father of positivism, Auguste Comte. Asked whether she is a positivist, she brashly replies, *"No, merely an atheist."* The matter-of-fact reply discloses the pleasure Ada takes in shocking her friends. She could have said *"agnostic,"* but *"atheist"* was a stronger word and more startling. *"The new word,"* she explains, *"has been coined principally to save respectability."*

The new woman in the likeness of Ada Warren is presented as a study of angry outspokenness, inflexibility, spiritual dryness, and stern defiance of men. When Bernard Kingcote comes upon her sketching in the countryside, she returns his gaze with a look of equal boldness. She is passionate in feeling and thought,

but is uncertain of her sexuality and how it relates to men. Her sexual energy finds release in activity. Like other new women in Gissing's work, Ada is busy from dawn to dusk but manages to make time for personal development. She reads Latin and Greek, writes short stories, practices critical acumen, paints, and plays the piano. Alert and alive, and apparently a woman of high value, she is nonetheless *"a strange specimen of womanhood."*

A new woman better realized and rendered than Ada Warren is Marcella Moxey of *Born in Exile.* By the time this novel was published in 1892, Gissing had become acquainted with Edith Sichel and was able to draw upon personality traits he saw in Sichel. On the whole, however, both Warren and Moxey are founded more on Gissing's reading than on firsthand observation. They stem from his broad acquaintance with the literature of the movement, and they mirror the extreme new woman most often presented in newspapers. Although Marcella shows greater subtlety of development and delineation, both characters are clearly types and not entirely believable.

Since both are deeply unhappy, the implication is that all women of their type are miserably maladjusted and live in lonely isolation. Marcella, like Ada, is dark, intense, and *"bitterly enlightened."* She is a young woman living in exile among traditional females and despising them. Her mission is to demand full freedom in all areas of life, but *"the burden of sex"* restricts her movements

and weighs heavily upon her. Her persistent sexuality gives her the strength to revolt against the past, but doesn't help her in the presence of men. In alliance with natural forces, impulses of her own nature work against her. Marcella Moxey is probably a lesbian, though Gissing can only hint at that; the times would not allow for anything more open.

Though an atheist and holding bitter thoughts regarding religion, Marcella's moral sense is highly developed. Practicing uncompromising honesty, she despises all falsehood, injustice, hypocrisy, and behavior of any kind that is negative or brutal. However, she is prone to attack the beliefs of ordinary people, and they shun her. She has great strength of mind and heart, but the world is unwilling to accept her as a sensitive, intelligent, aberrant human being. Her emancipation does not bring her any of the rewards promised by the feminists. On the contrary, her insistence on individual freedom only makes her different. Like Gissing himself, Marcella is fated to be an outsider even as she works hard to serve. She dies trying to prevent a brutal carter from mistreating his horse: *"Marcella tried to get between him and the animal just as it lashed out with its heels."* Gissing's attitude toward this character is at most ambivalent. Stressing the good in the young woman, he is conscious of defects that ultimately will destroy her. Perhaps to have an accident end her life suddenly was a kindness.

Standing in striking contrast to Marcella is her

sister Janet of *Born in Exile*. Better adjusted, Janet studies medicine in London and becomes a physician of some renown. That places her among the rare and clever women, the charmed circle that Jessica Morgan of *In the Year of Jubilee* longed to enter. In time Janet becomes an admirable woman of the new ideal. All sorts of people begin to recognize her value and pay attention to her. When she enters a room where people are gathered, all eyes are cast in her direction. As she moves from one person to another at a social gathering, she is singled out for notice. She is pleased by the recognition but not unduly affected by it.

Her job is more important to her than her social life. On one occasion when she leaves a gathering, Gissing observes: *"There lingered behind her that peculiar fragrance of modern womanhood, which is so entirely different from mere feminine perfume."* Earlier Isabel Clarendon, a social butterfly and quintessential womanly woman, was scented with delicate perfume suggesting flowers in springtime. Dr. Moxey's aroma is clinical. It speaks of cleanliness and medical efficiency. It's the essence of modernity and a new breed.

Dr. Moxey prefigures a fuller treatment of the accomplished new woman Gissing would have undertaken had he lived longer. His model for a complex and believable female physician would have been Dr. Jane Walker, whom he met in 1901 when he became a patient at her new sanatorium in Suffolk. Suffering from an ailment that he thought was tuberculosis, Gissing

went there near the end of June and left during the first week in August. He was impressed by any woman with the brains and drive to become a physician. This woman, who seemed to have a profound knowledge of a difficult field virtually unknown to him, left a strong imprint upon his psyche.

Jane Walker had acquired a sterling reputation as a specialist treating a killer disease with the newest methods. She had lectured on the subject and had earned respect in a man's profession. To H. G. Wells, Gissing wrote: *"Dr. Walker makes a good impression. She has been invited, I hear, to read a paper at the forthcoming international congress on Tuberculosis – a distinction which must mean something."* As one of her patients, he was acquiring the material for a memorable character to be modeled after her. However, his medical problems got the best of him before Dr. Walker could inspire imagination and enrich his fiction. He died in France only two years after meeting the woman and having her tell him he did not suffer from tuberculosis.

Gissing's finest portrayal of the new woman is Constance Bride of *Our Friend the* Charlatan (1901). In some respects she is the kind of woman he hoped all women would eventually become. In 1892 he had written that the simpering, vacant, conventional woman would have to yield to a much better type. In 1893 he depicted Rhoda Nunn and Mary Barfoot eagerly giving their energy toward producing that better type. In 1894 he believed that too many women in England were

neglecting their families to pursue careers traditionally reserved for men, and were possibly doing more harm than good. Near the end of the century, Bride was a new woman taking her characteristics from a close friend whom he deeply admired. Constance Bride had been created in the image of Clara Collet, a young woman who had stepped on the scene as a living, tangible new woman working to improve the lives of other women.

Gissing surely had Clara Collet in mind -- her honesty, loyalty, dependability, intelligence, resourcefulness -- as he created Constance Bride. This portrait of an exemplary new woman appears to be his tribute to virginal and constant Miss Collet; the name was intended to be suggestive. The two met in 1893, and before long she was a faithful friend of the family, including Edith and the children. He first heard of Clara Collet in March of 1892, when his sister Ellen mentioned her in a letter. She informed him that the woman had delivered a lecture on his novels before the London Ethical Society. He was pleased with the interest Collet had taken in his work. But when she wrote to him in early May of 1893, asking to meet him, he offered little encouragement. Undaunted, she sent him several articles which she had published in *Charity Organization Review*, including one on himself which he liked. During the next two months he declined several of her invitations, but in July he dropped his reticence and visited her home in Richmond, a London suburb. Jotting down a record of the meeting in his diary, he noted only

that Miss Collet was younger than he expected. It was a terse, oblique reference to the positive impression she had made. But as fate would have it, she had come into his life too late.

She must have seemed to him an excellent specimen of that type of woman whom in theory he had long admired. She had in fact all the qualities of the advanced woman of the late nineteenth century, all the traits of the enterprising new woman. At thirty-three Clara Collet was well educated, active in social reform, and in tune with the intellectual currents of the day. She claimed to be the first woman to graduate from the University of London with a degree in political economy, and to do advanced work in the field. To qualify for the coveted master's degree, her reading included Adam Smith, David Ricardo, John Stuart Mill, and John Ruskin. Gissing soon discovered she was a reader of novels as well.

In 1886 Collet became a researcher for Charles Booth, helping him prepare his monumental *Life and Labour of the People in London*. She specialized in the work that was open to women, and she kept track of the available careers for women. These jobs were increasing with each passing year, and the future was beginning to look less bleak for those superfluous women who had to support themselves. She was later named Booth's chief investigator for women's industries and went on to establish a career as a leading authority on women's occupations. After 1895, she wrote a number of books,

along with shorter pieces published in magazines, on the work available to women.

In August of 1893, after the publication of *The Odd Women* in April, Miss Collet visited the Gissing home in Exeter. By September, when Gissing was quarreling with a plagiaristic parson in a newspaper, the young woman had become a loyal and confidential friend. She was quick to understand the special circumstances of his domestic life, and didn't hesitate to let him know she was ready to offer whatever help she could. He was particularly moved when she asked permission to take care of Walter and support him should the boy's father ever find himself without an income. Gissing had never sought sympathy from anyone.

He might have rejected her on the spot, but the note won him over. On the following day he thanked her for her kindness, and from then to the end of his life they were the best of friends. He respected Miss Collet as a quiet woman of worth, attainment, and ability. He took pleasure in her calm good sense, her sweet reasonableness, but he did not fall in love with her. She was too much his equal for that. Moreover, he was already trapped in a prison of his own making. As to her private feelings we can only speculate, but we know she was devoted to Gissing all the years she knew him and to his memory for the rest of her life.

Even though Clara Collet was active in many causes, including some directly related to women, she didn't view herself as a bona fide feminist. Constance

Bride of *Our Friend the Charlatan* projects the same attitude. She has no special or abiding interest in the woman question, but is deeply concerned with improving the quality of life for the entire race. Her thinking has gone beyond the narrow views of the feminists: *"I hate talk about women,"* she declares. *"We've had enough of it; it has become a nuisance – a cant, like any other. A woman is a human being, not a separate species."* She was speaking for Gissing here, and he was surely in agreement with all she said.

That sentiment, or one like it, might well have come from Miss Collet to be stored in Gissing's memory and repeated later. However, in *Born in Exile*, published in 1892 one year before they met, a female character asserts essentially the same concept: *"There's no longer such a thing as woman in the abstract. We are individuals."* By then Gissing himself was supporting that view and presenting it whenever he could in his books. He disliked general categories for women because they could be inexact and unfair. In a letter to Gabrielle Fleury he insisted he considered some women capable of probing the deepest subjects.

If one is surprised to find Sylvia Moorhouse of *Born in Exile* reading Hugh Miller's *Testimony of the Rocks*, it is a greater surprise to discover Constance Bride looking into Nietzsche with Dyce Lashmar. Miller's book, published in 1857 two years before Darwin's *Origin of Species* and reading evidence of evolution in the rocks, was old and receding in the 1890's. Nietzsche

was new and current and shaping the most recent intellectual opinion. The German philosopher and classicist went insane in 1889 and ceased to write. His translated books were not available in England until near the end of the century. Before that time Gissing's friend Bertz had given him a good understanding of Nietzsche. Sylvia finds Miller's book amusing. She likes especially the chapter in which he discusses at length whether it would have been possible for Noah to collect examples of all living creatures. Devoutly religious, he defended the doctrine of special creation and maintained that the Bible, rightly interpreted, was not contradicted by geological discoveries. The six days of creation mentioned in Genesis corresponded to six geological eras revealed in rock formations, hence the title of his book.

Attracted by the philosopher's criticism of moral values and by his insistence on the right of the strong, Constance nonetheless judges his work dangerous. *"He'll do a great deal of harm in the world,"* she tells her friend. *"The jingo impulse, and all sorts of forces making for animalism, will secure strength from him, directly or indirectly."* His teachings, if carried out on a large scale, could result in *"a return to sheer barbarism, the weak trampled because of their weakness."* Constance Bride's fluent evaluation of Nietzsche's dark philosophy reveals flashes of prophetic insight from Gissing years before the German began to influence artists and philosophers

of the 1900's, and ultimately the Nazi propagandists in the new century.

Other memorable and striking new women in Gissing's fiction are Sibyl Carnaby, Bertha Childerstone, Bertha Cross, Beatrice French, May Rockett, Alma Rolfe, Eleanor Spence, and Stella Westlake. Two of them, Bertha Childerstone and May Rockett, deserve special consideration. Childerstone of the story "Comrades in Arms" has deliberately decided to make her way in a dog-eat-dog profession ruled by men: *"For seven or eight years she had battled in the world of journalism, and with a kind of success which seemed to argue manlike qualities. Since he had known her, these last three years, she seemed to have been growing less feminine."* Childerstone was competing in what Gissing viewed as an unforgiving profession. In 1894, he believed too many women were neglecting their families to pursue careers reserved for men simply because the coveted careers had become open to women.

May Rockett, in "A Daughter of the Lodge," is a new woman of democratic outlook humbled by the aristocratic order. She has come to believe that the old order of severe class distinction has yielded to the 1890's *"spirit of the times."* Visiting the country home of the baronet who employs her parents on his estate, she tries to behave on terms of equality with the baronet's daughter, Hilda Shale. Instantly mother and daughter conspire to punish Miss Rockett by threatening to dismiss her parents and move them off the estate.

Showing no mercy, they force her to apologize for her behavior and promise never to come to their house in future. Mistakenly believing that the new ideas that animate her have vanquished the old ways, she comes into conflict with inflexible tradition and is brought to her knees by it. Humiliated as she could never imagine, she returns to her friends in London and never visits the Shale estate again. The sad story drives home a realistic fact.

So what was the general reaction of men to these new women becoming so very numerous near the end of the century? In any public discussion of the woman question the masculine reaction was seen as very important and was given due attention. Gissing had three male characters in *Born in Exile* reflect the real-life reaction of ordinary men in England. Peak takes the conservative position, Malkin presents the liberal view, and Earwaker is the moderate person between the two.

"*I hate emancipated women,*" Peak declares. "*Women ought to be sexual.*" Not entirely disagreeing, Earwaker offers another opinion: "*But the woman who is neither enlightened nor dogmatic is too common in society.*" The high-minded new woman, he adds, does not have to be extreme in her behavior, nor plain in looks. She can be as charming as any woman and more attractive than most. Then Malkin presents the liberal view: "*Nothing like the emancipated woman! How any man can marry the ordinary female passes my understanding.*" One can see that Malkin is swayed

by feminist propaganda. Peak is emotional and too egotistical to arrive at a fair and balanced appraisal. Earwaker, calm and moderate and standing squarely between the two extremes, expresses Gissing's own views.

In 1892 Gissing still believed that education was the panacea to eradicate foolishness in women. He said as much in letters to his sisters, urging them to take their studies seriously. In *Born in Exile* he has Peak say this, speaking Gissing's thoughts: *"The defect of the female mind? It is my belief that this defect is nothing more nor less than the defect of the uneducated human mind."* He was saying that a lack of education and the negative effects it produced applied to men as well as to women. The solution, therefore, was universal education. At that time Gissing was in full sympathy with the feminist movement in its aim for equal education for both sexes. He believed that in time the movement would replace empty-headed women with a type of woman even more acceptable than the new woman. As 1892 got underway, his estimate regarding the new woman was in suspension, but already he was beginning to believe the new education was sterile. It was a year before Clara Collet became his friend for life and several years before Gabrielle Fleury, a lyrical woman he would love and marry, came into his life.

Chapter Seventeen

With Time Comes Change

As Gissing reached his fullest development as a novelist, his opinions on the woman question underwent change. At the beginning of his career he readily accepted the ideal of the womanly woman as described by Ruskin in *Sesame and Lilies* (1871). In his first novel Helen Norman was idealized as a sensible womanly woman who wanted to make a positive contribution to society. In his second Ida Starr, a prostitute made noble by a cleansing sea bath, became the ideal. In his third Isabel Clarendon emerged as his best representation of the womanly woman. In his next three books he somehow confused ideal womanhood with saintliness and produced a gallery of feminine characters called angel-women. By 1888 he sadly had begun to realize that his perception of woman, when translated to paper, was overly idealistic and unconvincing.

In letters to Bertz, he expressed artistic frustration when it came to rendering female characters

realistically, particularly the ones he admired. In the fall of 1891, he said: *"It is quite certain that some of my own girls and women err on the side of goodness. It is easy to tell an author that his women don't please one's critical sense, but damnably hard to represent the women one has in mind."* Near the end of the 1880's he became interested in the women's movement and quickly saw the possibility of using feminist types in his fiction. Here was a new kind of woman, an extraordinary woman, who made herself the topic of lively conversation wherever she went. Whether they sympathized with the feminist movement or not, readers would find the new type a refreshing change from the totally predictable conventional woman.

So in 1890 he showed the womanly woman throwing off the drab and gloomy mantle of puritanism. Influenced by Matthew Arnold, he had her move from strict hebraism to embrace hellenism. The process emulated the feminist cause with its cry for greater freedom in all areas of life. By 1892 he had brought into his work an authentic feminist, Mrs. Wade, and the next year in *The Odd Women* he presented the woman question in full detail for his readers to study. While giving his feminists every opportunity to be heard, he balanced their talk and opinions with the ultra conservative stance of Edmund Widdowson and characters of similar persuasion.

Devoutly and stiffly traditional, Widdowson cries out against the new developments that were changing

womankind. An admirer of John Ruskin, he sees Rhoda Nunn as unwomanly and despises her for trying to make other women unwomanly. Convinced that woman's place is the home, he is certain that working side by side with men, she will lose her femininity and her aptitude for those special duties assigned by tradition. His solution for women who have to work: let them become housekeepers for wealthy families, for the home is where they belong. Widdowson's conservative position prefigures the kind of thinking that Gissing would reveal in later years as his own. His voyage in troubled waters was from the liberal to the conservative.

While liberal Miss Barfoot considers the position old-fashioned, Micklethwaite, a character guided more by feeling than thought, tends to agree with Widdowson. He asserts that girls should not grow up thinking that marriage is the only career available to them. But in the same breath he expresses longing for female embrace. He has a liking for Rhoda Nunn, the feminist, and would like to test her sincerity by making love to her. Fifteen years earlier, in the spring of 1877, Gissing had jotted down in his American notebook: *"Trace the seduction of a masculine-minded woman."* He was now using that nugget in *The Odd Women,* one of his best-known novels and still in print.

Gissing's next novel, *In the Year of Jubilee,* embraced conservative opinion because the bitterness of his life with Edith left him snatching at straws. By 1894 their

marriage, so promising in the beginning, had fallen into irrevocable ruin. That caused him to view with disgust the typical woman of the lower middle class who cared for nothing beyond herself. Stephen Lord, lecturing his son on women, speaks Gissing's thoughts: *"When you are ten years older, you'll know a good deal more about young women as they've turned out in these times. You'll have heard the talk of men who have been fools enough to marry choice specimens."* The comment suggests that Gissing took comfort in the belief that other men had suffered mistakes similar to his.

Bristling with contempt, Lord speaks of *"trashy, flashy girls"* who call themselves ladies and consider themselves too good for *"honest, womanly work."* Unfit as wives and mothers, they have turned the home into a place of *"filth and disorder, quarrelling and misery."* Instead of staying home to look after a family, they jostle one another in the streets and shops as they chatter nonsense. They have nothing to recommend them, not even their youth. Lord's tirade is focused on women of the middle class and lower-middle class. He doesn't include upper-class women, for they are not so ready to accept every new fad that comes along and are not so vulgar. The attitude reveals that Gissing in maturity never lost his respect, even his sense of awe, for the upper classes. Though he would never be able to enter their ranks, he would admire them from a distance to the end of his life.

In 1890, denouncing *"the school of hypocritical*

idealism" that was Ruskin's position, Gissing opposed placing women on pedestals. At the same time he lamented their *"slavery to nature"* in the biological sense and their lack of freedom in many areas of life. He was in sympathy with Cecily Doran of *The Emancipated* when she refused to occupy herself with the demands of motherhood: *"Cecily did not represent the extreme type of woman to whom the bearing of children has become in itself repugnant; but she was very far removed from that other type which the world at large still makes its ideal of the feminine."* Cecily, one may recall, was carefully schooled in the new education and later tutored by a woman of the world to become fully liberated.

In *New Grub Street*, published a year later, he could show Edwin Reardon disliking his little son for demanding so much of the mother's time. Nature and the sordid scheme of things seemed unfair to women. Near the end of 1891, when his own son was born, Gissing's thoughts centered mainly on the pain Edith was forced to endure. Yet by 1894 he expected his wife to love and care for the child with all the energy at her command. His change of mind is mirrored in the attitudes of Arthur Peachey (1894) and Harvey Rolfe (1897). Both characters love their sons fiercely and reveal deep anxiety when their mothers neglect them.

Within a few years Gissing revised his opinions on the modern mother. By 1894 he was also beginning to question his earlier views concerning the place and position of women in the world. He never believed,

however, even when most cynical, that women were inferior to men. The notion defied logic and was an abomination to all thinking people. As late as August of 1898, he was asserting in letters to Gabrielle Fleury that he recognized no restraints whatever upon female intellect. The feminist movement had encouraged improvement of mind, and that was good. But regrettably it had also fostered a spirit of rebellion that was undermining domestic stability in young and fragile marriages. It was throwing too many English homes into tumult.

To stem that destructive tendency, a show of male dominance in the household was perhaps a necessity. A display of physical superiority at the right time might put a damper on the rebellious woman. A verbal warning in some cases might do the job. So Lionel Tarrant of *In the Year of Jubilee* lectures his wife Nancy like this: *"I am your superior in force of mind and force of body. Don't you like to hear that? Doesn't it do you good when you think of the maudlin humbug that's generally talked by men to women?"* Lionel despises the liberal gibberish of the feminist movement (and the men who parrot it), believing it has caused infinite harm.

In *The Whirlpool* Gissing vehemently opposed the view that a wife and mother should have unlimited freedom to indulge social activities. Alma Rolfe is granted such freedom and through the abuse of it wreaks destruction upon her marriage. By contrast Mrs. Basil Morton, an old-fashioned wife and mother

in the same novel, finds deepest fulfillment in the role nature intended for her: *"Into her pure and healthy mind had never entered a thought at conflict with motherhood. Her breasts were the fountain of life; her babies clung to them, and grew large of limb."* Gissing deliberately defied would-be censors by using risqué language.

Mrs. Morton is the kind of woman who would find it impossible to abandon her children to servants, but Gissing feared that women of her type were rapidly vanishing. On the first day of 1880 he could have read in *The Times* advertisements such as this: *"Governess Wanted. A middle-aged lady to educate and take care of our two little children. The mother is delicate and unable to attend to them."* If the mother were not actually sick, Gissing would have said, she would have to be considered lazy and criminally indifferent to the welfare of her children. A new trend had begun among affluent middle-class wives. Many of them were paying working-class women to raise their children. The very idea was abhorrent to Gissing. He found it alarming.

His next publication, a collection of short stories he titled *Human Odds and Ends* (1898), ended with a story about a wife and mother, Mary Claxton, who attains peaceful and perfect womanhood through self-sacrifice. Entitled "Out of the Fashion," its concluding paragraph suggested that by 1896, the year the story was written, Gissing was drifting backward toward the camps of Ruskin and Mrs. Ellis. *"She sits there, with thin face, with silent-smiling lips, type of a vanishing virtue....*

An old-fashioned figure, out of harmony with the day that rules, and to our so modern eyes perhaps the oddest of the whole series of human odds and ends." In a rapidly changing world her type, by the end of the century, was becoming a rarity. By then Gissing had convinced himself that in the new century such women would likely become extinct.

H. G. Wells, happily married to one of his former students, jokingly objected to the sentimental tone of the story. He said the character of Mary Claxton was beyond belief, coming from Gissing, and unworthy of a cynical realist. In reply Gissing wrote on July 16, 1898: *"As for 'Out of the Fashion,' why, you and I differ to a certain extent on the one great subject. Of course I have bungled what I meant; but the sentiment is ingrained in me, and will outstand every assault of humour."* The Mary Claxtons were out of fashion, he was quick to explain, because the Ada Peacheys by the thousands had taken over. In other words, the self-sacrificing woman of the old ideal, sweet and respectable and eager to please, had been replaced by the trashy, flashy, selfish shrew who was a product of troubled times.

The feminist agitation had promised a better type of woman, but it was producing busy women meddling in the affairs of others while conserving time for themselves. Linda Vassie of the short story "At High Pressure" (1896) is the best example: *"From morning to night – often, indeed, till past midnight – Linda was engaged, at high pressure, in a great variety of pursuits."*

The least domestic of persons, she makes use of her newly gained freedom *"to speed about in cabs and trains, to read all the periodicals of the day, to make endless new acquaintances, and to receive a score of letters by every post."* Though sparely educated, she dreams of vigorous leadership in high places and expansive knowledge of the world. However, the dream cannot be realized because she is not preparing herself for any recognizable career and is not productive.

Linda's excessive and misdirected energy disturbs more settled people and leaves them speechless. In many respects she is comparable to the kind of woman who raised the disgust of Stephen Lord. Also she prefigures Miss Rodney, the teacher who dabbles in the lives of others in the story "Miss Rodney's Leisure" (1903). Of good intelligence but lacking any real discipline, at twenty-seven Linda Vassie has not relaxed long enough to take an inventory of her abilities and has found no way to make a positive contribution to society. By now Gissing was thinking that the ideal of the new woman, so carefully nurtured over the years, was becoming distorted and debased by such women as Linda Vassie.

But what about women of the lower classes? In "A Free Woman" (1896), an intensely satirical short story, Gissing studied the effects of feminine emancipation upon Charlotte Grubb, a woman of the working class. The news of liberty and equality is shown as slowly filtering down to her from the upper classes. In a tone of bitterness Gissing remarks: *"It must not be supposed*

that female emancipation, in the larger sense, is discussed only among educated women; the factory, the work-room, the doss-house have heard these tidings of great joy." Feminist rhetoric in books, pamphlets, newspapers, speeches, and word of mouth soon convinces Grubb that *"the first duty of woman is no duty at all."* Gissing is saying the feminist cause wasn't confined solely to the middle and upper classes in England. By the 1890's, because working-class girls and women were taking advantage of the new education, the message of the movement was spreading to all levels of society. It began with the middle class but had touched all classes by the end of the century.

Even though Grubb belongs to the servant class, living day and night at the beck and call of another woman is unthinkable. It is worse than getting married and having to tolerate a demanding husband and hungry kids. So in good times she earns a precarious living doing odd jobs in lodging-houses. In not-so-good times she takes advantage of charitable shelters. Coming down with an attack of bronchitis, she is admitted to a free hospital and spends an enjoyable Christmas there, resting and relaxing while those caring for her work long hours and leave work exhausted. At no expense to herself she could train for a job, but in a nation rapidly becoming a welfare state why bother to work at all? She has learned how to play the system.

Charlotte Grubb is meant to be an extreme example, satirical and humorous, and yet she illustrates

Gissing's fear that emancipation was producing untoward results. In his Commonplace Book, he recorded another example, that of a female hunter who took extraordinary pleasure in slaying a lion and writing about it with equal pleasure: *"As I woke my husband, the lion – which was about forty yards off – charged straight towards us, and with my .303 I hit him full in the chest, as we later discovered, tearing his windpipe to pieces and breaking his spine. The lion charged a second time, and the next shot hit him through the shoulder, tearing his heart to ribbons."*

For one who experienced a troubled conscience when catching a writhing fish on a hook, the implicit brutality in the female hunter's language, was alarming. Gissing took the passage from a lengthy article written by one Mrs. Hinde for *Pearson's Magazine* in May of 1900. In *The Private Papers of Henry Ryecroft* (1903), he quoted the passage exactly as he had recorded it, and had his alter-ego Ryecroft exclaim: *"If not so already, this will soon, I dare say, be the typical Englishwoman."*

During the decade of the 1880's Gissing was in sympathy with the feminist aim to educate and liberate women. By the end of the 1890's, however, he had become disillusioned with the effects of the movement upon the women of his nation. The cry for equality was making women of every class independent and aggressive, but the new creed was not producing noticeable improvement. At the beginning of the new century he retreated from an earlier *avant-garde*

position regarding the woman question to the ranks of the conservatives. The hope of earlier years had yielded to doubt and cynicism.

His opinions on the subject were similar to those expressed by Martin Blaydes of *Our Friend the Charlatan.* Two causes, the old man explains, have brought Great Britain to its present sad condition: the tyranny of finance and the power of women. While both forces are considerable, the latter is the one to fear. Changing the status of woman was a bitter mistake, a vain illusion that has wreaked untold suffering upon all members of the British family and the entire nation. So put an end to the nonsense before it is too late: *"Back with them to nursery and kitchen."* It was the fond hope of the old man, but it didn't happen.

The charlatan of the title, posing as a strong believer in women's rights, secretly agrees with Blaydes: *"He knew that he himself would have spoken thus had he not been committed to another way of talking."* Sometime later Lashmar weds Iris Woolstan, a freckle-faced womanly woman, who pretends also to be what she is not. The charlatan had set his cap for Constance Bride, a genuine new woman, but failing to win her he rationalizes accepting Iris in this way: *"A womanly woman, the little mistress of the house; and all things considered, he couldn't be sure that he wasn't glad of it."*

While Gissing tends to agree with Martin Blaydes, the old man is too rigidly conservative to reflect accurately the author's state of mind. The thoughts

of Lord Dymchurch, a seasoned aristocrat, are more nearly Gissing's own: *"Frankly he said to himself that he knew nothing about women, and that he was just as likely to be wrong as right in any theory he might form about their place in the world."* As a thinking person and as a man of strong feeling, Gissing had struggled to understand women. As a novelist, he tried to present them realistically. But late in his career he was admitting he was not and had never been an expert.

One could interpret this final position as pessimistic denial that he had learned anything during his long and laborious career. However, Gissing was fascinated by women and continued to study them to the end of his days. He liked the earthy quality of Italian women. In Venice he ogled the girls and remarked to Bertz in a long letter: *"Heavens! The beautiful faces that I pass every hour. They are magnificent, Venetian work-girls!"* The last woman to be admired and studied was Gabrielle Fleury, a lively Frenchwoman whom he loved at first sight. He drank her beauty like nectar and eagerly embraced her as a splendid creature not quite of this world. After living with her a few years he tempered that opinion somewhat, but he died knowing that a beautiful woman whom he loved deeply also loved him deeply.

Chapter Eighteen

Gabrielle Marie Edith Fleury

When Gissing returned to England from Italy in the spring of 1898, the Surrey countryside was vibrant and pulsating, fragrant and full of color. But the natural beauty he had loved all his life failed to lift him from the gloom of mounting troubles with Edith. Tenacious emotional distress blunted his keen awareness of nature and left him dejected. In May he rented a house in Dorking within cycling distance of H. G. Wells but far enough from London to make it difficult for his troubled wife to find him. Throughout the summer, he lived in fear of the woman descending upon him when he least expected it. By then he had convinced himself that Edith suffered from mental problems and was capable of the most unpredictable and violent behavior. He knew that even for the sake of the children, he would never live with her again. He wanted a divorce, but she wouldn't sign the papers even for separation.

It was not an easy spring and summer for Gissing.

Wracked by worry and anxiety (Edith was trying to discover his address), he was not able to enjoy even the warmth of the new season. In June, however, he received a letter from a young Frenchwoman who wanted to translate *New Grub Street*. Her name was Gabrielle Fleury and she lived in Paris. In time she would bring him greater happiness than he had ever known. It would be a bittersweet happiness mixed with malaise. His health had begun to decline. Gabrielle's letter came on June 23, 1898. He made reply the same day.

Apologizing for writing in English, he informed her that a French translation was being considered by Georges Art, an author who had recently published a translation of *Eve's Ransom*. Then he added that he really didn't have any say in the matter, for the book -- already his best-known work -- belonged to Smith, Elder & Company. He told her that he was living in Dorking because his health would not allow him to breathe the air of big cities. He said he would be pleased to have her visit him. Just one day earlier, he had written to his friend Wells, saying he was lonely and agitated and much in need of company. *"My dear Wells, I really must see you. I know it is asking a great deal, but I am in the usual gloom (nay, worse than usual) and I really must talk to you."* Wells cycled over to Gissing's house to arrive by three o'clock in the afternoon so as to return to his own house before seven. The record doesn't show whether Wells, a maker of jokes and more cheerful than Gissing,

was able to lift the emotional gloom of his friend him or not.

For several weeks Gissing had been trying with all the energy he could muster to write a play. After time and struggle he had finished only one act. Conversation with a pleasant young woman, however brief, might help him get on with his work. He arranged to meet Gabrielle in London on July 5, but later changed his mind and asked that she visit him at Wells's home at Worcester Park. His friend was often critical of Gissing but could be generous and helpful too. He graciously permitted the rendezvous at his and his wife's home. The couple met on July 6, had tea together on the lawn, walked in the garden along the shaded and graveled paths, and enjoyed a lively exchange of talk.

In surroundings more luxurious than he himself had ever been able to afford, he gave his guest conditional permission to begin her translation. Again he cautioned that the owners of the copyright had the final word on such matters, and he urged her to get in touch with them. When she returned to London, Gabrielle had made (as Gissing later told Bertz) *"a very pleasant impression."* Intelligent, well educated, and self-assured, she appeared to be free of those negative qualities that he dreaded in educated English women. Displaying the cool femininity he prized in women of all classes, she was slim and graceful and sexy. She was also sensitive and sophisticated and charming.

Gabrielle Fleury, of Italian ancestry, was born

at Nevers in central France and grew up in Marseille. She came from a traditional, middle-class family but acquired as she grew older some of the characteristics of the Continental new woman. Widely read and interested in art and literature, she frequented literary gatherings in Paris and cultivated the friendship of intellectuals. She spoke and wrote English, knew German well enough to read through Bertz's books, and knew some Italian. She had a passion for classical music, which Gissing had loved even as a boy, and she was a skilled pianist. To his surprise, she also enjoyed vigorous physical activity, hiking and mountain climbing in Switzerland. She was known to go on long trips, accepting the challenge of traveling alone, and found them enjoyable. No one she met ever bothered her.

Without a companion or chaperone, she traveled to and through several countries, viewing herself as a full-grown adult who knew the world. Earlier she had been engaged to Sully-Prudhomme, a poet-critic of some rank, but he was almost thirty years her senior and not suitable for marriage. When Gissing met her she was twenty-nine and he was forty. Her friends knew her by her middle name, Edith. That struck him as cruelly ironical, and in a plaintive note sent to her in August, he requested the use of *"another name besides Edith."* He let her know why he wanted the change, and she gladly agreed on the use of her first name. From that day onward Gabrielle Marie Edith Fleury was known to him as Gabrielle.

Two analyses of her handwriting reflect with accuracy some of the highlights of her character. The first, done in 1887, underscores her pride, compassion, and love of excellence. It also declares that she is ardent, energetic, and self-confident. The second, dated 1893, points out qualities of mind and personality suggestive of the English new woman. She is said to have a superior, strong, almost manly intelligence. She has tremendous energy, high enthusiasm, a will of iron, and a penchant for authority. Passionate by nature, she scorns the commonplace and has a love of independence, which she applies to her daily life.

With their focus on a nervous, active, sensual but cerebral person, both analyses are fundamentally correct. They err, however, when they describe a representative type rather than an individual with unique qualities not always positive. They rely upon tired clichés still in use by graphologists today that fit the individual to the group. Nonetheless, she was a moderate new woman with many good qualities. She reflected in her pleasing personality the new attitudes but many of the old, and she emanated an abundance of femininity. For Gissing, visibly tired of the woman question and all the babble it had generated, that subtle blend of mind and body and spirit was refreshing and alluring.

During their first meeting she impressed him as a sincere young woman who spoke of his work with genuine interest. He later claimed he fell in love with

her at first sight. The evidence suggests, however, that neither her beauty nor sympathy moved him at the time. In his diary he failed to record his initial response to her, merely noting that she had come to Surrey and wanted to translate one of his novels. Yet on July 10, four days after her visit, he noted that he was thinking about a new novel to be called *The Crown of Life*. It would pay attention to some of the main issues of the day, as in all of his novels, but mainly it would probe the mystery of enduring love between a man and a woman.

From the moment he looked at Gabrielle's handwriting, holding and touching the scented letter she had sent him, Gissing was feeling he might be able to love this woman. Indeed in his loneliness he wanted to love her, but doubting that she could ever return his love, he thought of her with caution. At the same time he was shaping the theme of his next novel, the winning of a lover's ideal woman after years of suffering. Vicariously he was fanning the embers of hope. For solace, he occupied himself trying to remember every moment of her visit.

In an early letter to Gabrielle he described her impact upon him. On first seeing her he knew at a glance that she was more than beautiful. On speaking to her he saw that she was truly interesting, womanly, and sweet. At a time when he thought the best of his life was over, she had come to him mysteriously to renew him with hope and vigor. When he was beaten by anxiety and worry and thought his life would soon end, she came

with calm and steady reassurance. When he thought he would die never loving a real woman with unrestrained passion, this delicious person sent by destiny walked out of the mists into the core of his life. Though he didn't believe in miracles, he asked himself what else?

With nervous anticipation he looked forward to her second visit. On July 26, 1898 she came to his home at Dorking and spent the whole day with him. She was dressed in a summer outfit that called attention to her beauty. As he had hoped, the weather was warm and pleasant. They were able to walk down country lanes and talk under the blue sky in mild breezes. All business at first, she informed him that she had reached an agreement with the copyright owners, and her translation of *New Grub Street* would be published in a French newspaper in serial form. She flattered him by praising the strength of his work, and she charmed him with Gallic conversation about her numerous friends in far-flung places. Her English with a slight accent delighted him.

Her voice moved him to deep feeling, and he heard it long after she had left to return home. It was melodious and musical and pleased the ear with a power almost symphonic. He saw in this beautiful person all of those wonderful qualities he admired most in a woman -- beauty, dignity, gentleness, intelligence, and cultivation. He was delighted to learn that she played the piano, and he looked forward to a recital she promised him. When she left that evening on the 8:35, he was in love with the

young woman. This time, if he did any running at all, by no means would it be away from her but toward her.

The next day he wrote her a tender letter -- *"I hear your voice every moment"* -- and requested a photograph that he might hold in his hands. Not more than a week after her departure, in letters written almost every day, he passionately expressed his love. He would live for her, work for her, dedicate his life and talent to her, and make her the end and purpose of his existence. He would place himself totally in her service and do all he could to make her happy. He had not yet received an expression of her love for him, and that delay brought doubt. When she eventually made response, confessing that she returned his love in full measure, his feelings were those he had imagined for the realistic writer Biffen in *New Grub Street.*

A lonely and gentle person, but one gifted with original thoughts he wanted to set forth in his work a new theory of realism. Biffen was an alter-ego. At the time Gissing was writing that book in 1890 it seemed as though he would never succeed as a novelist, and that meant he could never hope to win a woman of comparable intellect and social class. As with Biffen (who killed himself), the love of a beautiful and cultured woman seemed forever beyond his reach, but Gabrielle Fleury was now declaring her love for him, invading his inner life, quickening his senses, and he was *"rapt to the seventh heaven."*

After a summer of correspondence, their

numerous letters quickly becoming passionate, both looked forward to the day Gabrielle would return to England. On October 5, 1898, Gissing noted in his diary that Gabrielle would be coming from Paris the next day, but complications prevented her arrival before October 8. On that day, a Saturday, he met her at East Croydon, waiting forty minutes for the train. Then he took her home to Dorking, where they spent a week together. During those days and nights their parched ethereal paper love became a fusion of flesh and blood and spirit.

The brief diary entries mention the weather, their talking about the future, long walks in the country, and at night reading aloud to one another. Not even one entry suggests a consummation of their love. With the passing of time any reference to physical love would have been deleted by well-meaning relatives, or perhaps Gissing himself refrained from overt description. In the 1890's he was aware of posterity and how it might treat him, and so he may have had the prudence not to record their intimate activity. Earlier with Edith, as we know, he was mindful of others reading his papers at some date in the future.

Even so, some of the letters, particularly the one dated January 1, 1899, contain oblique references to passionate lovemaking. It seems that Gabrielle was Gissing's equal sexually and emotionally as well as intellectually. To his great delight she received and returned his love with eager excitement. On October 15, 1898 when she returned to Paris, Gissing noted in

his diary: *"We have decided that our life together shall begin next spring."* Two days after Gabrielle's departure, her vivid image inspiring his imagination and stirring his style to poetic intensity, he began to work rapidly on *The Crown of Life*. He was certain it would become the best of all the novels he had crafted in twenty years.

As he worked on *The Crown of Life* he wrote passionate letters to Gabrielle daily. *"I dream of you every night,"* he exclaimed. *"I wake and long for you. All day it is you, you, you, who occupy my thoughts."* One is not surprised to discover echoes of Gabrielle in *The Crown of Life*. Irene Derwent's delicate description of a Frenchwoman she once knew is one such echo: *"Madame Rossignol was the sweetest little woman – surely you know that kind of Frenchwoman, don't you? Delightfully soft-voiced, tender, intelligent, using the most delightful phrases; a jewel of a woman."* Also, though Gissing later denied it, Irene herself is the counterpart of Gabrielle. One may see it in her unusual relationship with Piers Otway, the young idealist who falls head over heels in love with her.

A comparison of this fictional character with the man writing the love letters provides a rare glimpse into Gissing's state of mind. At first sight the visionary Piers Otway surrenders to lovely Irene. The special beauty of Gabrielle seized Gissing, who convinced himself that he loved her the moment he first glanced at her. As if afraid to come into the presence of Irene, Otway shrinks from meeting her face to face. On the station

platform, as he caught a glimpse of Gabrielle, Gissing quickly turned and moved away. Otway is compelled to compose himself before encountering Irene. Gissing, we are told, drew near Gabrielle only when he was calm again, only when he had regained his composure.

Irene and Gabrielle both share beautiful, well-modulated voices that clothe each spoken word with a personal magic. Both Otway and Gissing respond to this special gift in the same way: *"How her voice thrilled him! What music like that voice!"* Otway also finds a rare beauty in the girl's classical name: *"Your name is beautiful in any language,"* he tells Irene. *"I wonder how many times I have repeated it to myself."* In one of his letters Gissing exulted, *"Gabrielle! Gabrielle! Your name sings in my heart night and day, I have said it to myself a thousand times."*

Suffering from feelings of social inferiority, Otway has doubts that Irene will ever be able to love him. The same uncertainty pressed upon Gissing. Even when Gabrielle repeatedly proclaimed her love, he feared it would not endure. He knew that he would have to work hard to make himself worthy of her. Otway soon decides he must secure a place in the world before he tries to win Irene: *"Money he must have; a substantial position; a prospect of social advance. Not for their own sake, these things, but as steps to the only end he felt worth living for – an ideal marriage."*

Writing to Gabrielle, Gissing applied those same words to himself: *"From twenty to thirty-three, I worked*

hard for success in literature – always regarding it as a mere stepping-stone to that much greater thing, the love of the ideal woman." Although a malignant fate had dogged his footsteps all his adult life, he had somehow overcome great odds to discover that ideal person who would share with him the crown of life. The years of suffering and struggle must have been a test of fate. Having proved his resolve, his strength and determination, perhaps that rarest crown was meant for him after all. He had lived most of his life in great misery. Now perhaps he could dare hope for supreme happiness.

Gabrielle quickly became the woman of his dreams, *"the ideal of a passionate heart."* His perfect woman, as he now viewed this woman from France, was no aggressive new woman. In his imagination she had become a gentlewoman -- elegant and aristocratic. To picture her on a prancing horse, her face aglow and her dark hair lifted by the wind, thrilled and delighted him. However, when he thought of her riding a bicycle, the lady quickly became a middle-class woman of the world, and the image lost its charm: *"You are not that kind of woman – I think it would be unsuitable to your dignity. Very different it would be if you rode on horseback; that I should like; oh, how splendid you would look!"* The purveyor of the new realism had become a hopeless romantic.

Yet within months, as the visionary gleam faded into common day, Gissing suggested that lovely

Gabrielle learn to ride the bicycle for exercise. He knew that along with others of similar education she had accepted a moderate new womanhood, and cycling was part of that identity. On the surface she was one of those *"advanced women"* whom Gissing had long regarded with ambivalence. But beneath the surface, deeper than he was able to probe at that time, were qualities of the conventional woman. In his dreams she was the strong-minded lady of a knight or lord, an aristocrat exerting a commanding presence. In reality she was a middle-class woman eager to please the ones she loved.

For Gissing her quick intelligence alone placed her in the ranks of the new women. In *The Crown of Life*, Piers Otway, central to the novel, publishes in a Russian magazine an article on the new womanhood in England. Otway is hired by *Vyestnik Evropy* to write the article. In 1880 Gissing himself had been asked by the same magazine to write a series of articles on the political and social affairs of England. By researching and writing the article, Otway becomes an authority on the subject, and Mrs. Borisoff, a character of some importance, is eager to discuss its ramifications. She tells him that she could never become one of his new women because she prefers to live in the sun and air rather than in books. He replies that she is mistaken in her view of the new women as cerebral and bookish and sheltered. They can be strong, athletic.

In June of 1893 Gissing had made similar remarks to Bertz. Also, as early as February of 1882, he had

written to his sister Ellen that *"cultivation of the mind,"* and the resulting strength of intellect, would go a long way toward improving women. Gabrielle, well taught and with native ability, had become his perfect woman because she exhibited that rare cultivation of intellect in a woman. At the same time her intellect had not damaged her femininity, her sensuality. It made her a desirable womanly woman and a woman transcendent of type.

In similar fashion Irene Derwent, heroine of *The Crown of Life*, combines old and new values and differs significantly from the novel's consummate new woman, Miss Bonnicastle. Otway's guarded reaction to the feminine type represented by Bonnicastle is the same as Gissing's: *"He had no active dislike for this young woman, and he felt a certain respect for her talent, but he thought how impossible it would be ever to regard her as anything but an abnormality. She was not ill-looking, but seemed to have no single characteristic of her sex which appealed to him."* In other words, Miss Bonnicastle as a new woman lacked the femininity of the womanly woman.

Yet when she falls in love with Kite, a fellow artist, she loses her starch and stiffness, softens, and becomes more womanly, even more human. The change is slowly and subtly reflected in her work. Earlier she had painted *"glaring grotesques"* for the advertising industry. Now her work is more substantive and more graceful. Kite's influence has made her not only a better

person, but also a better artist. It has worn away the rough edges and made her less abrasive. Gissing saw the new woman as not quite a woman only when she isolated herself from the warmth of other human beings and shunned the influence of love.

It is important to note that Gabrielle in her Gallic charm and love of life went beyond a mere type. In many respects she was simply a woman in love with a man and neither conventional nor advanced. To Gissing's mind she was *"a jewel of a woman"* and her love the crown of happiness. He believed that her coming into his life, so improbably and unexpectedly, was wrought by destiny. Shortly after their meeting he used the word *miraculous* to describe their coming together. Later he said he found it difficult to resist the belief that she was sent to him supernaturally. All of his adult life he had scorned religion with its faith in the supernatural and endless talk of miracles. Now he was using orthodox and biblical terminology to describe an event occurring in his own life, a miraculous event that had shaken his soul.

This woman had come mysteriously from an unlikely place to take possession of his life. She had come at the crucial moment when he needed her most. But instead of attributing his good fortune to a deity with power to intervene in human lives, he gave the credit to fate or destiny. *"If ever destiny brought man and woman together, it did so in our case."* Any number of intricate details had to be adjusted to produce that

result, and only destiny could have done it. No other explanation was possible unless one considered the power of revelation -- epiphany and conversion -- and that for Gissing was ludicrous.

The mystery of their meeting he explained in the words and context of philosophical determinism, a concept that had already entered his books. One day when he was a carefree schoolboy ignorant of man's need of woman, a female child was born in a country with a different language and culture. In spite of differences, from the moment of conception she was meant for him. She lived happily through girlhood and entered womanhood without knowing that mysterious forces were saving her for one man in whose mind her image burned like a flame.

In a distant place, a struggling author was groping his way out of darkness, moving slowly but deliberately from obscurity to reputation, so that eventually the two would meet. Agents of fate prompted her to learn a language other than her own and become a translator. Then, carefully prepared, she was given to one who valued the love she bore as *"the supreme attainment – the crown of life."* Gissing's theory of love was shot through with idealism, but also with determinism: *"I am a determinist,"* he said to Gabrielle. *"I know that nothing could happen but that which did, for every event is the result of causes which go back into eternity."* It was an easy way to explain the miraculous.

The love story of Piers Otway, presented as a rare

instance of triumphant ideal Love, is unequivocally Gissing's own. At the heart of the story, deftly moving it forward, is the deep and abiding influence of Gabrielle. Gissing acknowledged as much in a letter of September 1898: *"I am constantly thinking about my book, 'The Crown of Life.' It has undergone changes since I met you; indeed, it is you who are shaping the book much more than I."* That remark cannot be interpreted as flattery; he was utterly sincere and accurate as he judged the work.

Appearing at a time when he was losing hope and direction, Gabrielle not only stimulated his imagination but also made him a deeper thinker and a better artist. He had planned the book as a love story interwoven with intellectual issues, but gradually he brought into the story a philosophical fabric uniquely his own. The novel would present a theory of love based on Plato and the Platonists, but formulated by Gissing after Gabrielle had come into his life. He would draw upon Schopenhauer and the determinists to help him shape his theory, but the main source of inspiration was his own experience.

Chapter Nineteen

Gabrielle Fleury and the Quest

From the beginning of his career Gissing was able to read Plato in the original. Not long afterwards he learned enough Italian and German to read Dante and Schopenhauer. In 1885 he was reading Plato and Dante simultaneously and deriving satisfaction from both. In a letter to Ellen dated August 2, 1885, he said proudly: *"I read a canto of Dante every day and derive vast satisfaction from it. I am also reading Plato. I am more and more determined to keep to the really great men, otherwise life is too short. Let us think Homer, Aeschylus, Sophocles, Euripides among the Greeks. Virgil, Catullus, Horace among the Latins. In Italian, Dante and Boccaccio. In Spanish, Don Quixote. In German, Goethe, Jean Paul, Heine. In French, Molière, George Sand, Balzac, De Musset. In English, Chaucer, Spenser, Shakespeare, Milton, Keats, Browning, and Scott. These are the indispensables. I rejoice to say I can read them all in the original, except Cervantes, and I hope to take up Spanish next year."*

Near the end of 1889, while touring Greece, he read Plato's *Symposium*, with its famous discussion of love, and began even then to put together parts of his theory of ideal love. For most of his life he had been reading Shelley and was in time no less a Platonist than Shelley himself, though incredulous in his later years. The idealism of Gissing's theory came from Plato, Dante, and Shelley. The emphasis on sexual instinct and persistent determinism came mainly from Schopenhauer. His theory of ideal love was therefore a mixture of Platonism and determinism liberally seasoned by his own experience. He sounded the theory in the letters to Gabrielle. It became the philosophical basis of *The Crown of Life.* The novel's theme and focal point was the mystery and the riddle of timeless love between a man and a woman.

That mysterious phenomenon existing among human beings, the theory preaches as dogma, is the one thing that makes life worth living, the one thing in all of human life that makes any person complete. It is the one great value of our existence and the only absolute sincerity. If an illusion, it is that which crowns all other illusions. To miss love is to miss everything, but love in the higher sense is very rare. Few people are capable of it, and fewer still attain it. To some it falls as if from heaven, but others acquire it only through patience, suffering, and hope as they make themselves worthy. It is the supreme blessing for the very few who receive it, and it brings invariably a new life and a new

soul. Gissing believed that he belonged to that group of persons required by fate to make themselves worthy of transcendent love. He placed Piers Otway, his fictional alter-ego, in the same category.

The crown of life is possible only with one's other half, with the complement that makes only half a person whole. *"Each of us is forever seeking the one half that will tally with himself,"* writes Plato in his famous *Symposium.* And Gissing explains to Gabrielle: *"You and I are the complements of each other."* For years and years, vaguely aware of the search and sometimes believing it had eluded him, he had been seeking her and her alone. Scarcely without knowing it he had moved toward her, for only she had the power to make him complete. His essential woman, she lived in his imagination until at length he found her.

Instantly he recognized her as the standard by which to judge all other women. Charmed by her delightful beauty, even by the way she walked and moved about as if on air, he understood that her face and form reflected an excellence of soul and mind. Had he been an artist, he would have tried to paint her in every detail. As a novelist his purpose would be to capture her radiance not only in words, but also in pictures as vivid as any painting. He would strive to appreciate and preserve for observation and study the nebulous, subtly shifting beauty of a dream woman. The artist Kite tries to interpret a romantic painting that he has worked on for a long time, attempting to

capture on canvas in subtle colors his vision of the ideal woman: *"It's simply woman, as a beautiful thing, as a—a—oh, I can't really get it into words. An ideal, you know – something to live for."*

Another aspect of the theory has to do with searching and finding. The idealist, the love-driven and dream-propelled seeker, may love his ideal woman for many years before meeting her in real life. Tragically, he may give his entire life to the search and come up empty-handed, for to find one's better half is a gift of fate to a selected few. Gissing was quick to tell Gabrielle that he had always loved her, had been looking for her all his life, and would have gone on searching till life ended. And why? Because, as he said to her more than once, *"you, and you only, are the ideal to which I have always aspired."*

As to the quality of her beauty, the real woman may surpass the dream woman, may exactly correspond to the ideal, or on rare occasions may fall short of it. But the reality on a higher plane or a lower always replaces the fragile dream, which can be sustained only so long as the search endures. The sight of one's complement dissipates the dream and inspires immediate love of the highest sort, *"heavenly Love"* as Plato put it. The experience is rare because only those with *"intelligence of the heart"* find their ideal. These are the ones with a special eye to see, the ones with *"emotional perspicacity,"* the chosen few guided by destiny.

These rare and gifted people have the power to

recognize through all forms of desire their counterparts of the opposite sex. This power is a gift bestowed upon very few in a multitude, and even then positive results may not follow: *"Not one chance in ten thousand,"* Gissing writes, *"that I should find the woman I longed for, or that, if I found her, she could love me."* But at a time when all hope is vanishing the lover is guided to his goal by unseen forces, which seem to control his direction in spite of circumstances. Sensing his election and aware instinctively of the forces which help him to achieve his heart's desire, he may see himself as the friend of fortune and pity those less fortunate. Yet the discovery of one's ideal is forever a mystery and miracle never to be fully understood.

At the time of discovery a process of realization occurs, and the lover begins to worship the actual woman instead of the dream woman. *"Henceforth,"* writes Gissing, *"I have no ideal. It has become an existing fact."* Yet the real woman, the physical embodiment of the ideal, often seems not quite of this world. Muted feelings involving spirituality soon rise to religious intensity, and the lover kneels before his lady in prayer. *"My heart and soul turn to you for comfort, for help, many, many times in the day. If prayer means anything, I do really pray to you."* Gabrielle, lifted out of the real world, had become his goddess to be worshipped.

The spiritual turmoil that had troubled the hearts and minds of earlier Victorian intellectuals also affected Gissing. By the time he went to college he was

losing the traditional faith passed on to him by his parents, and for the rest of his life he endorsed a brand of agnosticism quite close to atheism. With Gabrielle he substituted woman-worship for the orthodox religion he never had: *"Dogmatic faith I have none, so I find it impossible to believe in a personal deity. My religion is the mysterious beauty of the universe, and the infinite power of loving that is in the human heart."* Then quickly he confesses, *"I am mad with longing for you, with worship of you."* An atheist who had frowned on all forms of worship all his life was now quite willing to worship another human being. Overpowered by the agony of loneliness and lust, which blandly he interpreted as love sickness, scarcely without knowing it, he was becoming religious. Gabrielle did not object to being adored.

To find one's ideal means a new awareness of life and intense longing for union. One feels doubt, misgiving, and torment of the flesh, but the sensual merges with the spiritual in preparation for marriage. One attains a balance of physical need and spiritual craving. The result is a sacred marriage because it is based on the rarest kind of love. It is usually harmonious, and lasting (though not always happy) because it is decreed by destiny. It is the union of two halves, two complements, to make an intricate and beautiful oneness. Meant by nature for only the favored few and the culmination of a long-determined fate, it obeys the highest laws of the universe and so endures. Gissing's theory was based on classical studies, but also on experience. Shaped in the

heat of his love for Gabrielle, he put the theory to artistic use in the story of Piers Otway and Irene Derwent.

As with Dante gazing upon Beatrice, Otway is smitten by love at first sight. One supposes love at first sight has always existed in the world, and yet it appears to originate with the ancients. One might complete the comparison by adding the story of Palamon and Arcite when the two first saw "fair Emily." Their story is the subject of the "Knight's Tale" in Chaucer's *Canterbury Tales* (1387), a retelling of the "Teseide" of Boccaccio. The story was later cast into heroic couplets by John Dryden. The love-at-first-sight motif came into English literature quite early and has its origins in classical literature.

As with Dante, Otway is shaken by love at first sight. From that moment onward his aim in life is to win the *"one prize worth winning, the love of the ideal woman."* Otway becomes a neophyte in the religion of Love. For eight years he follows a strict regimen of discipline and denial to make himself worthy. He keeps himself scrupulously clean and makes a cult of physical fitness, putting down *"the temper of his blood"* by means of vigorous exercise and cold baths. His behavior is explained this way: *"Ideal love dwells not in the soul alone, but in every vein and nerve and muscle of a frame strung to perfect service."* Ideal love involves body and mind and soul as One.

Otway's father, a confidant and adviser, cautions him to remain true to his ideal by controlling physical

urges; he struggles to obey. To avoid temptation, he chooses to live away from London and carefully watches his diet. In time he is able to subdue the flesh while never ceasing to yearn. He learns how to control the bidding of young blood and how to channel the force constructively. Gissing is saying that the ideal lover must be the conqueror, never the victim, of the sex drive. Resistance and restraint ennoble the seeker and make him strong. Human will has the power to elevate the spirit and put down animal instinct. It is that which separates men and women from animals.

The person who yields entirely to the sexual impulse is soon controlled by it. Driven by a natural force without a moral sense, the unfortunate victim soon behaves like a brute in nature. Daniel Otway, the brother of Piers Otway, exemplifies this concept. Without thought of resistance, he yields to the sexual force and is corrupted by it. Observing a beautiful woman, or even her picture, his reaction is that of the male animal propelled by instinct. The nostrils begin to flare as breathing becomes heavy. He is no longer a man with heart and soul and free will; he is a projectile driven fiercely by forces he cannot understand.

In the role of the woman-chaser, Daniel Otway prowls selected streets, keenly stalking his prey. Engaged in *"the cautious pursuit of a female,"* his veneer of human culture falls away and he becomes an animal in its natural setting. He has become *"a typical woman-hunter"* with a half-stalking step, eyes sharply

focused, and head jutting forward. Buckling under the pressure of primitive drives, he desecrates human love, particularly the heavenly Love available to a rare few. He is fated to live unproductively in degradation before finding relief in death.

Another character in the novel, a passionate Italian named Florio, also surrenders to nature's will. Not able to understand the strange and brutal forces that are using him, he surrenders to them and becomes a sexually propelled *"natural man"* who pays little attention to the rules of society. His intense wooing of Olga Hannaford is that of the male animal, ignorant of human rights, running its mate to earth. He responds to her in the only way he knows how: *"I have given you no right to hunt me like this,"* said Olga, panting, timid, her look raised for a moment to his. *"I take the right,"* he laughed musically. *"It is the right of the man who loves you."* It is an argument Olga cannot resist.

Florio claims Olga as his mate because ineffectual and idealistic Kite, a social creature in argument with himself, is too hesitant to seize the opportunity. In their marriage, as in their courtship, Florio proves himself an unfeeling brute. Olga is pleased at first with her husband's sexual prowess, but since their life together is based entirely on sex, they soon go their separate ways. In this novel there is no mincing of words on so-called taboo subjects. Gissing had given up any hope of being able to please the managers of the lending libraries, who wielded power of censorship over authors.

Near the end of his career he was determined to write about all aspects of human life, and that included sex in good taste. He believed no mature reader could ever be shocked by anything in his books. Mrs. Rosalind Williams, youngest sister of Beatrice Webb, read *The Crown of Life* carefully and found nothing in it to cause concern. She wrote to Mrs. H. G. Wells on December 23, 1899: *"I have not heard anything of Mr. Gissing for such a long time. I often wonder what has happened to him, for I got his new book 'The Crown of Life' from the library recently and thought it exceedingly good."* The woman had met Gissing and Wells at a black-tie gala they all attended in Rome.

At one time in her life Olga Hannaford had the rare opportunity to marry the person ideally meant for her. But because he was an artist without security and seemingly without promise, her practical-minded, materialistic mother objected. Heeding parental influence, Olga denied her destiny and her chance to marry for love and so missed the crown of life. The majority of the novel's men and women are similarly buffeted by fate. They struggle by degree, reaching to the heavens for sunshine, but eventually finding their hopes and dreams dashed.

Mrs. Borisoff, in conversation with Irene, expresses Gissing's personal opinion: *"In England, at all events, they think they marry for love, but that's mere nonsense. When I say love, I mean Love with a capital L – not domestic affection. Marriage is a practical concern*

of mankind at large; Love is a personal experience of the very few." In similar vein Gissing observes that the average person, either man or woman, but particularly man, marries because it is necessary for his welfare, even his physical health. *"He marries because he must, not because he has met with the true companion of his life."* Gissing had done exactly that.

Love in the high sense between a man and a woman is rare. Even those capable of the highest form of love often marry for solace or comfort. By so doing they renounce their best selves and sink to a lower level. So at the end of his life frail Jerome Otway, absorbed in an endless study of Dante, cannot believe that in his youth he wasted his life by not seeking the perfect wife. *"Somewhere in the world he would have surely found her, could he but have subdued himself and maintained the high seriousness of the quest."* In a youthful poem the senior Otway had sung of ideal love as *"the crown of life,"* believing the concept fervently. His youthful idealism eventually gave way to the demands of modern life. In old age he knew with clarity exactly what he had lost.

Near the end of his life he continued to believe with a fervor even more intense than in youth. And why? Because in old age the flesh has ceased to pester and the concept has become more spiritual. He lived to the end with regret. Had he pursued the ideal quest, at the very least he might have discovered why he missed the goal. *"That crown he had missed, even as did the multitude of mankind. Only to the elect is it granted."* Here

again Gissing stresses the combat between spirit and flesh and the rarity of the high-minded Love experience. In wistful reminiscence he is thinking of himself as he describes Jerome Otway.

In another instance Gissing dwells poignantly on the waste of life when the crown is missed, and upon the tragic irony of the loss. He gives an example of an exquisite girl yearning to love and be loved but losing her life in daily drudgery. Within a stone's throw of the young woman lives a young man ideally suited for her, but they will never meet. They will pass each other in the streets, perhaps bump umbrellas in the rain and murmur apologies, but they will live out their lives without ever knowing what the other was capable of giving. Yielding to natural and social pressures, both will wed other persons for sexual gratification and economic security instead of love. The earthiness of their lives will be a desecration of the ideal, and they will look back upon long and painful years that somehow never went right.

Jerome Otway in his youth took only second best, *"sinned against the highest law,"* and subsequently suffered for it. His son Piers with his father's help is able to resist the prompting of nature and listen to the promptings of a higher will. To marry a woman other than the one who lives in his dreams would be a terrible crime, *"no less a crime for its being committed every day."* To lose either strength or direction during the long years of waiting and struggle would be *"to*

commit a sin for which there is no forgiveness." To lose hope at any time during his quest would be a greater sin. For that reason Piers Otway must keep himself in peak condition mentally, spiritually, and physically at all times. Also he must cultivate patience but know when to act.

The seeker cannot surrender to despair, not even to rational query, even for a moment. To do so is to lose sight of the goal and the prize. Otway is one of the chosen few granted intuitive powers to recognize through all the shades of physical need his other half. He has *"the genius of love"* which allows him to see and to know without error. Rich in the intelligence of the heart, a quality Gissing prized, he finds his soul's ideal and patiently endures ordeal to win her. Through sacrifice he fulfills his destiny, taking for himself the crown of life, but only after much time and herculean effort.

Otway's struggle is told in a framework of determinism. To win his ideal woman, he must overcome the obstacle of poverty and find for himself a position in the world. His choice of action seems guided by free will, but is really determined by a sequence of cause and effect independent of will. The advent of Irene, mysterious and sudden, causes him to give up plans to become a civil servant and go into business as the quickest way to advance. He takes a job in Russia, learns a great deal about the customs of that country,

and becomes an expert interpreter of Russia to the English at a time when they were eager to know more.

His progress is from simple clerk to professional writer. Though his journey has not been an easy one, with hesitation he forms the belief that destiny has become his friend. Certain forces he cannot understand, forces that express themselves mainly through cause and effect, direct him to an important, lucrative, and reputable career. That good fortune in turn allows Otway to become the economic, social, and intellectual equal of his dream woman. Equality in the relationship cannot be over stressed; it is a basic ingredient for the ideal marriage.

An underlying determinism prepares Irene Derwent to respond to Otway's love. As she becomes vaguely aware of her place in some great plan, forces apart from her personal will teach her to trust destiny. Without really wanting to, she finds herself often thinking about Otway. Then one day, four years after their first meeting, she receives from the young man a painfully sincere love poem. Graceful and beautiful, it strikes deep emotional chords within the young woman and moves her profoundly. Not understanding why, she memorizes the entire poem. Its words ring and sing in her head and touch her heart.

Without any urging from her, the sentiments of the poem play upon heart and mind. The verses quickly become lodged in her psyche. At crucial times they speak to her. Involuntarily she finds herself in step with

their rhythm and probing their meaning. After several years the separate destinies of the lovers slowly begin to come together. The poem functions as a magnet to draw them closer in spite of the gulf between them. When she did not reject the verses, indeed took them as her own and began to live with them, Otway knew in his heart that the time had come when Irene was certain he worshipped her.

As though carefully nurtured, year by year the verses grow and flourish in Irene's consciousness. *"Verses in her mind, verses that would never be forgotten, sang and rang to a new melody."* They shape her attitude toward Otway. They help her form an ideal impression of him and eventually to love him. Mysteriously, they help her know him even in absence. Slowly but with consummate skill, they place in her psyche a picture of Otway as the one individual ideally meant for her. Though intellectualized and achieved through mind and emotion, the image owes its existence to forces clearly deterministic: *"It had grown without her knowledge, apart from her will, this conception of Piers Otway."* The poem functions as a subtle agent to place the separate lives of the lucky couple in tandem. Then at the right moment they become One.

Helen Borisoff, introduced in chapter fifteen of *The Crown of Life,* catches and holds our attention because she is a very different agent of Gissing's determinism. The woman displays a striking similarity to those eccentric characters Thomas Hardy labeled

"Mephistophelian visitants." She has a roguish laugh that hints at demonic mirth. She has a mocking smile, and a way of meddling impishly in the affairs of others. While she is mostly devilish, on occasion she can be angelic. At a social gathering, influenced by determinism, she brings Piers and Irene together. Hardy's visitants tend to do good by accident.

Like those visitants, Borisoff's origins are shrouded in mystery. Not even she herself knows much about her background. Those close to her know she can be mischievous as well as loving: *"I'm a sport, plainly," she declares with a twinkle in her eye. "You will see my mother watch me every now and then with apprehension. I know she prays that I may not harm you."* The keyword here is "sport." In the biological or genetic sense a sport is a mutant, an organism showing marked variation from the normal. She is aware of the fact that she is no ordinary person, but is unable to understand more than that. Her function in the novel, aside from interfering in the lives of others, is mainly to guide Irene toward Otway. She is the one who persuades Irene, through subtle tutoring, to break her engagement to Arnold Jacks. From the outset Borisoff has seen that Jacks, a philistine of imperialistic tendencies, is incapable of higher love and not meant for Irene. Her stratagem is to bring before the young woman a shining domain of ideal love and impress upon her the lofty, selective requirements for admittance.

This appeal to feminine egotism, and to the

perennial yearning for a nobler life, creates in the young woman a gloomy mood of misgiving, doubt, and rejection: *"It did not flatter her self-esteem to think of herself as excluded from the number of those who are capable of love, the elect, the fortunate."* And yet Borisoff's teachings provide a sense of direction when she needs it most. In her voyage of the spirit a clever pilot is there to guide Irene through the fog and bring her back on course should she drift. From the skilled pilot comes the promise of safe haven.

Florio, introduced in chapter sixteen of the novel, is another agent involved in the plan to bring Piers and Irene together. His physical characteristics also reflect a blending of the diabolic and the divine. At one moment the eyes glow with noble emotion and the next with sharp shrewdness. He is said to have *"a noticeable visage, very dark of tone"* and a large mouth surrounded by *"thick and very red lips."* He is shown as a restive, sensual, isolated person always on the move and never satisfied: *"I have, you know, my affairs, my business,"* he murmurs under his breath. His function as an agent is evident when he takes Olga Hannaford in marriage, literally by force, at the very time she is about to marry Piers Otway. Thrown off course in the pursuit of Irene, Otway has persuaded himself that Olga is the woman to marry. But for the timely intervention of the importunate Florio, Otway would have made an irrevocable mistake. It is Florio who sets him once more in the right direction. This agent of mysterious forces,

this visitant unconscious of his mission but acting at exactly at the right moment, makes what he sees as a necessary adjustment to insure Otway a specific destiny.

The love story of Piers Otway powerfully demonstrates Gissing's theory of love. It is an eclectic but complicated theory immersed in Platonism and Dantean idealism. It was rendered more complicated and yet dynamic by concepts of fatalism and scientific determinism. Even though elements of the theory, and its outline, were long a part of Gissing's thought, their formation into a recognizable philosophy to be dramatized in fiction did not occur until Gissing met Gabrielle Fleury. Presentation of the philosophy in *The Crown of Life* became the central interest of that novel and its main theme.

The secondary theme of rising British imperialism, with its ugly emphasis on war, death, and violence, was introduced as a dramatic contrast to the theme of enduring, ineffable, profound love. It is to some extent the ancient theme of good reaching fruition in the presence of evil. The book was written to memorialize Gissing's love-fever and the woman in back of it. The attack on militarism and political expansion was an important statement of his broader views, but the love story was given his most careful thought. When the book was published in the autumn of 1899, the subordinate theme focusing on current affairs was singled out for brief mention and the delicately structured main

theme went virtually unnoticed. Gissing complained of *"shallow critics."*

The handful of critics who attempted to review *The Crown of Life* approached the task with stuffy indifference and without understanding the novel. That trend has continued to the present day. Critics have failed to judge the importance of Gabrielle in the novel's creation and composition. Gissing's love for the young woman gave him the initial idea, and she lived in mind and heart as he wrote the last paragraph. Her affectionate and abiding influence brought depth and dimension to a love story that otherwise might have been sterile and vapid. Their enduring, passionate love, and Gissing's mistaken belief that a hostile fate at long last had become his friend, gave a deeper, more satisfying meaning to the story. For that reason he saw the book as philosophical, took great delight in writing it, and considered it the best thing he had ever done. He was dismayed but not surprised when "shallow critics" pronounced the work a failure.

Chapter Twenty

Marriage to Gabrielle Fleury

On Sunday May 7, 1899 in a posh hotel at Rouen, George Robert Gissing married Gabrielle Marie Edith Fleury. Situated on the banks of the Seine in northern France, the old city was a treasure house of valued artistic masterpieces and known for its huge clock dating from the 1300's. It was also the city where the English burned Joan of Arc at the stake in 1431. Gabrielle's mother was the sole person in attendance as a witness. Edith Gissing was alive in England, and yet the couple viewed their marriage as legitimate and binding. To record the occasion for posterity, Gissing wrote this in his diary: *"In the evening, our ceremony. Dear Maman's emotion, & G's sweet dignity."* He said nothing of his own deportment, or perhaps what he said was lost.

At best the ceremony was a symbolic assertion of their love. It couldn't be a genuine marriage, for he was still legally bound to Edith. Because of the moral question, Gissing didn't inform his sisters of

the marriage. Also he felt they would have difficulty accepting a foreign woman as a member of the family. Several of his novels show English women prejudiced toward foreign women looking for husbands in the marriage market. In *A Life's Morning*, Philip Athel *"wedded his Italian maiden, brought her to England, and fought down prejudice."*

After their honeymoon in salty St. Pierre en Port on the coast of Normandy, the couple went to live with Mme. Fleury in her small but comfortable apartment in Paris. Earlier Gissing had explained to Bertz that he couldn't risk living in England again. He could be charged with breaking the law and arrested. Though temporarily living in Paris, in time the couple hoped to find a home in Switzerland. Sharing cramped living quarters with Gabrielle's mother was a trial for the fastidious and very private man, but no other arrangement seemed possible. Mme. Fleury was too old to live alone, and her daughter wouldn't hear of a stranger living in the Parisian flat to care for her.

The woman dominated her daughter and made it clear to Gissing that in her apartment she was head of the house. Within a month he was quarreling with Mme. Fleury over the kind of food he felt he needed. For breakfast each morning, he wanted bacon and eggs, but she considered the standard English meal too heavy and unhealthful. Domestic friction, which Gissing had always hated, began to plague him in this, his ideal marriage. Also he came to believe that his

health was declining. He was able to live with these daily annoyances because, as he confessed to Bertz, for the first time in his life he was truly happy: *"So there! For the first time in my life I am happy! And, if health does not fail me, I shall be happy for many a year."*

During June and most of July 1899, the three lived in Paris while Gissing worked smoothly and with great satisfaction on *By the Ionian Sea*. He completed the book, based on the notes of his Calabrian trip, while he and Gabrielle were on holiday in Switzerland. For several weeks they had moved about in the Alps, seeking a place of residence beneficial to his precarious health. Gissing suffered from eczema and respiratory ailments. He had been told by a doctor to find fresh air in the mountains. He was certain that domestic peace and mountain air would make him sound again.

With the coming of spring, he couldn't resist returning to England. The month of April in 1900 he spent in the company of his family at Wakefield. Later he visited Edward Clodd in London and H. G. Wells at Sandgate. After he returned to France he moved to a pleasant house in St. Honoré les Bains, where he worked steadily through the summer on "The Coming Man." He completed the book at the end of August but had to wait for publication as *Our Friend the Charlatan* in 1901. He wanted it published in the autumn of 1900 so that he could choose 1901 as the date of the historical novel he was calling "The Vanquished Roman." That book was eventually published posthumously as *Veranilda*

in 1904. Just two days after completing "The Coming Man," he began to write *The Private Papers of Henry Ryecroft*, his autobiographical book.

Henry Ryecroft was written in only two months, September and October of 1900. For several years Gissing had been pondering such a book and storing away bits of material in various notebooks. That and the constant support of a loving wife allowed for rapid composition. Published in serial form as *An Author at Grass*, and later as a volume with the present title, the book has since become a minor classic. Before his death, Gissing saw *Henry Ryecroft* go through three editions. Its popularity pleased him greatly, for he saw himself in the book, at least in the *"literary sense,"* as mellowed and philosophical.

It was a fitting book to be published in the year of his death, for in many respects Ryecroft is the kind of man Gissing hoped to become in maturity. The word "calm" is a full summary of Ryecroft. He is at peace with himself and the world (as Gissing was not), having come to terms with all those forces that wear a man down. His thoughts and feelings no longer torment him, and the daily round of human life is not a burden. The hours of each day are pleasant. Living the life of the mind, he finds his pleasure in little things and savors simplicity. For the people close to him and for all others, he has tolerance, patience, and compassion.

In the early months of 1901, as Gissing worked on the novel that was published in 1904 as *Veranilda*,

Gabrielle's translation of *New Grub Street* (the project that had brought them together) was serialized. He was happy for her and with the way his life was going. Then of a sudden he suffered an attack of influenza and was examined by a French doctor. The physician discovered serious respiratory problems -- emphysema, bronchitis, and a dark spot on the right lung. He ordered Gissing to stop working and go immediately to the nearest mountains for rest, proper diet, and clean air. The latter was thought an absolute necessity.

But instead of following the physician's orders, Gissing yielded once again to the siren call of England in springtime and went home. Gabrielle was included in his plans, and the two visited Wells and his wife during the last week in May. There Gissing ate with gusto the hearty English meals denied him in France. After several days in Wells's home Gabrielle went back to Paris to look after her mother. Without informing his protective and solicitous mate, Gissing made plans to stay longer in England and enter a new sanatorium, which he hoped would improve his health.

Near the end of June 1901, with nervous Gabrielle fuming over an important decision made without her, Gissing went to Dr. Jane Walker's sanatorium in Suffolk. He stayed there a month, taking the open-air and over-feeding treatment in vogue at that time. On the day he departed he had convinced himself that his health was vastly better. In future, as he told Bertz, he would sleep with his windows open and would settle once and

for all the conflict with Mme. Fleury over the food he needed for good health and to remain strong. He would find a way to eat good and rich food that would put flesh on his bones and a bounce in his step.

To Mrs. Wells, Gabrielle disclosed that her beloved husband's dissatisfaction with household matters was a mere façade that sprang from a deeper dissatisfaction with the world itself. Though she had tried to make the man happy, she was convinced that his temperament was so rooted in ill-defined gloom that happiness would forever evade him. Her sensitive analysis of his character was accurate, but she was wrong to suppose he cared more for his family than for her. Also she was not able to see that Gissing worried about her losing her own health in a household with two sickly people. Increasingly she became the garde-malade for her husband and mother. She would have it no other way, but it placed her under great strain, taxing her strength.

Early in August, Gissing rejoined Gabrielle in Autun. There they lived in pleasant surroundings until October 1901. When his doctor in Paris suggested a warmer climate for the winter, they moved southward to a town called Arcachon. He didn't suffer from tuberculosis, as he had feared, but the examination did show a gradual hardening of the surface of the lungs and emphysema becoming more serious. At Arcachon he spent his days resting in the open air in a place occupied mainly by invalids. He did little work, complaining to his friends in England that any work at

all was impossible on a chaise longue. He even put aside his diary, that record of his emotional life, and didn't make entries in it for a year. By Christmas of 1901 his health was improving. He had never liked winter, and the month of January in 1902 seemed interminable.

However, in February of 1902 came good news that made him feel instantly better. Miss Orme, the woman who had tried to help him with Edith, wrote to inform him that the woman at long last had been judged insane and committed to an institution. The disturbed woman had not found peace, but she would no longer be able to cause her husband trouble. Alfred (the younger son) would receive proper care on a farm in Cornwall. *"I cannot tell you how greatly I am relieved,"* he wrote in a tone of exultation to Bertz. *"Indeed, I believe that this event is already having a good effect upon my health."* For years Gissing had fretted helplessly about Alfred, believing the boy would have no future and blaming himself. Now came the news that he would be safe in a good environment with good people. Alfred Charles lived a long but ordinary life and never knew his father except by reputation.

Gissing soon returned to his long-delayed historical novel, making the final outline and plans for writing it. Once more, however, worldly matters intervened to put off the actual writing. He had to find a new house, for Mme. Fleury's flat in Paris was unsuitable for work and the city's air difficult to breathe. In search of a milder climate, the three decided

to move to St. Jean de Luz, where Gissing spent a month looking for a residence. At length he rented *"half a dozen good rooms"* in the private home of a quiet family who made a point of not interfering with their tenants. He liked the picturesque town and judged it beautiful. His health was rapidly improving, or so he thought, and he seemed *"twice as strong as six months ago."* Their plan was to live at St. Jean de Luz, enjoying the seclusion and favorable climate, for at least a year and perhaps longer. They moved there in June 1902, and by July 10 Gissing had begun *Will Warburton*, the last novel he would complete before his death. He would soon labor steadily on his Roman novel but would not finish it. His emotional health was good but he lacked strength.

The remainder of 1902 saw not the gradual improvement in health he so earnestly hoped for, but a steady decline. An overwhelming fatigue descended upon him, and try as he might he could not regain vigor with rest. He continued his work on *Warburton* but was able to produce only a page a day, writing mainly in the morning. In November he gave up the diary he had kept for fifteen years. A workbook as well as a diary, it confided his thoughts and feelings to himself and to some future reader who might stumble upon it. The diary was also a place to store ideas, prompted by daily events, for books he might write.

He was heartened by the favorable reception of *Henry Ryecroft*, but characteristically he complained the book brought only recognition, which he no longer

valued, and little money. To the end of his life he revealed to friends that his books earned him scarcely enough to live on. Less talented authors were becoming rich writing execrable English on topics readers liked. Publishers bought their books but were convinced that Gissing's novels were risky to finance. Cerebral and often somber, they lacked an eager audience ready to buy them. By now Gissing was an expatriate living in expensive resort towns and needed more money than ever just to meet expenses.

The literary agent Pinker was able to secure £300 for *The Crown of Life* from Methuen. That was £50 more than the firm had paid for *The Town Traveller*. Publication of that book was delayed because Pinker was trying to get the best price for it. Writing to Wells on June 24, 1902, Pinker confided that Gissing was always in need of money. He required his agent to sell his books in such a big hurry, there was little chance to negotiate terms. Gissing received £150 from *The Fortnightly Review* for the serial rights of *An Author at Grass*. Constable paid him £100 for the work when it was published as *The Private Papers of Henry Ryecroft* in 1903. The firm also paid Gissing a 20% royalty. Because he sold most of his books outright, he received almost no income from royalties.

Early in 1903 Morley Roberts came to visit. They talked of the old days going all the way back to the college experience in Manchester. They remembered those uncertain times when they were hopeful young

men at the beginning of their literary careers in London. It was bitter-sweet reminiscence for both of them. To Wells, Gissing wrote that if he were ever in London in future, he would make better use of his time, but he doubted he would ever see the great city again. A decade ago he had written a book, autobiographical in part, titled *Born in Exile* (1892). He had lived in figurative exile during most of his London years. Now he found himself living in literal exile in a place he described as beautiful, but a village on foreign soil that could never be compared to London.

Roberts noted that Gissing was no longer in robust good health. In fact his friend appeared fragile and somewhat feeble, moving with a gait that made him seem much older. He seemed to be guarding his health so carefully that even on good days he hesitated to leave the house. Once a great walker eager to walk long distances, Gissing now found walking a burden. Roberts didn't know that his friend was suffering from sciatica, a chronic neuralgic pain in the area of the hip or thigh. It was only one of his ailments, but a disorder that made him almost lame and no longer capable of walking briskly.

In March Gissing completed *Will Warburton*, which he termed a light and fanciful book in spite of its social criticism and the echoes of his early years in London. Then half-heartedly he began to work on the long-delayed historical novel, *Veranilda*. He made little progress on the book and feared that he was losing

"combative force." Though only in his middle forties, he was certain that he was growing old too fast. In June they moved to the neighboring town of St. Jean Pied de Port, where he hoped to benefit from the change of air and thus regain his strength. *"I earnestly hope my health may improve,"* he confided in one of his many letters to his friend Bertz, *"for I am getting weak to a dangerous degree."* He was losing spiritual strength, apart from the physical ailments, and couldn't be certain of the cause. He believed rest would restore his strength rather than exercise.

Was the devastation brought on by something psychological? Had he discovered that Gabrielle was not his splendid, heavenly woman after all? Was he beginning to feel that fate had not blessed him, as he had thought, but was hurting him grievously to hasten the end of his life? Was their nomadic existence in search of a favorable climate becoming too much to bear? Was he finding himself unable to tolerate Gabrielle's mother, Mme. Fleury, in their daily lives? Did the exile in France and the loss of his sons and family in England prey upon him emotionally? And his low income, his inadequate income: was that good reason to look back in bitterness over the years and question the value of his struggle? Given the evidence, his frame of mind may have killed him.

Bertz had written him a note in praise of *Henry Ryecroft* and had added that Gissing as Ryecroft had mellowed and seemed at peace. On February 15, 1903, to

set the record straight, Gissing replied: *"Made my peace with the world, do you think? Why, only in a literary sense. The troubles about me and before me are very grave, and any day I might find the world very much my enemy. My need of money grows rather serious, for though we live very economically indeed, I earn so little, so little! Last year my income was not quite £300."* He had told himself repeatedly that no middle-class woman would live with him on so little income. He was wrong. Gabrielle weathered the storm and stress and supported him with unconditional love and care to his last breath.

During the summer and fall of 1903 Gissing worked steadily on his last book, but not at the usual pace of several pages a day. In July he reported to Bertz that he was working seriously on the historical novel and expected it to be a strong book, clearly accurate in its depiction of the times. He complained, however, of insomnia and feared that his fragile health could break at any time. He liked the striking mountain scenery and tranquility of the Pyrénées, but unlike the Romantic poets, a group he deeply admired, he was unable to imbibe strength from elemental nature. He intended to remain in his latest residence through the winter and finish "The Vanquished Roman," published as *Veranilda* in 1904 after his death.

In October he explained to Wells that even though the task was proving almost too much for his present state of health, he was more than half finished. By November he was forced by physical weakness to lay

the manuscript aside, but continued to work whenever he could. *"I might be finished,"* he told his sister Ellen, *"before the end of January."* He would not live to see January or the New Year. Just before Christmas of 1903, with five chapters yet to be written, he fell desperately ill. He tumbled into his bed, became semiconscious and delirious, and threw Gabrielle into a state of shock. In terse little notes she informed his friends in England that he was dying. It was plain to her, and she could do nothing. He held on through Christmas but steadily grew worse.

Gissing died of double pneumonia at forty-six years of age on Monday, December 28, 1903 at St. Jean Pied de Port. On December 27 Gabrielle had scribbled a hasty note to Bertz, announcing that *"dearest G"* was dying. *"Every hope of saving him must be abandoned and his end is now awaited at every moment. He is delirious since seven days, and speaks about his 'Veranilda' which he leaves unachieved."* Before she mailed the brief letter, she added a postscript: *"Monday. Died today this afternoon."* There was talk of bringing his body back home for burial, but his final resting place was St. Jean de Luz, France. A number of English people, including H. G. Wells and Morley Roberts, gathered just before and after the final moments. A brief eulogy of Gissing's life and career appeared in *The Times* a day later on December 29, 1903. It was well meaning and sympathetic but lacking accuracy.

It's been said that Gissing didn't live long enough

to immortalize Gabrielle in his fiction. If one looks for an outstanding fictional character modeled obviously on Gabrielle, that observation might be true. But the pervasive influence the woman had upon *The Crown of Life* cannot be ignored. The book is a sincere tribute to Gabrielle more endurable than any fictional portrait of her. She is, therefore, as much a part of Gissing's life and achievement as Nell or Edith or the Gissing sisters or the female friends (Gaussen, Sichel, Collet). After his death, as if to prove her love in its intensity, Gabrielle lived on for more than half a century with only his memory to sustain her. She made her residence in Paris and never married again. In April of 1954, frail with age, she was injured in a street accident in Paris and died a few months later.

In *Will Warburton* Norbert Franks, an artist similar to Kite in *The Crown of Life*, shuns realistic subjects to paint portraits that idealize women. *"This is my chosen specialty,"* he explains, *"lovely woman made yet lovelier, without loss of likeness."* Gissing smiled at Norbert Franks, liked him for his idealism and naiveté, and allowed him to prosper. Had not he himself painted similar portraits of ideal women while living and suffering and struggling? And were they not in the manner of Franks? At the end of his career of slightly more than two decades, if he reviewed his achievement at all, his extensive gallery of female characters must have given him a quiet satisfaction.

Despite the uncertainty he felt in afterthought, his feminine portraiture surely pleased him.

The women in his life, from Nell to Gabrielle, each left a dominant imprint upon him. The influence allowed him to portray women vividly and memorably, though at times in tones of black and white. Gissing's portraits of women, rendered in shades of somber experience, are one of the most striking features of his work and one of the most valuable for readers today. They derived from his intense and abiding interest in women and how they lived their lives. His warm and human portraits were shaped in all their detail by an essential sympathy that made them neither topical nor contemporary but timeless. The female characters in the novels of George Gissing are as alive today as when his books were first published. Without stinting he gave them good looks, sharp minds, strength of character, and soul. They will live and breathe long after the author himself has faded from memory.

So there you have it – the life and work of George Gissing. Go now and read his books. Any good library will have them. Read them all. It will be an adventure you will long remember.

A George Gissing Chronology

1857 — Born November 22 in Wakefield, Yorkshire, England, son of a chemist. The oldest of five children (three boys and two girls), he was christened George Robert Gissing. As a child he attended Back Lane School in Wakefield and quickly became known as a diligent student.

1870 — His father, Thomas Waller Gissing, died suddenly in December of this year, leaving behind a young wife and five children. His mother, Margaret Bedford Gissing, managed to keep the family together on the small inheritance left by her husband.

1871 — With his two brothers, William and Algernon, George became an exemplary student at a Quaker boarding school, Lindow Grove, at Alderley Edge in Cheshire.

1872 — In October he matriculated at Owens College, Manchester on a scholarship that provided free tuition for three years. Continued to live at Lindow Grove until he went off to college.

1875 — Moved to private lodgings near the college in Manchester. Won high honors in English and Latin and distinguished himself as a gifted student. Dreamed of becoming a classical scholar in a university.

1876 — Met Marianne Helen Harrison (Nell), a young prostitute he attempted to rescue and reform. Her picture shown to Morley Roberts, who became his life-long friend. On May 31 arrested for stealing planted and marked money in the college cloakroom. On June 6 convicted and sentenced to a month in prison at hard labor. On June 7 expelled from Owens College. In August sailed for United States to start a new life. Hoped to send for Nell when settled in America. Wrote sentimental poems declaring his love and idealizing Nell.

1877 — Taught briefly in a public school at Waltham, Massachusetts. Went by train to Chicago and published first fiction, "The Sins of the Fathers," in *Chicago Tribune* on March 10. Published several stories before leaving Chicago in July to return to New York and New England. Sailed from Boston in September, arrived in Liverpool October 3, found himself living in London lodgings by end of October.

1878 — Lived at 22 Colville Place, London, between January and September. Continued to use American notebook for plot outlines. On birthday, November 22, received his share of a trust fund (about £500) left by

his father. Advises two sisters on their reading and education.

1879 — In January met Eduard Bertz, a young German intellectual who became an enduring friend to whom he wrote many letters. Married Marianne Helen Harrison on October 27. Earned a spare living as a tutor and worked on first proletarian novel.

1880 — In March *Workers in the Dawn* published at own expense. Friendship with Frederic Harrison helped him meet upper-class people. Brother William died of tuberculosis April 16.

1881 — In February moved to Worthington Road, earned 45 shillings a week tutoring children of wealthy families. In August moved to 15 Gower Place. Lived in rented lodgings with Nell who was often ill. Worked on his second novel, which he hoped a publisher would accept.

1882 — Tutored ten pupils from 9 to 6 and wrote in the evenings. Second novel, "Mrs. Grundy's Enemies," completed in September and accepted for publication but never published. Nell, alcoholic and sick, sent to an invalids' home in Battersea. Returned in October, soon left. Gissing moved to 17 Oakley Crescent, Chelsea, where he lived two years.

1883 — Nell back on the streets as a prostitute, involved in street disturbance in September. Gissing lived alone,

worked on third novel, tried and failed to get a divorce, never saw Nell until after she was dead.

1884 — Moved to a single room at 62 Milton Street near Regents Park. Bertz left London in April for home country, Germany. *The Unclassed* published as second novel, in June. In summer met Mrs. David Gaussen, visited her country home in September, began to tutor her son at better quarters, 7K Cornwall Residences.

1885 — In the spring spent a week with the Gaussen family along with sister Ellen. Worked on *Isabel Clarendon*, begun in 1884 and influenced throughout by Mrs. Gaussen. Also completed *A Life's Morning* in this year, both a departure in subject matter from earlier novels.

1886 — *Isabel Clarendon* published in February. *Demos*, a return to his "special line of work," published a month later and reviewed favorably.

1887 — *Thyrza* published in April. Colorful scenes of working-class life dominated by girls and women living free of want. Main character, a working girl, Thyrza, idealized.

1888 — *A Life's Morning*, written before *Demos*, published in February. Nell died February 29. Gissing viewed her body on March 1. Began work on *The Nether World* and completed novel in four months. On way to Italy stopped briefly in Paris, attended a speech by a

leading feminist. In Italy five months. Loved the country, climate, people.

1889 — *The Nether World* published in March. Completed Italian trip. Began trip to Greece and Italy. Met Edith Sichel in September.

1890 — *The Emancipated* published in March. In April visited Paris with his sisters. On September 24 met Edith Underwood in a working-class London neighborhood. Made rapid progress on his next novel, *New Grub Street*, after he met her and completed it in December.

1891 — Married Edith on February 25 and moved from London to Exeter, noted for its scenery. Son, Walter Leonard, born December 10. Edith suffered from neuralgia, showed first signs of sour temper. *New Grub Street*, his best-known novel, published in April.

1892 — Two novels published in this year, *Denzil Quarrier* in February, *Born in Exile* in April. Lived in pleasant surroundings away from London and better off financially. But for Gissing it was a year of "domestic misery and discomfort."

1893 — *The Odd Women* published in April and well reviewed. In September some newspaper publicity when he accused a parson of stealing a long passage from *The Nether World* and publishing it as his own. The parson after hemming and hawing blamed the printer. Met Clara Collet in July, visiting her in Richmond.

1894 — *In the Year of Jubilee* published in October. Finished *Eve's Ransom* in June and moved to Somerset. Complained of isolation and uncertain health and low income in spite of never-ending work.

1895 — Three short novels published in this year. *Eve's Ransom* ran serially in *Illustrated London News*, out in book form later in year. *The Paying Guest* and *Sleeping Fires* published near end of year. Domestic turmoil increased.

1896 — Second son, Alfred Charles, born January 20. By the end of year, Gissing's troubles with Edith had convinced him he would have to abandon his family. Worried about welfare of sons.

1897 — In February driven "vixen-haunted" from home. Published *The Whirlpool* in spring. Returned to Edith in June and moved in July to Yorkshire. In September he fled from Edith and domestic conflict again, making the separation final. Italian trip of six months later provided materials for *By the Ionian Sea*.

1898 — Returned to England April 18. Met Gabrielle Marie Edith Fleury on July 6 at home of H. G. Wells. Saw wife Edith and son Alfred for last time on September 7. Published *Human Odds and Ends*, a collection of short stories, *The Town Traveller*, and *Charles Dickens, A Critical Study*. Pervasively influenced by Gabrielle, began work on what he thought would be his best novel.

1899 — Began to live with Gabrielle Fleury in France after a marriage ceremony in a hotel on May 7. Finished *By the Ionian Sea* and "Among the Prophets," later destroyed. Published *The Crown of Life* in October.

1900 — In April visited his family in Wakefield. Worked through the summer on "The Coming Man" published in 1901 as *Our Friend the Charlatan*. In autumn, *The Private Papers of Henry Ryecroft* written in fewer than two months.

1901 — With Gabrielle visited Wells in May. In June went alone to Dr. Jane Walker's sanatorium in Suffolk. Stayed there a month. In August joined Gabrielle in Autun, living there until October 12. Then moved southward to Arachon for better climate in failing health. Published *Our Friend the Charlatan* and *By the Ionian Sea*.

1902 — In February Edith Underwood Gissing committed to insane asylum. With Gabrielle Fleury and her mother, he moved to St. Jean de Luz in June to take advantage of the climate. Worked sporadically on historical novel and other projects in spite of steadily declining health.

1903 — Published *The Private Papers of Henry Ryecroft.* Completed *Will Warburton* in March. During summer and fall worked on historical novel, *Veranilda*. Fell ill with five chapters yet to be written and was not able to finish it. Moved to Ispoure in St. Jean Pied de Port and

died there of double pneumonia at forty-six years of age on December 28. Buried at St. Jean de Luz.

1904 — Unfinished historical novel *Veranilda* published.

1905 — *Will Warburton* published.

1906 — *The House of Cobwebs*, a collection of short stories, published.

1917 — On February 27 Edith Underwood Gissing, his second wife, died at forty-five in asylum of "organic brain disease."

1918 — His son Walter was killed in World War One.

1954 — In April, Gabrielle Fleury Gissing, (his third wife in name only) was injured in a street accident in Paris and died several months later.

A List of Gissing's Novels

1880...................... Workers in the Dawn
1884...................... The Unclassed
1886...................... Isabel Clarendon
1886...................... Demos, a Story of English Socialism
1887...................... Thyrza: A Tale
1888...................... A Life's Morning
1889...................... The Nether World
1890...................... The Emancipated
1891...................... New Grub Street
1892...................... Denzil Quarrier
1892...................... Born in Exile
1893...................... The Odd Women
1894...................... In the Year of Jubilee
1895...................... Eve's Ransom
1895...................... The Paying Guest
1895...................... Sleeping Fires
1897...................... The Whirlpool
1898...................... The Town Traveller
1898...................... Human Odds and Ends (Short Stories)
1898...................... Charles Dickens: A Critical Study
1899...................... The Crown of Life
1901 Our Friend the Charlatan

A List of Female Characters

Mary Abbot	The Whirlpool
Mrs. Allchin	Thyrza
Mrs. Argent	Victim of Circumstances
Miss Armitage	The House of Cobwebs
Amy Baker	The Paying Guest
Mary Barfoot	The Odd Women
Mrs. Tom Barfoot	The Odd Women
Lady Isobel Barker	The Whirlpool
Amelia Barmby	In the Year of Jubilee
Lucy Barmby	In the Year of Jubilee
Miriam Baske	The Emancipated
Mrs. Batt	Human Odds and Ends
Mrs. Batterby	The Nether World
Mrs. Batty	Stories and Sketches
Mrs. Baxendale	A Life's Morning
Mrs. Bellamy	In the Year of Jubilee
Bevis sisters (three)	The Odd Women
Mrs. Bevis	The Odd Women
Mrs. Blatherwick	Workers in the Dawn
Mrs. Bloggs	Human Odds and Ends
Mrs. Bolsover	The Town Traveller

Mrs. Bolt	Isabel Clarendon
Miss Bonnicastle	The Crown of Life
Mrs. Borisoff	The Crown of Life
Mrs. Borrows	Stories and Sketches
Mrs. Boscobel	Demos
Mrs. Bower	Thyrza
Mary Bower	Thyrza
Mary Bowes	The House of Cobwebs
Mrs. Bradshaw	The Emancipated
Mrs. Breakspeare	Our Friend the Charlatan
Constance Bride	Our Friend the Charlatan
Agnes Brissenden	The Odd Women
Mrs. Brookes	Stories and Sketches
Mrs. Bubb	The Town Traveller
Budge sisters (4)	Stories and Sketches
Mrs. Budge	Stories and Sketches
Mrs. Budge	Victim of Circumstances
Bessie Bunce	Thyrza
Mrs. Buncombe	The Whirlpool
Mrs. Butterfield	Thyrza
Mrs. Byass	The Nether World
Evelyn Byles	Victim of Circumstances
Jessie Byles	Victim of Circumstances
Mrs. Byles	Victim of Circumstances
Emily Cadman	Born in Exile
Maria Candy	The Nether World
Pennyloaf Candy	The Nether World
Sibyl Carnaby	The Whirlpool
Edith Carter	New Grub Street

Amy Cartwright	A Life's Morning
Barbara Cartwright	A Life's Morning
Eleanor Cartwright	A Life's Morning
Geraldine Cartwright	A Life's Morning
Jessie Cartwright	A Life's Morning
Mrs. Cartwright	A Life's Morning
Hilda Castleldine	Victim of Circumstances
Mrs. Catterick	Human Odds and Ends
Mrs. Charman	The House of Cobwebs
Mrs. Chattaway	Demos
Bertha Childerstone	Human Odds and Ends
Mrs. Chittle	In the Year of Jubilee
Winifred Chittle	In the Year of Jubilee
Mrs. Christopherson	New Grub Street
Mrs. Christopherson	The House of Cobwebs
Isabel Clarendon	Isabel Clarendon
Mary Claxton	Human Odds and Ends
Kate Clay	Demos
Lucy Cliffe	Human Odds and Ends
Hannah Clinkscales	Workers in the Dawn
Lizzie Clinkscales	Workers in the Dawn
Miss Cloud	Victim of Circumstances
Louisa Clover	The Town Traveller
Minnie Clover	The Town Traveller
Mrs. Conisbee	The Odd Women
Lady Florence Cootes	Isabel Clarendon
Mrs. Cope	Workers in the Dawn
Mrs. Cosgrove	The Odd Women
Bertha Cross	Will Warburton
Mrs. Cross	Will Warburton

Emily Enderby	The Unclassed
Maud Enderby	The Unclassed
Jenny Evans	Stories and Sketches
Muriel Featherstone	The Paying Guest
Sally Fisher	The Unclassed
Mary Fleetwood	Victim of Circumstances
Mrs. Fletcher	Human Odds and Ends
Beatrice French	In the Year of Jubilee
Fanny French	In the Year of Jubilee
Mrs. Frothingham	The Whirlpool
Mrs. Thomas Gale	Born in Exile
Mrs. Gallantry	Our Friend the Charlatan
Sarah Gandle	Thyrza
Ivy Glazzad	Denzil Quarrier
Mrs. Goldthorpe	The House of Cobwebs
Mrs. Gorbutt	New Grub Street
Mrs. Grail	Thyrza
Maud Gresham	Workers in the Dawn
Charlotte Grub	Human Odds and Ends
Mrs. Gulliman	Demos
Mrs. Gully	The Nether World
Mrs. Gunnery	Born in Exile
Mrs. Halliday	Victim of Circumstances
Mrs. Hammer	A Life's Morning
Olga Hannaford	The Crown of Life
Mrs. Hannaford	The Crown of Life
Hannaford's sister	The Crown of Life
Mrs. Handover	The Whirlpool

Mrs. Jenkins	A Life's Morning
Mrs. Jephson	Human Odds and Ends
Rosamund Jewell	Victim of Circumstances
Sukey Jollop	The Nether World
Miss Jupp	Human Odds and Ends
Mrs. Jupp	Human Odds and Ends
Winifred Kay	Stories and Sketches
Mrs. Keeting	The House of Cobwebs
Lady Kent	Isabel Clarendon
Miss Kerin	Stories and Sketches
Kate Kirby	Stories and Sketches
Mrs. Lane	New Grub Street
Miss Lant	The Nether World
Mrs. Lanyon	Stories and Sketches
Mrs. Ascott Larkfield	The Whirlpool
Mrs. Larrop	Thyrza
Mrs. Lashmar	Our Friend the Charlatan
Dora Leach	The Whirlpool
Gerda Leach	The Whirlpool
Mrs. Leach	The Whirlpool
Mrs. Ledward	The Unclassed
Mrs. Lessingham	The Emancipated
Laura Lindon	Sins of the Fathers
Mrs. Liversedge	Denzil Quarrier
Nancy Lord	In the Year of Jubilee
Lumb sisters (2)	Born in Exile
Alice Madden	The Odd Women
Gertrude Madden	The Odd Women

Mrs. Murch	In the Year of Jubilee
Alice Mutimer	Demos
Mrs. Mutimer	Demos
Totty Nancarrow	Thyrza
Annabel Newthorpe	Thyrza
Helen Norman	Workers in the Dawn
Lillian Northway	Denzil Quarrier
Rhoda Nunn	The Odd Women
Mrs. Oaks	Workers in the Dawn
Mrs. Ogle	The Unclassed
Lady Ogram	Our Friend the Charlatan
Mrs. Orchard	The Odd Women
Mrs. Ormonde	Thyrza
Bridget Otway	The Crown of Life
Mrs. Jerome Otway	The Crown of Life
Mrs. Paddy	Human Odds and Ends
Mrs. Bruce Page	Isabel Clarendon
Constance Palmer	Born in Exile
Ada Peachey	In the Year of Jubilee
Charlotte Peak	Born in Exile
Mrs. Peak	Born in Exile
Clem Peckover	The Nether World
Mrs. Peckover	The Nether World
Pettindund sisters (4)	Workers in the Dawn
Mrs. Pettindund	Workers in the Dawn
Phoebe	Stories and Sketches
Martha Pimm	Human Odds and Ends

Printed in the United States
by Baker & Taylor Publisher Services